The
Plant
Hunter's
Atlas

A WORLD TOUR OF BOTANICAL ADVENTURES, CHANCE DISCOVERIES AND STRANGE SPECIMENS

AMBRA EDWARDS

greenfinch

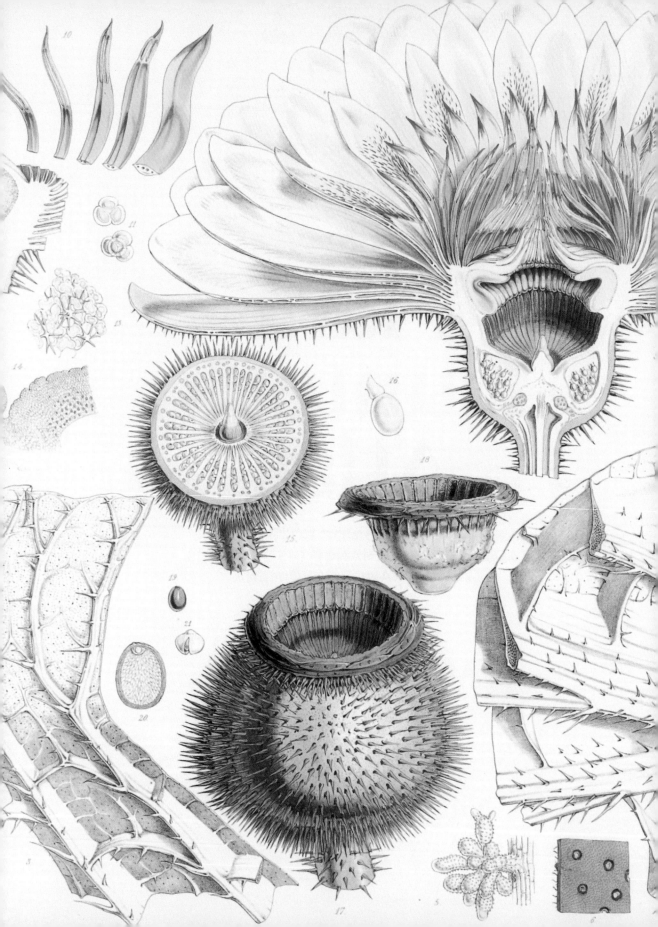

Contents

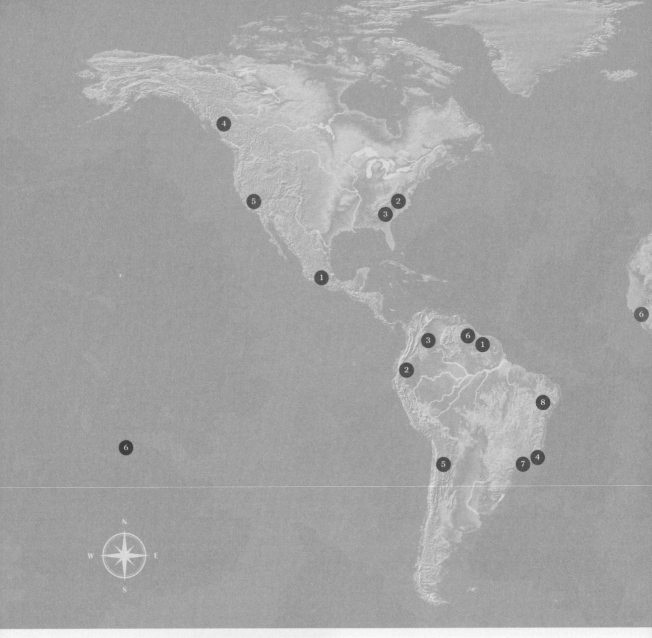

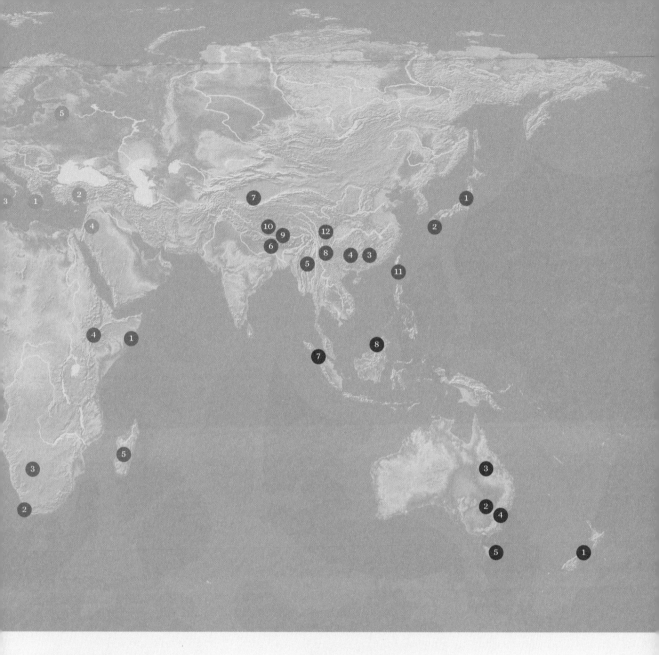

● AFRICA AND MADAGASCAR

1 Frankincense (*Boswellia*), Somalia
2 Starfish flower (*Stapelia*), South Africa
3 Living Stones (*Lithops*), South Africa
4 Coffee (*Coffea*), Ethiopia
5 Flamboyant tree (*Delonix regia*), Madagascar
6 Linsonyi (*Talbotiella cheekii*), Guinea

● NORTH AMERICA AND MEXICO

1 Dahlia (*Dahlia*), Mexico
2 Tulip tree (*Liriodendron tulipifera*), Virginia, US
3 Southern bay (*Magnolia grandiflora*), Carolina, US
4 Douglas fir (*Pseudotsuga menziesii*), British
 Columbia, Canada
5 Giant redwood (*Sequoiadendron giganteum*),
 California, US

● SOUTH AMERICA

1 Peacock flower (*Caesalpinia pulcherrima*), Suriname
2 Fever tree (*Cinchona*), Ecuador
3 Brazil nut (*Bertholletia excelsa*), Colombia
4 Bougainvillea (*Bougainvillea spectabilis*),
 Rio de Janeiro, Brazil
5 Monkey puzzle (*Araucaria araucana*), Chile
6 Amazon water lily (*Victoria amazonica*), Guyana
7 Heliconia (*Heliconia*), Rio de Janeiro, Brazil
8 Orchidelirium (*Cattleya labiata*), Brazil

Introduction

*The greatest service which can be rendered to any country
is to add a useful plant to its culture.*
Thomas Jefferson, 1800

We were all plant hunters once, scouring the wilderness for food. Once we learned to grow our own, plants took on a different aspect in our settled lives, as medicines or the source of domestic comforts. But from the earliest times there were those who possessed a deeper knowledge of plants, who knew where to look for them and what their special properties were, often revered as medicine men or wise women. In modern industrialized societies that knowledge is all but lost, and plants have become little more than commodities. In societies that live closer to nature, however, whether in the tropical rainforest or the snows of Lapland, a shamanic knowledge of plants persists, in which plants are valued as potent tools, instruments of healing or portals to a spiritual realm offering insights not accessible in the everyday here and now. Curiously, there is a sense in which plant hunting today has come full circle, and is belatedly learning to respect that ancient plant knowledge, as scientific botanists race to discover the 'unknown unknowns', the undiscovered properties (whether medicinal or biotechnological) of plants not yet known to science, before they are wiped out by economic forces too arrogant, or too ignorant, to value them.

Plant hunting as we understand it in the West today has its origins in the Renaissance, but of course plants had moved around the globe long before that, carried by soldiers and sailors, by merchants and traders, by pilgrims and refugees. Our earliest known plant hunting story is that of a great Pharaoh who imported trees from conquered lands. Alexander the Great's armies returned home bearing poplars; the ferocious forces of Genghis Khan planted willows and apples in their wake. Spices and herbs, but also seeds and bulbs, were among the precious goods that travelled the overland silk routes between the Mediterranean and China from the 2nd century BCE until the 15th century CE, when, following the fall of Constantinople in 1453, European traders began to seek out maritime routes to the silks and spices so desired in the West. Now advances in maritime technology ushered in the Age of Discovery,

In 1817, German botanist Karl Friedrich Philipp von Martius
set off for a three-year exploration of Amazonian Brazil. This
illustration from his *Historia Naturalis Palmarum* shows him
collecting the whale tail palm *Chamaedorea linearis*.

8

creating new trading routes between the Old World and the New – India, China and the Far East, new conduits for the exchange of plants.

At the same time, European scholars were beginning to rediscover the texts of Ancient Greece and Rome, among them the writings of Aristotle and Theophrastus. For over 1,200 years, plants had been of interest only for their utility, whereas the *Enquiry into Plants* of Theophrastus revealed an entirely different way of looking at plants, investigating them for their own sake, in what is often considered the founding text of modern botany. The Renaissance engendered a powerful desire to understand nature – to study, record and classify nature in all its forms. Scholars became collectors, amassing not only knowledge, gathered in the increasingly elaborate herbals that followed the advent of printing, but also botanical specimens.

By the 1540s, the first universities devoted to the new learning were springing up in the Italian city states, and to them were attached botanical gardens. These were intended as teaching tools for physicians, and were by no means the first botanic gardens in the West. The study of plants had prospered during the Islamic Golden Age, which flourished from the 7th to 13th centuries, giving rise to important teaching gardens in Cordoba and Toledo in Spain; while there had been notable medical schools at Salerno in central Italy as early as the 9th century and Montpellier in France in the 12th century, both founded largely on Arabic knowledge. However the new botanic gardens at Pisa, Padua and Bologna, and their many successors throughout Europe, steadily saw botany diverge from medicine to become an independent discipline. By the time the botanic garden was established at Leiden in the Netherlands in 1590, it contained not only medicinal plants but also those of economic or ornamental interest, many brought from distant lands by traders of the Dutch East India Company. Students studied not only the living plants, but the *hortus siccus* (literally 'dry garden') – dried specimens gathered in what we now call herbaria. Similarly the books that promulgated this knowledge developed from medical handbooks to Floras that described the plants growing in distinct geographical areas.

At this time of intellectual ferment, Britain was still an insignificant island on the fringes of north-west Europe: it was one of the last European countries to experience the Renaissance humanist revival. But over the next century, the focus of both culture and trade would shift from the Mediterranean to the sea-going nations of western Europe. As maritime trade routes were forged across the Atlantic and around the Cape of South Africa into the Indian and Pacific Oceans, first Spain and Portugal, then Holland, France and Britain, grew in wealth and power. The 17th and 18th centuries

saw a period of rapid colonial expansion, as more and more of the world fell under the economic control of a handful of aggressively imperialist European nations. By 1900, the once backward British Isles boasted the world's most powerful navy and most extensive empire, and London had become the world's largest city. Industrialization had opened a yawning economic gap between the technologically advanced nations and the rest of the world – one that has never closed. It is during this time of political, economic, cultural and scientific upheaval that most of our plant hunting stories are set, and it is important to understand the context in which they take place.

In recent years, much criticism has been levelled at Western scientific and cultural institutions for the arrogantly Eurocentric and colonialist approach they bring to history. Plant hunting in particular has been denounced as a form of piracy, as botanical theft, and new global regulations such as the Convention on Biological Diversity and CITES (Convention on International Trade in Endangered Species of Wild Fauna and Flora) have very properly been put in place to ensure that the countries in which plants originate should benefit from any economic advantages those plants might bring. But we cannot unmake the past. Plant hunting holds up a crystal-clear mirror to history, reflecting its economic, political, intellectual and religious tides with uncomfortable precision: plants flooded into Europe from colonised and exploited lands, they followed Chinese Buddhism into Japan, persecuted Huguenots out of France and the Pilgrim Fathers to America; plants provided the weaponry for the great existential debates of the 19th century, and today they are the totems for our most pressing global concern, namely climate change.

It is inevitable that the history of plant hunting should be seen through a European lens, for it was in Europe that the great centres of study such as Kew, Uppsala, Leiden and Paris developed; where there was sufficient wealth to mount lengthy missions of discovery, to fund expensive books and paintings to record these discoveries and to support an intellectual class with leisure to study them. The fact that a substantial part of this wealth derived from slavery is an abhorrent truth that cannot be shied away from. An estimated 12 million Africans were forced across the Atlantic to work sugar and cotton plantations that had been established through colonial plant exchange, while in the Indian sub-continent, systems of indentured labour were created that amounted to slavery. Science may have profited, but there was a terrible human cost.

Some of the earliest plant collectors were missionaries – the Jesuit priest Matteo Ricci became the first European to enter the Forbidden City of Beijing in 1601; by the 1670s, Henry Compton, Bishop of London, was filling his garden with exotics

sent from America by clergy whom he had instructed to secure plants as well as souls. Diplomats and merchants were a regular source of plants, none more than the many employees of the British and Dutch East India companies, which dominated European trade with the East. Global corporations to rival today's multinational tech companies, they set up botanical gardens where they assessed and distributed potentially lucrative plants such as tea, rubber, spices and sugar. As more lands were occupied, colonial administrators whiled away the lonely hours in remote outposts of empire with the study of botany, and smoothed the path for plant hunters eager to explore these regions. Their belief in the imperialist project may seem arrogant to modern eyes, but it is fair to say it was well-intentioned, that many of them genuinely believed they were doing good by bringing the benefits of civilization to benighted people.

Some of the plant hunters described in these pages admired and respected the people whose lands they visited, and were eager to learn from them, notably women explorers Maria Sibylla Merian and Maria Graham, but also David Douglas, William Burchell, Augustine Henry, E. H. Wilson and George Forrest. Many, such as Nathaniel Wallich, George Forrest and Sherriff and Ludlow, relied on local collecting teams whose contribution was rarely specifically acknowledged. (Sherriff and Ludlow were the exception.) Some forged close relationships with local collaborators that endured over years. Others, such as Joseph Dalton Hooker, regarded indigenous peoples as irrevocably 'other', and themselves as inherently superior. Yet in 19th-century Britain this would have been the norm, and Hooker no doubt felt the same about the French as the Chinese or the Lepcha, and behaved in much the same way towards his own countrymen of an 'inferior' class. Most of the young men sent out to run the British Empire were the product of English public schools, and the confident sense of entitlement they engender remains unaltered to this day. (It is notable that Sir Joseph Banks, first de facto director of Kew, believed the better educated and more humble Scots made better plant hunters – and the historical record suggests he was correct.)

Plant hunters collected for different reasons – some to advance the cause of science; others with a commercial impetus, to find plants of economic value that might prove of benefit to empire, or garden-worthy plants to supply a burgeoning nursery trade. (The British firm of Veitch maintained collectors in the field from 1840 to 1904.)

For scientific purposes, pressed and dried specimens were sufficient. Their function was to record the salient characteristics of each plant (as leaves, stems, roots, fruit and flower), each specimen mounted on paper and accompanied by a label that detailed when and where it was collected, the conditions in which it was

growing and any useful observations such as altitude. Each new species required a 'type' – a definitive example of a plant being described for the first time, to which subsequent discoveries could be compared. Sometimes, where it was not possible to preserve a plant, accurate botanical drawings could serve as the type. For example, the beautiful drawings made by Indian artists became the types for many of the specimens described by Nathaniel Wallich, Director of the East India Company's botanical garden at Calcutta. Although digital photography has become an essential tool for plant collecting today, botanists continue to make herbarium specimens, not least to provide material for DNA sequencing.

Making herbarium specimens in the field was by no means easy, as plant hunters Aimé Bonpland and Maria Graham, both working in the humid tropics, discovered to their woe. (Bonpland resorted to kippering himself in a low tent filled with acrid smoke to dry his specimens, while Graham gave up and drew them instead.) Bringing home live material was even more difficult. Seed was sent back packed in sand, soil or moss, or encased in wax or even dripping. The first rhododendron seeds to reach Europe, sent from Calcutta by Nathaniel Wallich, were packed in tins of brown sugar. Living plants were even harder to transport: a voyage from the Far East could take as long as six months, and few plants survived the dramatic fluctuations in temperature as the ships passed through different climate zones, the lashing by wind and salty sea spray, the attacks of rats, cockroaches and other ship-borne animals (monkeys were a particular pest), and the indifferent care or outright hostility of seamen who resented precious supplies of fresh water being squandered on a 'useless' cargo. Plants stacked on the poop deck could cause a ship to roll in heavy seas; they would be the first things overboard if danger threatened.

In 1819, Dr John Livingstone, a surgeon working in Macau for the East India Company, reckoned that all but one in every thousand plants perished en route to Europe, raising the outlay for each plant from the original cost of around 6/8d to well over £300. It would be well worth it, he suggested in a letter to London's Horticultural Society, to employ a trained gardener to care for the plants in transit – advice that the unfailingly stingy Society chose to ignore. However, it did prompt its assistant secretary, John Lindley, to publish five years later a fearsomely comprehensive advisory leaflet, *Instructions for Packing Living Plants in Foreign Countries, Especially within the Tropics; and Directions for Their Treatment during the Voyage to Europe*, which included designs for a glazed box sent by the Governor of Mauritius, Robert Farquhar. Similar boxes, glazed with slices of translucent shell, had been successfully employed by

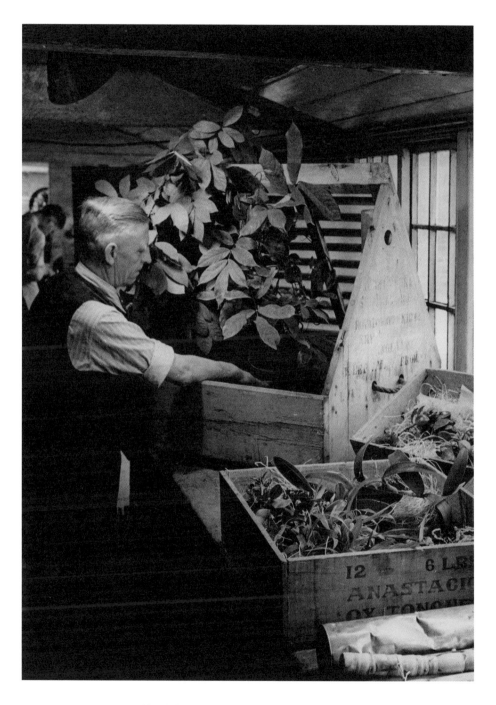

A horticulturalist packing plants into a Wardian case
ready for transportation, Kew Collection, *ca.* 1940–50.

Livingstone's friend John Reeves and Nathaniel Wallich. But the problem was only finally solved in 1829 by a London doctor, amateur entomologist and fern-addict, Nathaniel Bagshaw Ward (1791–1868).

Having placed the pupa of a moth in some leaf mould in the bottom of a sealed glass jar, the doctor waited patiently for it to hatch. It didn't, but Ward observed that moisture from the soil would evaporate during the day, condense on the glass, then drip back down each night, creating an enclosed ecosystem. When a small fern and some shoots of grass emerged from the soil, they survived for three full years without water: not only had he stumbled upon a foolproof way to grow ferns in London's sooty air, but also a system that could keep plants alive for months at a time with no attention at all. To test his theory, in 1833 Ward filled two cases with plants from Loddiges nursery and sent them to Sydney, where they arrived in good condition. The cases were refilled with a selection of notoriously miffy ferns, and after eight months on deck, unwatered, in temperatures that had ranged from -7°C to 49°C (19.4°F to 120.2°F), arrived in a near-freezing London in what Loddiges described as a 'very healthy state'.

Joseph Dalton Hooker was the first plant hunter to try out this new technology, successfully shipping live plants from New Zealand, while Robert Fortune famously used Wardian cases to send 20,000 tea plants 'in safety and in high health' from China to India in 1848–9. Soon Wardian cases were being used to transport plants of every kind across the world. The effect on global trade was immense: it was now possible to break agricultural monopolies by removing (some would say stealing) commercially significant plants from their native habitats and introducing them to cultivation in other countries – as with the transfer of rubber and cinchona from South America to the Far East. The effect on gardens was equally marked, as an influx of new plants from Asia fed into a new styles of garden-making. Some of the plants embraced by gardeners were already known to science, and had been named and described in the scientific literature. But plant hunters such as Ernest Wilson were now able to introduce living plants to cultivation for the first time. (A distinction is always drawn between the date of discovery and the date of introduction.)

Today, only a very few dauntless individuals continue to seek out new plants for our gardens. Strict restrictions on the gathering of live plant material mean that most modern plant hunters are either botanical tourists, gathering only exciting photographs, or scientists engaged in conservation. In many ways, they have it easier. They reach their destinations in days rather than months; where earlier plant

explorers set off blindly into unmapped territory, today's are armed with Google Earth and GPS; they have high-tech boots and lightweight waterproof clothing, where their forebears braved the Himalayas in tweeds. Yet read their blogs, and the trials and tribulations remain exactly the same – rain, fog, leeches and innumerable biting insects; burned ears, frozen toes and skulls splitting with altitude sickness; impassable paths and unclimbable trees; the frustration of arriving at a spot too soon or too late to gather seed. As distinguished American plant hunter Daniel Hinkley put it, reflecting on a fortnight in 2014 during which he was never dry, 'There are innumerable times that this process is rewarding and enjoyable and then there are times when it is only rewarding.'

Early 20th-century collector Frank Kingdon Ward described the lot of the plant hunter as long days of tedium interspersed with mere seconds of joy that might just make the process worth all the anguish and boredom.

So why would anyone choose to do it?

For some, like Maria Sibylla Merian or John Bartram, the beauty and mystery of plants was evidence of a benign Creator. Others, like Joseph Banks, Alexander von Humboldt and Charles Darwin, were groping for a new scientific understanding of the world. Ernest Wilson fell in love with China, George Forrest with the Himalayas, David Douglas and numerous others simply with adventure. Some became plant hunters by accident, plucked from peaceable jobs tending greenhouses. Few ever wanted to return to their old lives.

The last word rests with Frank Kingdon Ward, from his book *From China to Hkamti Long,* published in 1924: 'The plant collector's job is to uncover the hidden beauties of the world, so that others may share his joy.'

AUSTRALIA AND THE PACIFIC

FROM THE 15TH TO THE 18TH CENTURY, a vast southern continent, described as *Terra Australis Incognita*, was routinely represented on European maps of the world. The geographers of classical Greece had known full well that the Earth was round, and had developed a theory that a southern continent was necessary to balance the land mass they knew to exist north of the equator. But during the Middle Ages, the Church's insistence that the Earth was flat suppressed the notion of a southern continent, and it was not until the great era of exploration by sea in the 15th and early 16th centuries confirmed that the Earth was indeed roughly spherical, that the great southern continent reappeared in various guises, each new voyage of discovery prompting a shift in its position.

In 1768, James Cook was despatched by the British government to find it. What he found came to be known as Australia. (The name was proposed by Matthew Flinders, the British sea captain who made the first circumnavigation of this colossal new land.) For the scientists who travelled with Cook, the plant and animal specimens they brought back from this journey had all the mystery and wonder that rocks from the moon held for the 20th century. These pioneers, notably British naturalist Joseph Banks and Swedish botanist Daniel Solander, were collecting with purely scientific intent. However, encountering such completely unfamiliar plants and seeing how they were used by the indigenous populations prompted Banks to consider how the importation and exchange of plants might be of benefit to a growing Empire.

The consequences would be far-reaching. At Banks's instigation, the British would colonise Australia. And he would also gain royal approval for a systematic programme of plant hunting, creating a new kind of explorer, the professional plant hunter.

As the maritime nations of western Europe established empires that straddled the globe, ever more wondrous plants found their way from the Pacific Ocean back to Europe. Among them were plants that proved to be carnivorous and the biggest flower the world had ever seen.

New Zealand flax

Scientific name
Phormium tenax

Botanist
Joseph Banks

Location
New Zealand

Date
1769

IT IS DIFFICULT to imagine how it must have felt to the 90 surviving men crammed aboard the *Endeavour* – a repurposed cargo ship just 32m (105ft) long, built to shift coal out of Whitby – setting off on 13 July 1769 from the South Pacific island of Tahiti, to sail due south into the vastness of an ocean where no man, or certainly no European, had ever ventured before. It can only be likened to a space mission – a tiny craft alone in the great unknown, possibly on a fool's mission (perhaps the 18th-century equivalent of the search for life on Mars): the search for a theoretical southern continent, the *Terra Australis Incognita*, that promised unimaginable wealth and glory to the bold nation that discovered it.

These orders were secret, and had come from the king himself, George III, who had financed the expedition. Officially, the *Endeavour's* assignment was to observe from Tahiti the transit of Venus, which had taken place on 3rd June – 'a phenomenon that must contribute greatly to the improvement of Astronomy on which Navigation so much depends', according to the Royal Society, which had instigated the expedition.

The choice of Tahiti was a fluke – the first Western ship to 'discover' Tahiti, just two years previously, had returned to Britain less than a month before the Society proposed the mission, bearing extravagant tales of this paradise island, but only the sketchiest information on where it lay. To find it again was a miracle of navigation – testament to the extraordinary abilities of Lieutenant James Cook, who was also a skilled astronomer and outstanding cartographer. (Maps he made of the Great Barrier Reef were still in use in the 1950s.)

More wonders followed, as the delights of 'Otaheite' were revealed. The French explorer Louis-Antoine de Bougainville, who had landed there the previous year (see page 266) described the island as 'Utopia', while to Joseph Banks it was 'the

Phormium tenax by William Jackson Hooker, from *Curtis's Botanical Magazine*, 1832.

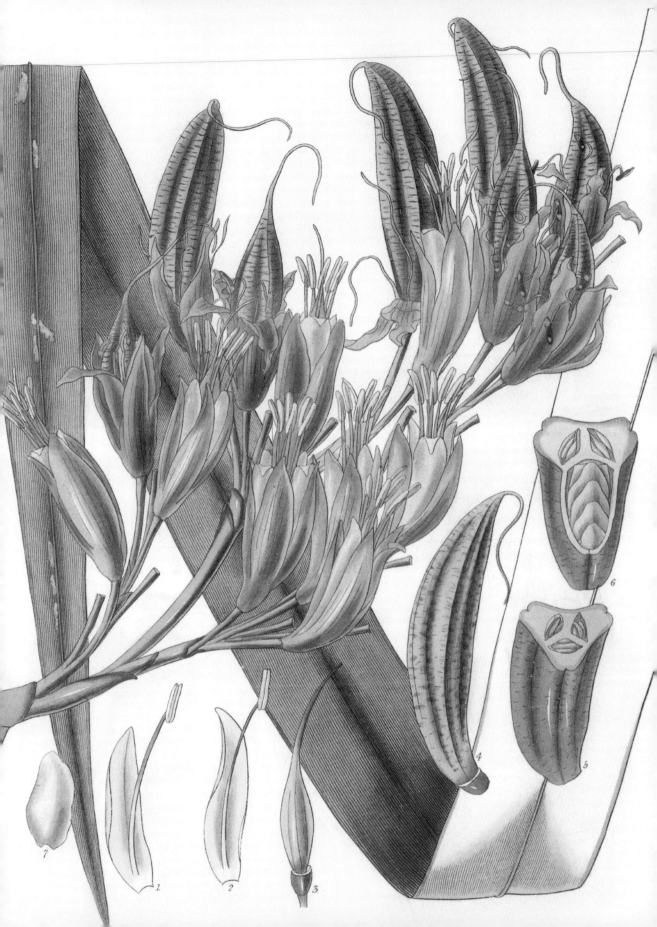

truest picture of an Arcadia'. Whereas Europeans must labour for their daily bread, he sighed, the happy Tahitians had only to pluck the abundant fruits that grew all around, and could fill their ample leisure hours with surfing and sex: 'Love is the Chief Occupation, the favourite, nay almost the Sole Luxury of the inhabitants.'

Joseph Banks (1743–1820) was a remarkable young man who had been able, by dint of his enormous wealth, to buy a place for himself and a scientific party aboard the *Endeavour*. He was the first generation of a successful landowning family to enjoy a gentleman's education, which he largely neglected, preferring to roam the country lanes in search of wild flowers. On going up to Oxford and finding that the Professor of Botany gave no lectures, he imported a tutor from Cambridge to give paid tutorials – an early example of the energy, audacity and organizational ability that would characterize a long and uniquely influential life: Banks would become what David Attenborough has termed 'the great panjandrum' of British science over the next two generations.

Banks's father died in 1761, and three years later, at the age of 21, Banks came into a fortune. Rather than embark on the Grand Tour customary for moneyed young men, he elected instead to accompany an old friend from Eton on a naval expedition to Newfoundland and Labrador, from which he returned with records and specimens of around 340 plant species, and a solid reputation as a naturalist. On his way home in 1766 he was elected to the Royal Society. He would later serve 42 years as its president.

In 1764 he had met Daniel Solander (1733–82), pupil and heir apparent of the great Swedish botanist Linnaeus, who had revolutionized science with his new binomial system for classifying species. Encouraged by Solander,

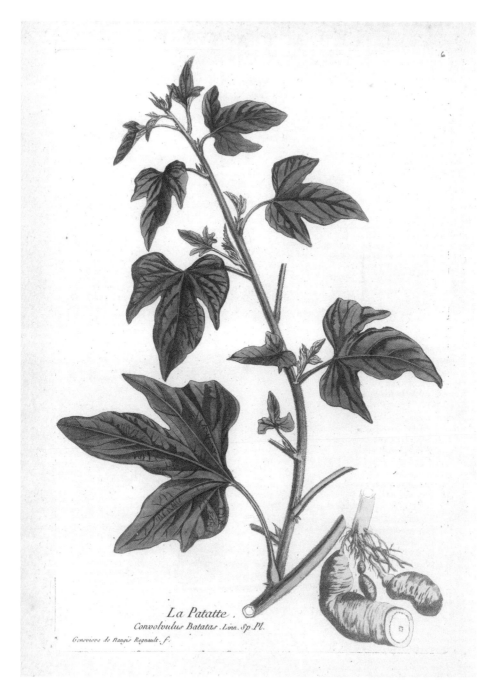

Ipomoea batatas by Geneviève Nangis-Regnault,
from F. Regnault, *La Botanique Mise à la Portée
de Tout le Monde*, 1774.

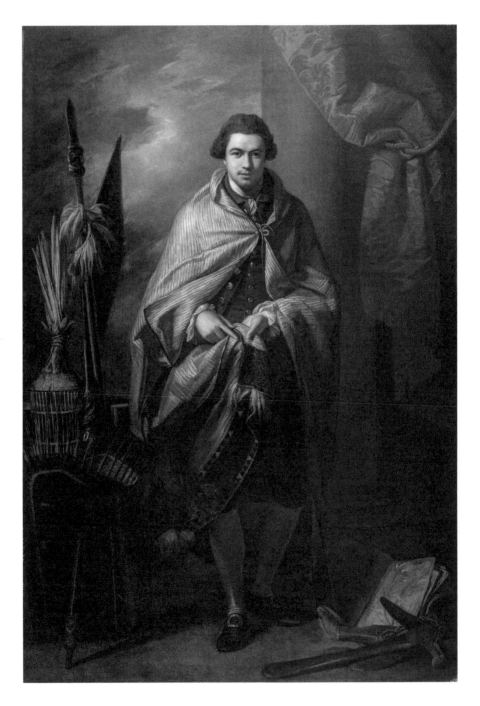

Portrait of Sir Joseph Banks by the artist Benjamin West.
Banks wears a cloak made from New Zealand flax.

believe; but if ask'd why I believe so, I confess my reasons are weak; yet I have a prepossession in favour of the fact which I find difficult to account for.'

Banks's first day in New Zealand was 'the most disagreable day My life has yet seen', ending with the deaths of several Maori, who defended themselves stoutly against the interlopers. He would be consoled, over the coming months, by the astonishing flora of the islands, and develop a deep respect for this warlike people. Among the 400 plants he collected was the beautiful pōhutukawa (*Metrosideros excelsa,* also known as the New Zealand Christmas tree as it flowers in December*),* exotic red-flowered kakabeak (*Clianthus puniceus*), many ferns and mosses, an orchid he named *Orthocera solandri* (now *O. novae-zeelandiae)* and sweet potatoes (*Ipomoea batatas*) – the staple crop of the Maori, which had been carried throughout Polynesia from South and Central America long before Europeans arrived. But the plant that made the deepest impression was *harakeke,* the New Zealand flax (*Phormium tenax*). This plant, a swamp-dweller native only to New Zealand and Norfolk Island, was used by the Maori to produce fibres of many kinds, from soft bandages that stopped bleeding (the plant contains blood-clotting enzymes) to ropes and nets many times stronger than anything ever seen in the West. The Maori were skilled at selecting different plants for different purposes – for basket making, fishing equipment, mats, shoes and clothing: a famous portrait of Banks made in 1773 depicts him wearing a *harakeke* cloak brought back from the voyage.

It was the tensile strength of *P. tenax* that particularly impressed Banks. With this plant, he began to think of botany in a new way – not just for its pure scientific interest, but as a way of bringing benefit to Britain and her colonies. A ready supply of *Phormium,* he later wrote, 'would be of great consequence to us as a naval power' for the production of both sail canvas and rope. It would reduce Britain's dependence on Russian flax. (Indeed a gift of *P. tenax* to Russia in 1795 was read as a politely veiled threat: Banks became adept at using plants as vehicles of diplomatic exchange.) And the ideal place to grow it, he suggested, would be a new colony in Sydney: Banks would become a major player in both the exploration of Australia and the colonisation of New South Wales.

But on 31 March 1770, when the *Endeavour* set course for home, Cook and Banks did not yet know that the elusive southern continent lay less than three weeks ahead of them.

Saw banksia

Scientific name
Banksia serrata

Botanist
Joseph Banks, Daniel Solander

Location
New South Wales, Australia

Date
1770

JOSEPH BANKS was not the first Englishman to botanize in Australia. That distinction belongs to an unusually erudite pirate, William Dampier, who collected on the other side of the continent in 1699. (Banks refers to Dampier's travelogue in his journal.) But Banks was the first to sight Australia's east coast, on 19 April 1770. He was not impressed by what he saw, likening the landscape before him to 'the back of a lean cow', but once they anchored, he found a scene so rich in extraordinary new plants (he gathered 132) that the bay Cook had mapped as 'Stingray Bay' was renamed 'Botany Bay'. By 3rd May Banks could write, 'Our collection of Plants was now grown so immensely large that it was necessary that some extrordinary care should be taken of them least they should spoil in the books.' He spent a busy day on the beach drying out his specimens in the sun, including the newly collected saw banksia (*Banksia serrata*) and coastal banksia (*B. integrifolia*) – his first encounters with the spectacular genus that would eventually bear his name.

There are some 170 species of banksia, all but one endemic to Australia, ranging from small scrubby bushes to 30m (98ft) trees. They are members of the Protea family, and like their African cousins are pollinated by honey-eaters. The vivid red and yellow inflorescences attract nectar-feeding birds, while the honey possum, a tiny marsupial no bigger than a mouse, is a key pollinator for many banksias. Like the proteas, they grow on very poor soils, and fire plays a vital part in their ecology. While a good many southern hemisphere plants exhibit serotiny – where a seed is only released in response to an environmental trigger, usually fire (see page 239) – banksias have an even more clever adaptation, whereby fire is needed to open the cones, but the seed does not drop until fire is followed by rain, offering perfect conditions for germination.

Banksia serrata by Stella Ross-Craig,
from *Curtis's Botanical Magazine*, 1942.

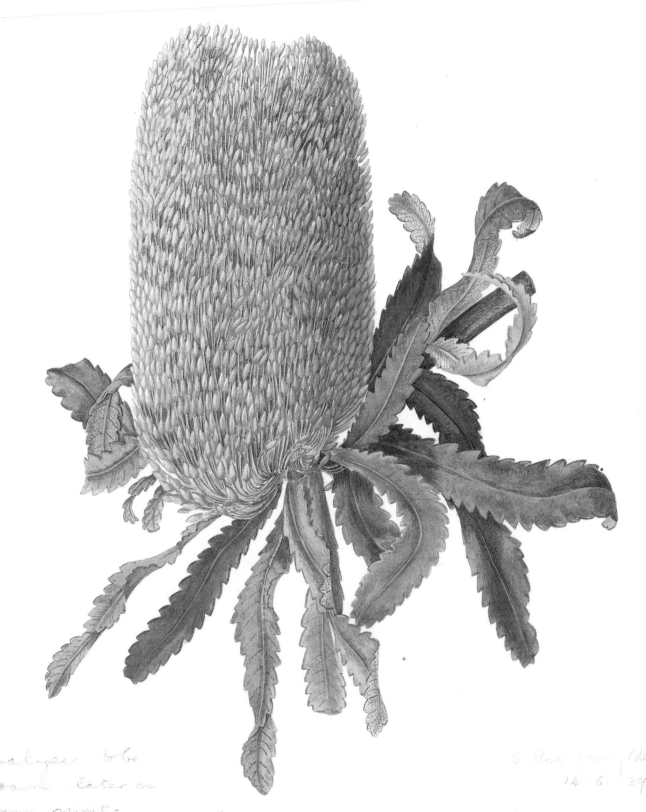

964

S. Rai Ma. del
14. 6. 39

Banksia serrata

From Botany Bay, Cook set off northwards to chart the coast, unaware that they would soon be trapped by the Great Barrier Reef, still unknown to Western navigators. Two years earlier, de Bougainville (see page 269) had approached the reef from the east, heard the crashing of surf, and rapidly turned tail. 'This was the voice of God,' he wrote, 'and we obeyed it.' For over 950km (600 miles) the *Endeavour* inched north, preceded by a rowing boat taking soundings, threading a tortuous path through the lethal coral, until on 11th June, the inevitable happened and the ship ran aground, holed beneath the waterline. Banks, exhausted by hours at the pumps, was sure he would die. It was a midshipman who saved them, with an improbable plan to block the hole with a sail padded out with oakum (a fibrous material made from unpicking old rope): it slowed the water long enough for the ship to float off and limp to safety in the mouth of what is now the Endeavour river. While the hull was repaired, Banks and Solander had six full weeks to botanize, gathering further eucalypts, grevilleas, bottlebrushes and acacias. They also saw – and ate – their first kangaroo.

The crew had fixed the hull as best they could, but the *Endeavour* needed more substantial repairs to get home. There was therefore no alternative but to stop at Batavia (modern Jakarta), reached only after more terrifying encounters with the reef. But Batavia held terrors of its own: the crew that arrived healthy, 'rosy and plump', rapidly contracted malaria and dysentery from the city's stinking canals, and within weeks over a third of them perished. Of Banks's original party of nine, only four landed at Deal on 12 July 1771 – two servants, Solander and Banks himself. Even Lady, his beloved greyhound bitch, had died.

Despite losing part of their haul when their store was flooded, Banks and Solander had returned with thousands of illustrations and over 30,000 specimens of plants, which would result in the description of 110 new genera and 1,300 new species. In a single journey, they increased the world's scientifically described flora by 25 per cent. They became instant celebrities, and were introduced to the king at the royal garden at Kew, which George III had inherited from his plant-collector mother, the Princess Augusta. By 1773 Banks had created an unofficial role for himself as 'a kind of superintendence over his Royal Botanic Gardens', persuading the king that Kew could be more than a private pleasure garden: it could become a great botanic garden, the greatest in the world. The first step would be for the

king to employ, through Kew, his own plant collectors, rather than relying on random gifts from foreign dignitaries or colonial merchants. The first, Francis Masson, was sent to South Africa as early as 1772, and dozens more would soon be despatched across the globe: Anton Hove and George Caley, followed by Peter Good, David Nelson, Allan Cunningham, James Bowie, William Kerr and others. (Banks favoured Scots as collectors, as they were frugal and industrious, and did not make the mistake of thinking of themselves as gentlemen rather than servants.) Their mission would not be purely scientific, but also to find plants that would be of benefit to the British Empire. It is thought that almost 7,000 new plant species were introduced to Britain at Banks's behest.

Banks himself only went on one more expedition. He had planned to join Cook on a second circumnavigation aboard the *Resolution,* bringing a massive party that unaccountably included two French horn players. But when the extra accommodation he had insisted on rendered the ship unsafe, and the Admiralty scrapped it, Banks high-handedly threatened to pull out. The Admiralty called his bluff, the *Resolution* departed, and Banks was obliged to arrange his own expedition. There being at that time a fad for volcanoes, he chose Iceland as his destination. The expedition lasted for just six weeks.

Thereafter Banks devoted his energies to Kew and to the Royal Society. In 1778, at the age of just 35, he was elected president, and would serve until only days before his death in 1820. With these two institutions at his command, he would work tirelessly for the rest of his life for the advancement of science, most significantly in botany and agriculture. (The Australian wool industry, the tea industry of Assam and Caribbean mangoes all owe their genesis to Banks.) His library and herbarium at Soho Square became an international meeting place for botanists, even in times of war. Science trumped politics throughout his life: Banks maintained cordial relationships with fellow scientists throughout the French Revolution, Napoleonic Wars and the American War of Independence. The loss of the American colonies however, formerly such a convenient dumping ground for criminals, radical thinkers and religious zealots, did focus his mind on the colonisation of New South Wales, and it was he who proposed Botany Bay as the site for a new penal colony. He became deeply involved with the establishment of the new colony, corresponding with its successive governors right up to his death.

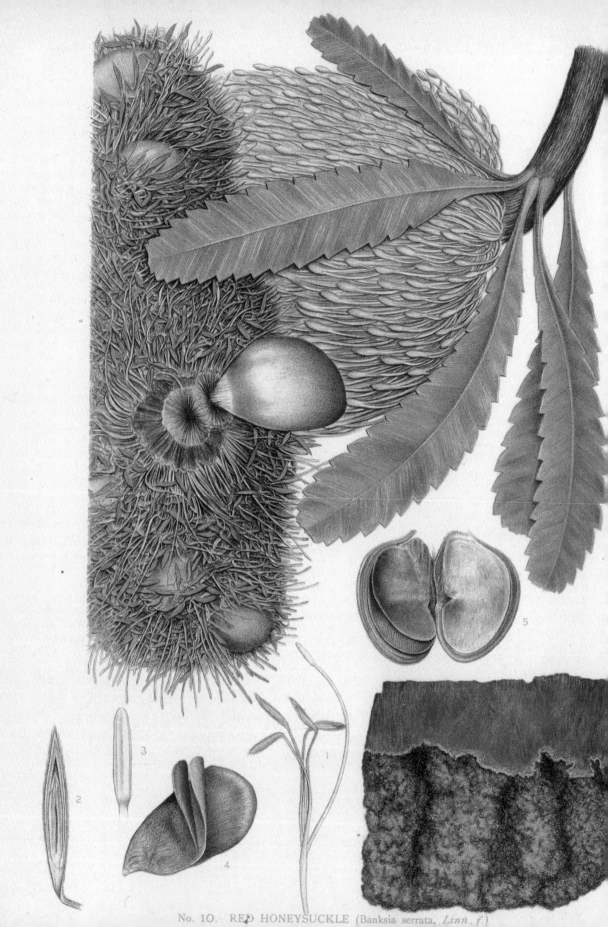

No. 10. RED HONEYSUCKLE (Banksia serrata, *Linn. f.*)

At Kew, Banks worked hard with head gardener William Aiton to expand the collections, and by 1789 they were able to publish the *Hortus Kewensis,* a definitive three-volume list of all the plants at Kew. There were no fewer than 5,600 species. Among them were hothouse exotics and exciting new trees from North America, along with a wide range of plants that promised to be of economic value. Banks saw Kew as 'a great botanical exchange house for the Empire', at the centre of a global network of botanic gardens stretching from Jamaica to Calcutta and Ceylon. These were largely the property of the British East India Company, whose merchants and seamen, along with the growing number of army officers, diplomats and missionaries attending to the needs of Empire, were all enjoined, in the name of the king, to contribute whatever they could to Kew. Plants which seemed to offer economic potential – whether fruits or fibres, spices or medicines, or the raw materials needed to supply the new factories of the Industrial Revolution – could be tried out at Kew, and the most promising ones shipped out to the colonies where they might be of most use. At a time when plant products (such as timber, sugar, tea and tobacco) accounted for 90 per cent of global trade, the movement of plants from one subjugated part of the world to another was not perceived as piracy (a late 20th-century notion), but rather as a patriotic enterprise that would reduce hunger, increase wealth and benefit all mankind.

At the same time, there was a steady traffic of ornamental plants between Kew and the fast-growing nursery trade. *B. serrata* was first raised by Banks's friend James Lee at the Vineyard Nursery in Hammersmith, the first Australian plant to be cultivated in England. It was grown from seed sent from Botany Bay in 1788: Banks had brought back little viable seed, his interest being scientific rather than horticultural. Yet in 1804 he became one of the eight founder members of the Horticultural Society in London, which after his death would in turn become a major force in plant exploration.

Banksia serrata by Edward Minchen, from J. H. Maiden and W. S. Campbell, *The Flowering Plants and Ferns of New South Wales,* 1895–8. In the Sydney region alone there are over 2,000 native plants – more than in the whole of the UK.

Wax flower

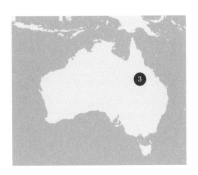

Scientific name
Hoya australis

Botanist
Sydney Parkinson

Location
Queensland, Australia

Date
1770

A KEY MEMBER of the *Endeavour* crew who did not make it home was Sydney Parkinson (1745–71), the brilliant young Edinburgh artist engaged by Joseph Banks to record his discoveries. Parkinson died of dysentery on 26 January 1771 and was buried at sea. He was just 26 years old.

Banks had employed Parkinson to record his Labrador collections, and been impressed by his accuracy and speed. Parkinson's task aboard the *Endeavour* was to record natural history specimens while they were still fresh, before the colours faded. When his fellow-artist Alexander Buchan died of an epileptic fit, he also took on his work of recording landscapes and people. In all, he made nearly a thousand drawings, an incomparable record of a journey where every day brought something hitherto unguessed at in creation: Tahitian villages or Maori tattoos, extraordinary rock formations, entirely unfamiliar new plants, fish, birds and other animals. (He is credited with the first European depiction of a kangaroo.)

Often the specimens came so thick and fast that he only had time to sketch them in pencil, making reference notes for colours, so he could finish up the drawings later. His notes for *Hoya australis*, found at a brief stop just north of present-day Cairns in Queensland, were relatively simple: 'The flower white with a speck of purple at the base of each petal. The calyx & peduncle white.'

Although *Hoya* commemorates Thomas Hoy (*c.*1750–1822), head gardener at Syon House, just across the river from Kew Gardens, Hoy never grew it: it was not cultivated in Britain until 1863. It is an evergreen climber with succulent stems up to 10m (32ft) long and strongly scented flowers, widely distributed throughout the Indo-Pacific region. The genus includes several species commonly found growing on ants' nests or from cavities in trees where ants have made a home.

Hoya australis by Walter Hood Fitch,
from *Curtis's Botanical Magazine*, 1870.

Fitch, del et lith.

Vincent Brooks Day & Son

Hoya australis print based on James Miller's watercolour, which was derived
from Sydney Parkinson's annotated pencil drawing. The specimen was
collected by Banks and Solander in Cape Grafton, Australia in June 1770.

Parkinson certainly suffered for his art. The fleshpots of Tahiti, which delighted his crewmates, upset his modest Quaker sensibilities: he preferred to spend his time compiling a vocabulary (as he did later in Australia) and catching up with his painting. This was no easy matter, for he was tormented by mosquitoes and flies, which 'not only covered his subject so that no part of its surface could be seen,' reported Cook, 'but even ate the colour off the paper as fast as he could lay it on.' Returning to sea, Parkinson had to contend with the rolling of the ship, sharing a table with Banks and botanist Daniel Solander in a cramped cabin, often working through the night to deal with the backlog of samples. Nonetheless, he managed to produce 955 botanical drawings on the voyage, comprising 675 sketches and 280 finished watercolours, along with 170 zoological paintings and comprehensive studies of the indigenous people he encountered, all the while helping Cook with his map-making by drawing coastal topographies. He also kept a journal, which was published by his brother Stanfield as *A Journal of a Voyage to the South Seas*. The ownership of the journal and artworks became a matter of dispute between Banks and Stanfield, ending badly for all. Banks was excoriated in Stanfield's introduction to the journal; Stanfield was shortly afterwards committed to an asylum, and the artist remained, until very recently, unpublished and all but forgotten.

On returning to England, Banks determined to record his discoveries in a characteristically lavish 14-volume florilegium. Five artists were engaged to work up Parkinson's sketches into finished portraits, and over the next 11 years, while Solander laboured to supply definitive botanical descriptions of the many plants new to science, 18 engravers patiently prepared 743 copper plates capable of capturing every last, exquisite detail. Work continued after Solander's sudden death in 1782, and by 1784 Banks wrote that the work was almost ready for publication. Yet it never happened, and on his death in 1820 the plates were bequeathed to the British Museum, where they remained forgotten for 160 years. It was not until 1980–90 (it took ten years) that Banks's *Florilegium* was finally printed, using the rediscovered plates. At last the contribution of the heroically hard-working Parkinson could be recognized.

Wollemi pine

Scientific name
Wollemia nobilis

Botanist
David Noble

Location
New South Wales, Australia

Date
1994

HOW CRUEL would it be for a population of trees to survive 200 million years, only to be wiped out by fire in a single day? This was the fate facing Australia's Wollemi pines in January 2020 – trees known from the fossil record, but presumed extinct until discovered in 1994 in a rainforest gorge in the Blue Mountains. Park ranger and wildlife officer David Noble had been abseiling the sheer sandstone cliffs of a remote canyon, deep in pristine forest in the Wollemi National Park, when he noticed a small grove of unfamiliar conifers – perhaps 100 mature trees and as many seedlings. Curious, he took a sample for identification – to learn that he had found, only 200km (125 miles) from Sydney, an ancient relative of the monkey puzzle that hadn't been seen since dinosaurs walked the earth. The tree was named *Wollemia* (after the park) *nobilis* (after him, but also reflecting the tree's majestic stature: it can reach 40m/130ft in height.)

Immediately a conservation plan went into action. With such a tiny population (though two more sites were found in the ensuing decade) the location of the trees became a closely guarded secret – both to protect them from theft, and to prevent dangerous pathogens being carried in on visitors' boots. (Nevertheless, a harmful mould infected some of the trees in 2005.) It was quickly decided that the best way to conserve the *Wollemia* would be to make it available commercially. (Another 'fossil tree', the dawn redwood, *Metasequoia glyptostroboides*, was discovered in China in 1944, and rapidly became *the* must-have tree for collectors. Although critically endangered in its natural habitat, it now thrives in parks and gardens around the world.) The first 292 *Wollemia* saplings were sold at auction in 2005, fetching nearly £500,000.

The Wollemi pine is a remnant of the great forest that once cloaked all Australia, New Zealand and Antarctica, and over the millennia, it has developed some effective

Wollemia nobilis by Beverly Allen, from The Florilegium, Royal Botanic Gardens Sydney.
© Royal Botanic Gardens & Domain Trust.

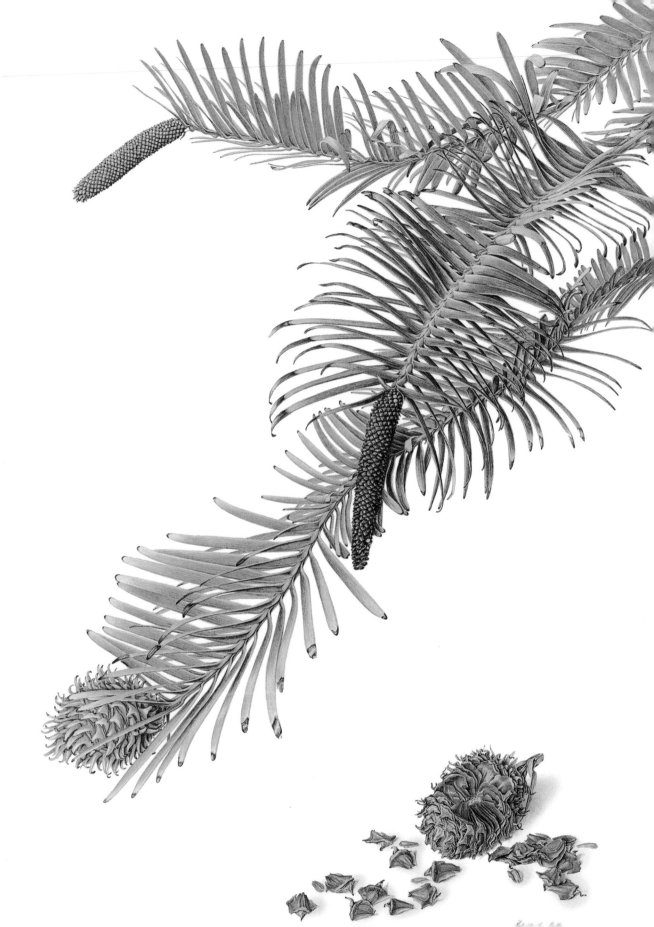

survival strategies. It can withstand temperatures from a scorching 47°C right down to -7°C (117°F to 19°F), remaining dormant during spells of cold, when it develops a white waxy coating over the growing tips. This 'polar cap' is believed to have helped it survive through successive ice ages. And its habit of producing multiple stems ('coppicing') may well be a defence against fire, allowing it to regenerate from below the ground over periods of hundreds of years.

However, when fires raged through the park in January 2020, destroying 90 per cent of the vegetation and ravaging even those rainforest gullies that would not normally burn, drastic action was needed. For a week as the fire approached, firefighters helicoptered into the canyon every morning to activate pumps and sprinklers among the trees. Air tankers were deployed to drop fire retardant in the path of the advancing blaze, slowing it down so that the heat would be less when it finally hit. For two days the smoke was so thick that no-one could tell what had happened, but on 17th January it was joyfully announced that all but two trees were likely to survive the inferno. The Wollemi pine had cheated extinction once again.

Beverly Alley

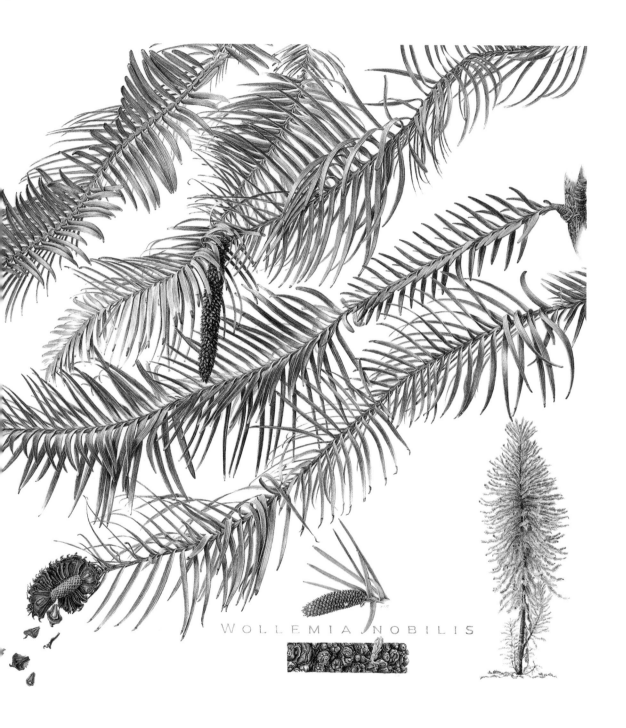

WOLLEMIA NOBILIS

Wollemia nobilis by Beverly Allen. © Beverly Allen.

Scoparia

Scientific name
Richea curtisiae

Botanist
Dr Winifred Mary Curtis

Location
Tasmania, Australia

Date
1971

RICHEA CURTISIAE is named in honour of the indefatigable botanist Dr Winifred Mary Curtis (1905–2005). It is a naturally occurring hybrid of Scoparia (*Richea scoparia*), a small, ferociously prickly shrub widespread in Tasmania, and the more striking *Richea pandanifolia*, a plant of sub-alpine woodland which boasts long tapering leaves up to 1.5m (5ft) long, superficially resembling a phormium. Like its smaller parent, *R. curtisiae* has distinctive red flowers, shown here in the definitive account of Tasmanian flora, *The Endemic Flora of Tasmania*.

It is a flora of extraordinary diversity, with a high proportion of endemic species (28 per cent overall, rising to 60 per cent in alpine habitats), and some of the most ancient life-forms on earth, dating back to a time when the continents were all joined as single landmass known as Pangea, over 200 million years ago. When Pangea split into two super-continents, the southerly one, Gondwanaland, included what is now Antarctica – then much warmer and wetter, and densely forested. The plant-rich forests of Tasmania are thought to be the nearest thing that remains to that primeval vegetation that once covered much of the southern hemisphere.

This unique island flora thrilled Dr Curtis when she arrived in Tasmania in 1939 to take up a post at the university. She was only the second woman to be appointed to the academic staff, and despite her distinguished career as a botanist, was never given the top job. (Indeed, when in 1948 it was noted there were now five women in post, their salaries were cut to 90 per cent of that of men…) It was after her retirement in 1966 that her career truly blossomed. *The Student's Flora of Tasmania* she had begun in the 1940s expanded into the definitive text on the island's plantlife, keeping her busy till she was almost 90, and in 1967 she started work on *The Endemic Flora of Tasmania*, a project that began as a commission for

Richea curtisiae by Margaret Stones, from Winifred Mary Curtis, *The Endemic Flora of Tasmania*, 1967–78.

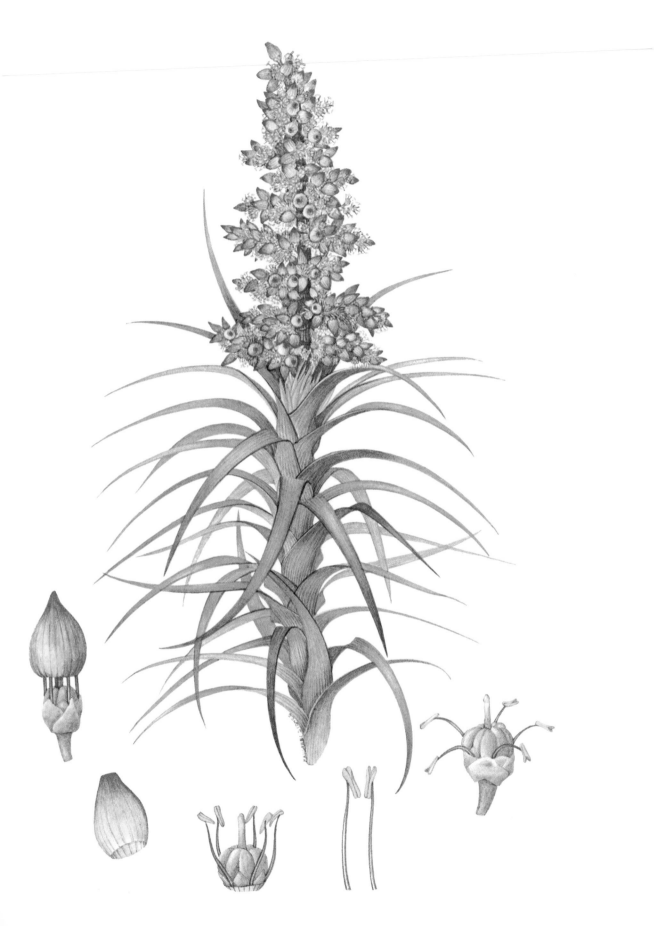

35 drawings of attractive Tasmanian plants, but ended as six hefty volumes, now hailed as one of the most important botanical works of the 20th century.

The instigator of this Flora was Milo Talbot, 7th Baron Talbot of Malahide (1912–73) a somewhat eccentric bachelor and passionate gardener whose career as a diplomat came to a hasty end when his good friend and Cambridge tutor Anthony Blunt was unmasked as a Soviet spy. The baron had inherited both an Irish castle and an extensive estate in northern Tasmania, to which he travelled for the first time in 1952. For a man who delighted in rare plants, Malahide in Tasmania was pure joy: he was soon sending plants back to Malahide in Ireland (the Talbots were not imaginative in naming their properties), where he built up a huge collection. When he decided to expand the initial commission into a serious scientific work, Curtis was the obvious choice of author. Curtis organized bands of enthusiasts to comb every part of the island for fresh plant material, identifying the specimens at high speed before flying them to London to be illustrated before they faded by botanical painter Margaret Stones.

Australian-born Stones (1920–2018) discovered her métier by chance. Already an artist, she began to draw flowers when confined to a hospital bed for 18 months after contracting tuberculosis. This led her to study botany and botanical illustration, and in 1951, intent on developing her botanical knowledge, she moved to England and settled round the corner from Kew. Within a few years, she had become the principal artist for the most revered of botanical publications, *Curtis's Botanical Magazine,* contributing over 400 watercolour paintings of plants over a period of 25 years. For *The Endemic Flora of Tasmania* (1967–78) she provided 254 exquisitely detailed watercolours. Working on opposite sides of the globe in pre-internet days might have proved difficult, but Curtis noted with satisfaction that 'Stones never needed to be told, but invariably knew, which sections to draw in order to facilitate correct taxonomical classification.'

Milo Talbot died in mysterious circumstances in 1973, aged just 60, soon after the fourth volume was published. The project was completed by his sister, Rose. Both his collaborators, by contrast, enjoyed a long and productive old age, Stones living to 98 and Curtis to 100 years old.

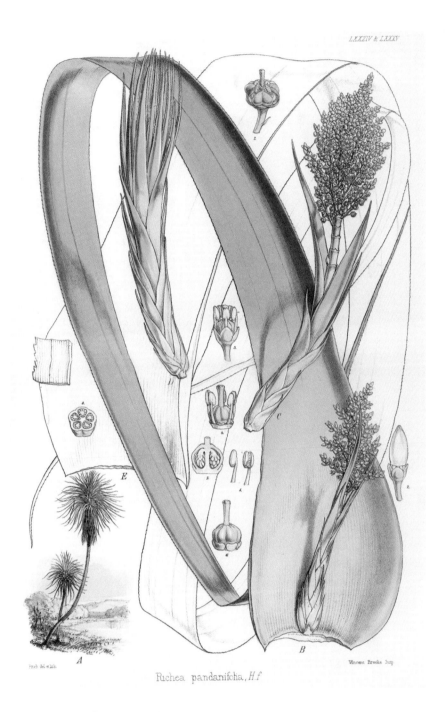

Richea pandanifolia, H.f

Richea pandanifolia, from J. D. Hooker's *Flora Tasmania*, 1860,
recorded on the Antartic voyage of Hooker and Ross. Hooker was the
first Western botanist to describe the flora of Tasmania.

Breadfruit

Scientific name
Artocarpus altilis

Botanist
David Nelson

Location
Tahiti, French Polynesia

Date
1769

WHEN CAPTAIN James Cook and botanist Sir Joseph Banks sailed out on the *Endeavour* in 1768 to observe the transit of Venus (see page 20), their official destination was the newly discovered Pacific Island of Tahiti. Here they found a paradise of peace and plenty, an Arcadia of free love and abundant food, where the trees were decked in flowers and laden with fruit. Banks was particularly struck by the munificence of the breadfruit tree (*Artocarpus altilis*), growing in what we would now call an agroforestry system. Swift to mature and remaining productive for many decades, this tree bore heavy crops all year round of a clearly highly nutritious starchy fruit, and seemed to require no care whatsoever.

So when, in 1784, Banks was approached by plantation owners in the West Indies seeking to introduce breadfruit as 'a wholesome and pleasant food' for their slaves (which, crucially, could be raised 'with infinitely less labour' than the staple plantain), he was quick to lend his assistance. Over thousands of years, the breadfruit had been spread from its homeland in the Malay archipelago right across the Pacific, carried by Polynesian navigators voyaging in search of new lands. Now the tree was on the move once more.

In the wake of the *Endeavour* voyage, Banks had become a very influential man: a friend of George III, unofficial director of the royal garden at Kew and President of the Royal Society. He at once set about organizing an expedition to carry breadfruit from Tahiti to the Caribbean, overseeing every detail of the enterprise from planning the route to refitting a ship to act as a floating nursery. The Great Cabin, usually the private domain of the ship's captain, was commandeered for the plants, fitted with skylights and ventilation grilles, a false floor into which plant pots could be securely inserted (with a reservoir beneath) and a stove to keep them

Artocarpus altilis (as *A. incisa*) by Lansdown Guilding, from *Curtis's Botanical Magazine*, 1828.

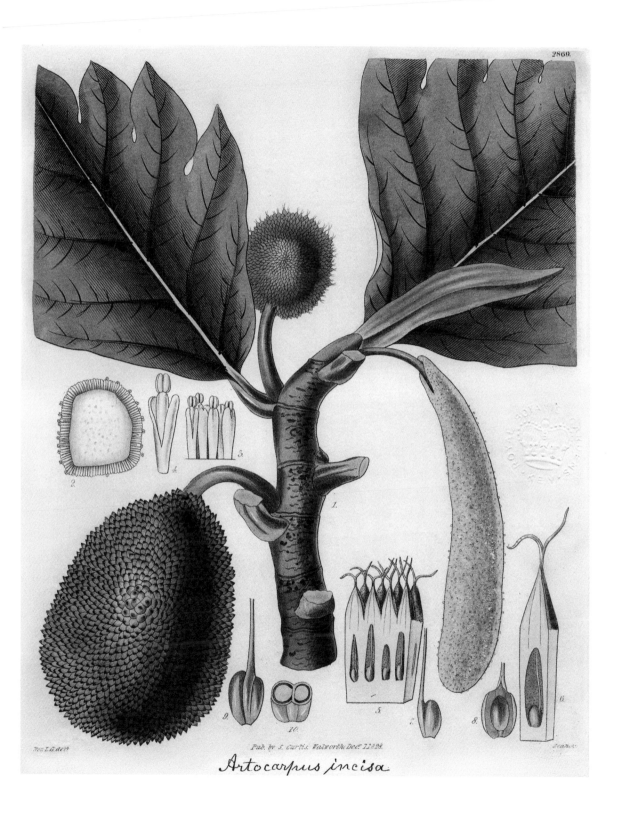

2869.

Pub. by S. Curtis. Walworth Dec. 1.1828.

Artocarpus incisa

warm through the icy southern oceans. To command the ship, renamed the *Bounty*, he chose Lieutenant William Bligh, who had served under Cook on his second great journey of exploration. And to care for the precious cargo he appointed gardener David Nelson, who had collected for Banks during Cook's last voyage and had some knowledge of the island.

When Banks had visited Tahiti, he had taken full advantage of the island's many delights. No such indulgence was to be granted to Nelson. Even an hour's

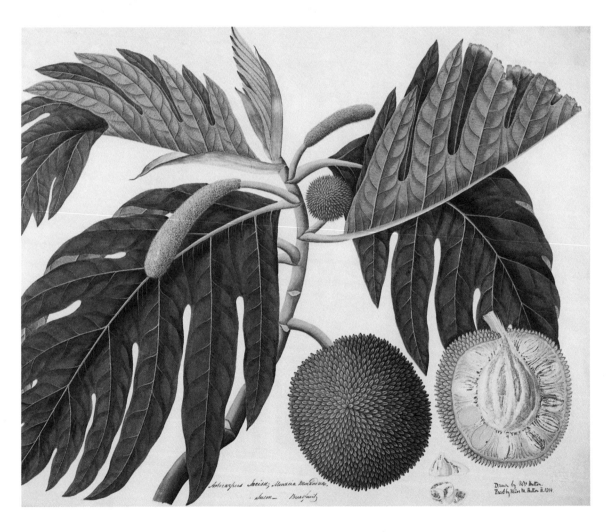

Artocarpus altilis, from the collection of
Miss Jane Hutton, Kew, 1894.

negligence, Banks wrote to him sternly, could be 'the means of destroying all the trees and plants which may have been collected' and render the whole undertaking useless. 'I therefore cannot too strongly recommend it to you to guard yourself against all temptations of idleness or liquor.'

His words were prescient. It took ten months for the *Bounty* to reach Tahiti: having failed three times to round Cape Horn, she was forced to turn tail and sail in the other direction. While Nelson diligently tended his young trees, eventually squeezing over a thousand sturdy saplings aboard, the crew enjoyed five months of tropical idyll. By April 1789, when it was time to leave, some, including the Master's Mate Fletcher Christian, had acquired Tahitian 'wives', and were extremely reluctant to put to sea. Tensions rose, and there were no marines on board to enforce the captain's authority. Twenty-three days into the voyage, Christian led a mutiny. In the middle of the night, Bligh was forced from his bed at bayonet point, then he, Nelson and 16 crew deemed loyal to Bligh were crammed into an open boat and cast adrift, 2,090km (1,300 miles) from shore. All Nelson's carefully nurtured trees were hurled overboard.

What Bligh lacked in interpersonal skills (he was known for his 'violent Tornadoes of temper'), he redeemed by his brilliance in navigation. Armed only with a compass, a 10-inch sextant, a quadrant and two books of mathematical and astronomical calculations, he miraculously guided the boat across the South Pacific through deadly coral reefs to the island of Timor – a journey of 47 days and 3,618 nautical miles. Here, weakened by the journey, Nelson died – apparently after a day's botanizing. The others returned to England, where Bligh was court-martialled for the loss of his ship, but exonerated from blame.

By 1791, Bligh was back on his way to Tahiti. This time his mission was successful, and he was able to deliver 678 healthy breadfruit trees to St Vincent and Jamaica. A year later, the trees were reported to be 'thriving with greatest luxuriance'. Banks was delighted, and even more so when Bligh returned in 1793 with the biggest haul of plants ever received at Kew – no fewer than 1,283 plants gathered from Tahiti, Tasmania, New Guinea, Timor, St Vincent and Jamaica.

Bligh's efforts were less enthusiastically received by the enslaved population of the West Indies: it took generations before they were prepared to eat the strange-looking pimply green fruits. Now, of course, breadfruit is a staple of Caribbean

cooking and is touted as a 'wonder food' – a vital tool in relieving world hunger. An energy-rich, high-fibre, gluten-free food packed with essential minerals, breadfruit provides not only B vitamins, niacin, thiamine and vitamin C, but a complete protein, containing all nine amino acids essential to human health. The US National Botanical Garden, based in Hawaii and Florida, has established The Breadfruit Institute to research the crop: with 815 million hungry people in the world, 80 per cent of whom live in the tropics, the hope is that breadfruit may offer a cheap and sustainable means of offering them food security. Unlike traditional starchy crops such as cassava, rice or potatoes, which are replanted every year, the trees only need planting once, and require minimal maintenance. They can thrive in a wide variety of conditions, even on salty, low-lying atolls. And in countries suffering the devastating effects of climate change, such as Haiti and the Bahamas, replanting with breadfruit offers shade and shelter for people, wildlife and additional crops, timber for building, and multiple environmental benefits including improved soil and water holding, defence against erosion and carbon sequestration.

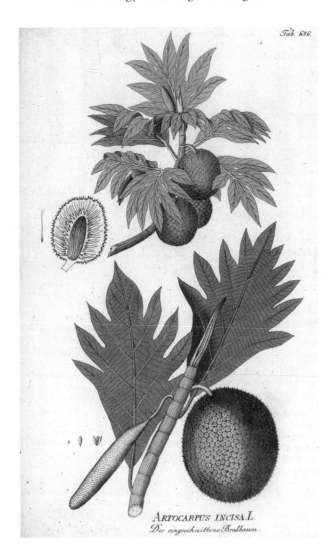

Artocarpus altilis (as *A. incisa*), from J. J. Plenck, *Icones Plantarum Medicinalium*, 1788–1812.

The Breadfruit, Painted at Singapore by Marianne North, 1876.

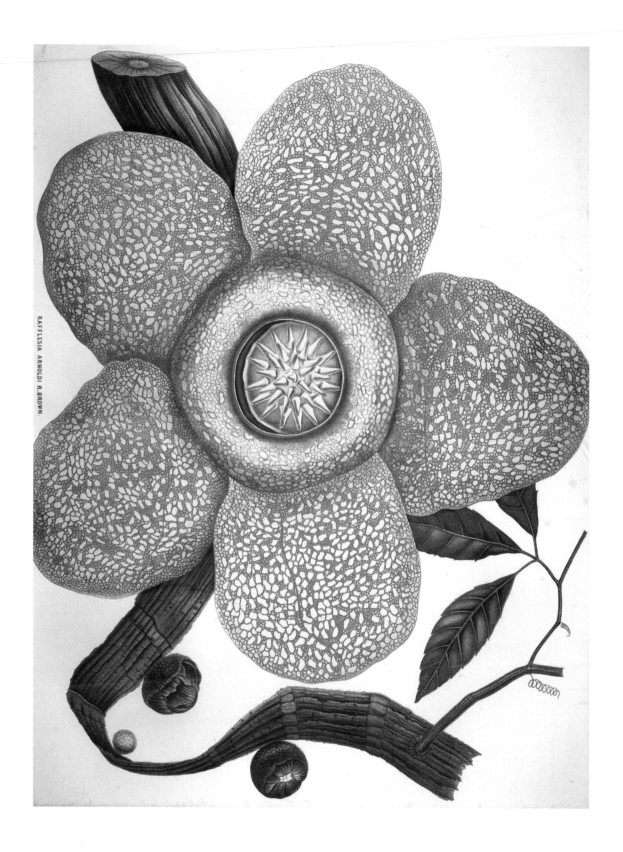

RAFFLESIA ARNOLDI R.BROWN.

53

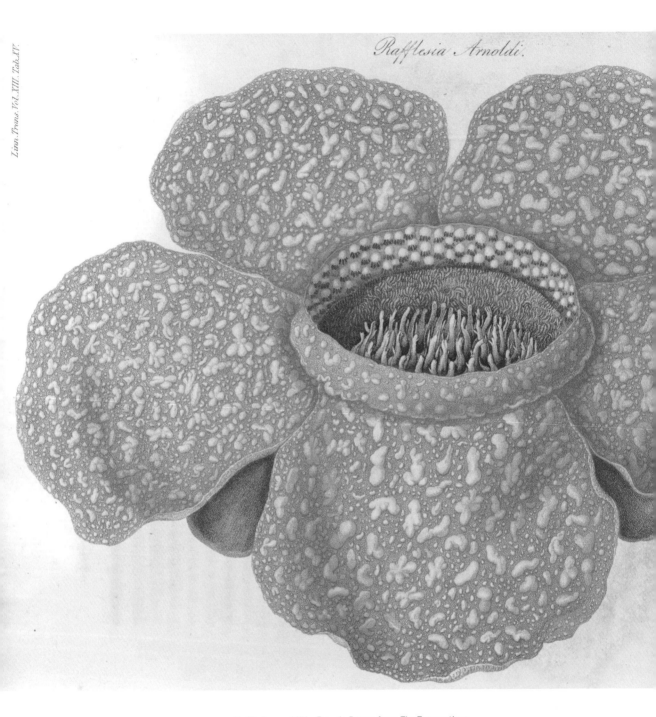

Rafflesia arnoldii by Francis Bauer, from *The Transactions of the Linnean Society of London*, 1822.

into the Sumatran jungle in May 1818. Also in the party was a young American physician and aspiring botanist, Joseph Arnold, who was summoned by the unnamed servant to behold this 'truly astonishing' plant. 'To tell you the truth, had I been alone, and had there been not witnesses, I should, I think, have been fearful of mentioning the dimensions of this flower', Arnold wrote later to a friend. Stamford and Lady Raffles immediately set about making a paper pattern of the plant. 'The Nectarium in the opinion of all of us would hold twelve pints, and the weight of this prodigy we calculated to be fifteen pounds...' Within months Arnold was dead from a fever picked up in Batavia (modern Jakarta). It is not known what happened to the servant. Raffles went on to be the founder of Singapore – and also of London Zoo.

Rafflesia is now one of three national flowers of Indonesia, along with the beautiful moon orchid (*Phalaenopsis amabilis*) and the altogether sweeter-smelling jasmine (*Jasminum sambac*). It is a potent symbol of the abundant biodiversity of Indonesia, which is home to over 10 per cent of the world's flowering plants. As a result, the corpse lily has become something of a tourist attraction: despite its relative rarity, it is common to see advertising boards by the roadside, offering walks to a nearby plant in all-too-brief flower. Although the species is not itself endangered, this disturbance has clearly had some impact on the plants, with the number of flower buds produced each year showing a marked decline at many sites.

More worrying is the rapid rate of deforestation in Indonesia. Since the 1960s, when about 80 per cent of the archipelago was still pristine rainforest, Indonesia has lost over half of this forest cover. Despite recent efforts to slow the destruction, it is estimated that at least a million hectares (2.4 million acres) of rainforest is still being cleared every year. This puts at risk the vine on which *Rafflesia* depends, as well as the archipelago's unique animal life, including its famous orang-utans.

Giant Malaysian pitcher plant

Scientific name
Nepenthes rajah

Botanists
Thomas Lobb, Sir Hugh Low

Location
Sabah, Borneo

Date
1851

THE COLOSSAL *Nepenthes rajah* is indeed a regal plant – the largest of all the tropical pitcher plants, with scrambling stems up to 6m (20ft) long and scarlet pitchers so capacious that incautious rats are frequently found drowned in them. This astonishing plant grows only in the mossy forests on the slopes of Mt Kinabalu and nearby Mt Tambuyukon in Sabah, on the island of Borneo, generally in open clearings among rocks and sedges. These habitats are low in essential nutrients, so the Rajah has developed a cunning survival strategy.

Like all the *Nepenthes* (there are around 120 species, 40 in Borneo alone), the Rajah is carnivorous. Its bright markings and sweet nectar attract insects, which lose their footing on the slippery rim of the pitcher (especially after rain) and tumble into a gloopy pool of digestive juices lurking in the bottom. Unable to climb up the sheer waxy walls of their prison, they drown, and their bodies are gradually absorbed. But for a big beast like the Rajah, and its Kinabalu neighbours *N. lowii* and *N. macrophylla,* a diet of ants and beetles is a little sparse. So for extra nutrition, they have found a way of feeding on animal poo.

The lids of the pitchers secrete a fruity-smelling fluid calculated to appeal not to insects but to two specific rodents: tree shrews (*Tupaia montana*) by day and nocturnal rats (*Rattus baluensis*) by night, ensuring a steady supply of nutrients. This fluid has a usefully laxative effect. And as the mammals balance on the rim of the plant to lick the lids, they use the pitcher as a toilet bowl, providing the plant with plentiful nitrogen-rich droppings.

Nepenthes rajah by Matilda Smith,
from *Curtis's Botanical Magazine*, 1905.

an enlarged opening which reflects the ultrasound calls of the bats, helping them to locate the plant among dense vegetation. The bats pay their rent in droppings, which provide 95 per cent of the plant's nitrogen requirement.

While botanists were accustomed to animals eating plants, it took a long time to persuade them that plants could eat animals. Such a notion, declared the pre-eminent naturalist Linnaeus in the 1770s, went entirely 'against the order of nature'. Yet the idea of a carnivorous plant held a gruesome fascination, and when, in 1844, Thomas Lobb sent the first two *Nepenthes* species back to Britain, his employer, nurseryman James Veitch, could see their potential as exotic curiosities in the new conservatories that were fast becoming the latest fashion in Victorian England.

The Veitch nursery had been founded in 1808, and would develop over five generations into the most illustrious nursery in Britain, famous for introducing the most exciting new plants, growing them on with far greater success than either the Horticultural Society or Kew. It was the first to employ professional plant collectors, sending in the 1840s a pair of Cornish brothers, William and Thomas Lobb, to opposite ends of the earth. First William went to the Americas, whence he would return with landscape-changing trees (see pages 236 and 275). Then 26-year old Thomas, who had started as a 13-year-old apprentice and was now the nursery's expert on orchids, was sent to Southeast Asia in search of these most marketable of blooms (see page 290).

The plan was originally to go to China, but on being refused entry, Thomas Lobb collected instead in Java, Singapore, Malaysia, Malacca and Penang. His first consignment of hothouse treasures arrived in England during the freezing winter of 1844 only to be held up at customs. By the time it was retrieved, the plants had all been frosted. However, Veitch did his best to 'vegetate' some seeds, bringing the beautiful striped and spotted *N. rafflesiana* into cultivation.

On Lobb's second trip he had specific instructions to find more pitcher plants, as well as more orchids and new hothouse rhododendrons. He hunted in northern India, Lower Burma, Sarawak, Sumatra and the Philippines, returning with sufficient stock to allow Veitch to stage a spectacular display of pitcher plants to coincide with the Great Exhibition of 1851. He also brought the fabled blue orchid *Vanda caerulea* and the *Phalaenopsis*, or moth orchid, the parent of all the supermarket hybrids we enjoy today.

On his third trip Lobb went to Mount Kinabalu in search of *N. rajah*. This had been found by Sir Hugh Low during the first Western ascent of the mountain in 1851, and named after his mentor Sir James Brooke, the first white rajah of Sarawak in Borneo. But Low had collected only herbarium specimens. Lobb's attempt to secure living material was derailed by civil unrest in the region and he had to make do with smaller epiphytic *N. veitchii*. He tried again on his final expedition in 1858. Again he failed – unable to persuade hostile locals to take him up the mountain. Probably, suggested Low, this was because Lobb's expedition party was too modest to bully or bribe the villagers into acquiescence. But Lobb had more pressing worries: he broke his leg so badly on this trip that it eventually had to be amputated.

It was not until 1877 that two more Veitch collectors, Peter Veitch and Frederick Burbidge, guided by field notes from Low, found their way to the 'King of Nepenthes'. 'All thoughts of fatigue and discomfort vanished as we gazed on these living wonders of the Bornean Andes!' exulted Burbidge. 'Here, on this cloud-girt mountainside, were vegetable treasures which Imperial Kew had longed for in vain.' As well as *N. rajah*, they collected elegantly hourglass-shaped *N. lowii, N. edwardsiana*, with its long red pitchers and knife-edge ribbed lip*,* and *N. villosa,* with its similarly intricate lip. All proved monstrously difficult to cultivate: it was not until the days of micro-propagation that pitcher plants would really become a commercial proposition.

Even today, new *Nepenthes* species continue to be found. (Three were published by Martin Cheek of Kew in 2016 alone.) Perhaps the most exciting of recent discoveries is *N. attenboroughii*, named after the much loved British natural history broadcaster David Attenborough. Another giant, though not quite as large as *N. rajah*, it was discovered in 2007 in the highlands of the central Philippines. Botanists were first alerted to this new species by two Christian missionaries in 2000, who, attempting to scale the remote peak of Mount Victoria, became lost on the mountainside for 13 days. On being rescued, they described their wanderings among giant pitcher plants – claims originally thought to be due to heatstroke. This stupendous plant, so new to science, is classified as critically endangered: like most of its tropical relatives, it is under threat from the wholesale habitat destruction caused by palm oil, pineapple and other plantations, as well as open-cast mining.

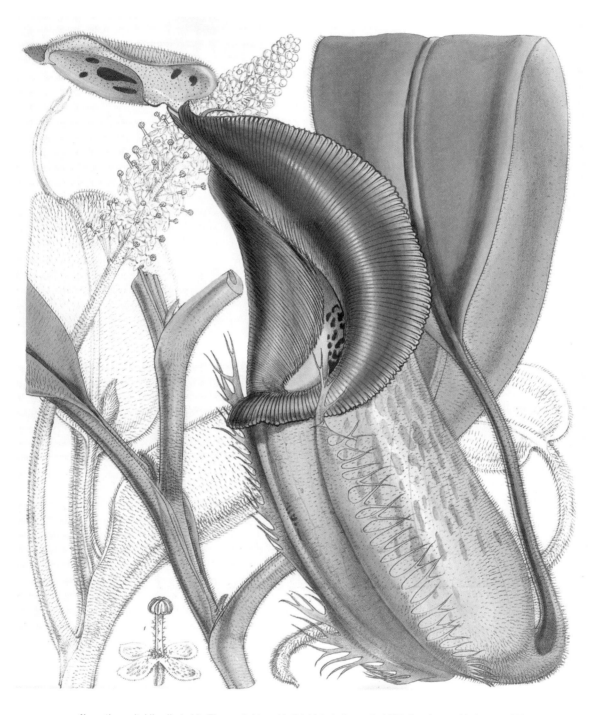

Nepenthes veitchii, collected by Thomas Lobb on his third trip to Borneo in 1854–7 and named in honour of his employer, was misidentified by Sir William Jackson Hooker when it was illustrated in *Curtis's Botanical Magazine* in 1858. It was presented as the larger *N. villosa*, also with a distinctive frilled lip.

ASIA

1

2

7

10 9

12

6

8 4

5

3

11

NO CONTINENT HAS CONTRIBUTED more to Western gardening than Asia: in fact it's fair to say that most of the plants that characterize the globally admired English garden originate in Japan, China or the Himalayas.

Asian plants had been trickling into Europe since antiquity, following trading routes that reached across Persia and Mesopotamia deep into the Indian sub-continent and China. Theophrastus described the Indian banyan tree as early as the 3rd century BCE; by the 1st century CE the Roman Empire in Europe was trading with the Parthians in Mesopotamia, the Kushan Empire in northern India and the Han dynasty in China.

It was Dutch and Portuguese traders who brought the first plants from Japan, until the shogunate, alarmed by the aggressive proselytizing of Portuguese missionaries, closed the borders in 1633. China, too, became essentially a closed country from the 15th century, although Jesuit missionaries were tolerated and made significant discoveries, while Russian botanists maintained a presence in the North. The primary conduit of plants, however, remained the English and Dutch East India companies, until the British crown took control of India, and the Opium Wars in China and American gunboat diplomacy in Japan forced open these countries in the 1850s. Botanic gardens established in India played a crucial role in the transfer of plants, especially those deemed of economic value.

Western China and the Himalayas offered particularly rich pickings for plant hunters engaged in the search for ornamental plants. These areas are less affected by glaciation than northern Europe, and high mountain ranges in subtropical areas host a rich temperate flora very adaptable to Western gardens. In addition, the geologically recent formation of the Himalayas sealed off immigrant arrivals and produced new ecological niches which encouraged the evolution of new species, resulting in an astonishing diversity of plants. And as the capacity to transport living plant material improved, the results proved ever more spectacular.

The role of the plant hunter was not without its trials. As one of the most successful, George Forrest, wrote in a letter home from the banks of the Salween river:

…insect life is both vigorous and troublesome. Creatures with inconveniently long legs plunge suddenly into one's soup, great caterpillars in splendid but poisonous uniforms of long and gaily coloured hairs arrive in one's blankets with the businesslike air of the guest who means to stay. Ladybirds and other specimens of *coleoptera* drop off the jungle down one's neck, whilst other undesirables insert themselves under one's nether garments. The light in the tent attracts a perfect army of creatures which creep, buzz, crawl or sting.

He was to encounter rather more fearsome dangers…

Maidenhair tree

Scientific name
Ginkgo biloba

Botanist
Engelbert Kaempfer

Location
Japan

Date
1712

THE GINKGO TREE is the ultimate survivor. It has been on this earth for at least 240 million years: this is the date of the oldest fossil remains, found in the Karoo Basin of southern Africa. Indeed, the fossil record shows that ginkgoes once covered vast tracts of the globe, growing in Arctic Canada, Greenland, North America and Africa, throughout Asia and in continental Europe. Yet around 100 million years ago the population started to decline, so that today there are only two places left on the planet where ginkgo survives in the wild. Both are in southern China, in populations so tiny and remote that the tree was long thought extinct in nature. Over the millennia the once great diversity of ginkgoes has been reduced to a single species – but a species so entirely unique that it occupies a genus (*Ginkgo*), family (Ginkgoaceae) and order (Ginkgoales) all of its own.

The ginkgo has survived the break-up of super-continents, cataclysmic meteor strike, extremes of climate change and the extinction of the dinosaurs. It has even survived an atomic blast: six ginkgo trees still grow in Hiroshima, just a mile from the epicentre of the 1945 bombing that wiped out 140,000 people. And it is this extraordinary resilience that has enabled the tree to thrive in the Anthropocene age: while the natural populations may be critically endangered, the tree is now common in our parks and gardens, and is planted worldwide as a street tree. In New York alone there are over 16,000 ginkgo trees, while ginkgo is the most widely planted street tree in Japan. Its sturdy resistance to drought, disease, air pollution and root compaction has made it a winner. There is, however, one drawback. The genus is dioecious – meaning that there are separate male and female trees. The male trees produce tiny cones, but the female trees bear plump yellowy fruits that look rather similar to apricots. They have nothing, however, of the apricot's

Ginkgo biloba by unknown Chinese artist, from the collection of Robert Fortune, Kew, c.1850–60.

64

delicious scent: when ginkgo fruits ripen, they smell of sick. Consequently, only male trees are generally planted.

It was from Japan that the ginkgo was introduced to Western science. From its home in China, it probably travelled to Japan in the 6th or 7th century, along with Chinese script, Chinese systems of medicine, Chinese styles of architecture and garden-making and the new religion of Buddhism. As in China, trees were often planted in temple precincts, and the longevity of the ginkgo – there is a tree in China today thought to be 3,500 years old – made it an object of reverence. It was in a temple in Nagasaki that the ginkgo was observed in February 1691 by German physician Engelbert Kaempfer (1651–1716), who described it in his book *Amoenitates Exoticae* (1712), noting the resemblance of its fan-shaped leaves to those of the maidenhair fern, *Adiantum*. (The kernels, he recorded, were roasted and nibbled to conclude a heavy meal, in order to reduce bloating.) The same book also described aucuba, skimmia, hydrangea, chimonanthus, various lilies and over 30 varieties of camellia.

Often the story of plant hunting is one of colonial arrogance. In 17th-century Japan, however, the boot was on the other foot. Since the 1630s, the Tokugawa shogunate, the military rulers of Japan, had pursued a policy of isolationism, known as *Sakoku*. No Japanese were allowed to leave the country, and foreign trade was tightly controlled through five gateways, only one of which was open to the West. In 1639 all Portuguese traders and missionaries were expelled; only the Dutch East India Company was permitted to remain, its staff restricted to a man-made island in Nagasaki Bay, just 236 by 82 paces in extent. Kaempfer would spend two years (1690–2) on Deshima island, serving as doctor to this claustrophobic community. It was not his first choice: he had hoped for a position in Batavia (Java), where he might botanize in a tropical treasure-house. But ten years of travelling throughout the Near and Far East had opened his mind and honed his powers of observation, so he arrived in Japan unusually free of Christian and Eurocentric prejudice, and consumed by an insatiable curiosity.

Just once a year, a deputation of foreigners was permitted to cross the heavily guarded bridge to the mainland, to make a deferential journey to the court at Edo (modern Tokyo), bearing gifts for the shogun. The journey lasted two months, and was a precious opportunity for Kaempfer to gather not only plants, but impressions of a society all but unknown in the West. Botanizing was good cover: pretending to

draw plants he had plucked by the roadside (officially forbidden), he made rapid notes and sketches of every aspect of Japanese life. Everything fascinated him – masked beggars walking on iron stilts, others carrying large pots with green trees upon their heads, the details of the shogun's castle, even the use of the lavatory. (When a high-status traveller needed to relieve himself, the toilet would be sanitized, Covid-style, by pasting sheets of clean white paper around the toilet and over the door fittings.)

On arriving in Edo, Kaempfer was required to sing, dance and perform tricks for the amusement of the court, which he did with good grace. It was forbidden for the Japanese to engage with the despised foreigners in any way outside the narrow parameters of trade, but a little free medical treatment, humbly offered, or some teaching in astronomy and mathematics, 'while cordially serving them European liqueurs' would generally elicit the information he required, 'even on prohibited subjects'. Kaempfer added to his own observations whatever details he could glean from previous employees at Deshima and from the few Japanese allowed to enter the Dutch enclave for instruction in European medicine or technology (known as *rangaku*, or 'Dutch learning').

All this fed into a book, *The History of Japan*, which would shape the European view of Japan for the next 200 years, influencing everything from wallpaper design to the libretto of *The Mikado*. And none of it, Kaempfer gratefully acknowledged, would have been possible without the assistance of his student, translator and cultural interpreter Gen-emon Imamura, a young Nagasaki linguist who not only learned Dutch with astonishing rapidity (it was a capital offence to teach foreigners Japanese), but also provided him with a constant stream of information, books and strictly outlawed maps, all at considerable risk to himself.

The book, translated into English and published in 1727, became a best-seller – too late for Kaempfer, who died in 1716, having been unable to finance its publication. The manuscript was bought by Sir Hans Sloane, founder of the British Museum, and reluctantly translated by his Swiss librarian John Gaspar Scheuchzer, who added flourishes of his own and even redrew Kaempfer's sketches. An accurate translation from Kaempfer's original manuscript was not published until 1999.

For 300 years it was thought that Kaempfer introduced the ginkgo to Europe, and that the venerable trees in the botanic garden at Utrecht in Holland had grown from seed he brought home in 1693. However, genetic research conducted in 2010

indicates that the origin of these trees is almost certainly Korea. How they reached Europe is a mystery. The London nurseryman James Gordon was growing ginkgoes by the 1750s which were thought to come direct from China – and he is the most likely source of the tree planted at Kew in 1762, one of Kew's famed 'Old Lions'. By 1784 ginkgoes had reached America, to join the exotic tree collection of Philadelphia gardener William Hamilton. Hamilton gave one of his three trees to the plant hunter John Bartram (see page 222), which is still growing in the Bartram garden by the Schuylkill river and is thought to be the oldest ginkgo in the Americas.

This is not the end of the tree's mysteries. Botanists puzzle over its role as a missing link between ferns and conifers. It has recently been mooted as a miracle cure for dementia. Even the name is an enigma. Why should Kaempfer have transliterated the Japanese name (meaning 'silver apricot') as 'gink-go' – a pronunciation that does not exist in modern Japanese? Scholars now think this was not a mistake, but a faithful rendition of the name as pronounced, in his strong Nagasaki dialect, by Kaempfer's Japanese collaborator Gen-emon.

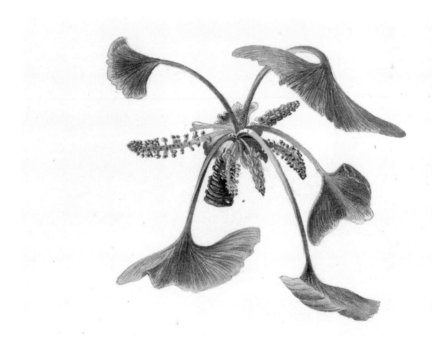

Ginkgo biloba (as *Salisburia adiantifolia*) by Thomas Duncanson, Kew Collection, 1823. Pollen-bearing catkins and young leaves of ginkgo.

Hydrangea otaksa

Scientific name
Hydrangea macrophylla 'Otaksa'

Botanist
Philipp Franz von Siebold

Location
Japan

Date
1839

JAPAN'S SEASON of *hanami* is well known throughout the world – when friends and families gather in spring to revel in the fleeting glory of the cherry blossom. What is perhaps less well known is that in the rainy season, another flower takes centre stage – the *Ajisai*, or hydrangea. The flower, which is indigenous to Japan, China and Korea, has been cultivated in Japan since at least the 8th century, but fell from grace among the Samurai class during the Edo period. For the *Ajisai* has another name – *Nanahenge* (七変化), meaning 'seven transformations'. This name reflects the habit of several Japanese species (notably *Hydrangea macrophylla* and *H. serrata*) of changing colour according to where they grow, producing blue or purple flowers on more acidic soils and pink or red ones on alkaline soils. This feature, embraced by poets as symbolic of a fickle or changing heart, was despised by the warrior Samurai for whom loyalty and steadfastness were cardinal virtues. (Curiously, pink hydrangeas are regarded as a love token, and traditionally are given on the fourth anniversary of a marriage.)

Other species of hydrangea, notably *H. arborescens* and the oak-leaved hydrangea, *H. quercifolia*, are native to North America, and these were the first to reach Europe, imported by the plantaholic London linen draper Peter Collinson (see page 222). It was Swedish botanist Carl Peter Thunberg (1743–1828) who claimed to introduce the first hydrangeas from Japan. After studying at Uppsala with Linnaeus, the founder of modern systematic biology, Thunberg made it his mission to get to Japan, and having perfected his Dutch at the Cape (see page 180), spent 16 months (1775–6) as surgeon to the Dutch trading enclave of Deshima. Japan was still closed to the outside world, and the island remained the closely guarded home of just 14 Europeans and a handful of slaves, attended by a cohort of Japanese officials and

Hydrangea macrophylla var. *serrata*, painted by Japanese botanist and entomologist Kan-en Iwasaki (1786–1842), a generation before it was described by Western botanists.

一種

土常山　一名三百頭牛藥　甘草
　　　　　　　　　　　　　�明

きあまちや

　　　　冪はあまちやと云物八枚
　　　　荒本草れ絞殿藍あり

諸国深山の産みとま生に葉ハがくま似て狹く六月花ひり中ニやき碧花
ウ里する周四五弁の白花を開き日を經て紅色を添形全くかくま似ウ葉の
味ひ甘し葉を採蒸て青汁を去飲とへ四月佛事ま用ゐるあまちや是なり

interpreters who left when the gates were locked at night, leaving the inhabitants 'in a manner dead and buried'. Plant collecting was not easy. At first Thunberg's only option was to sort through the fresh green fodder brought in for the island's livestock:

> The fodder of the cattle I examined three times a day, and selected out of
> it the rare and uncommon plants it contained for the purpose of drying
> them for the botanical collections of Europe – plants which I was
> not at liberty to gather in the adjacent plains.

Among them were two hydrangeas. Eventually, after much bureaucratic wrangling, Thunberg obtained permission to botanize around Nagasaki, but could only do so accompanied by a large retinue of interpreters and guards, for whom he was obliged to buy drinks at the end of each expedition. The cost was crippling. However, he succeeded in establishing a garden on the island, from which he despatched living specimens to Amsterdam, including two plants of *Cycas revoluta*, several ornamental maples and the ever-popular *Berberis thunbergii*. In 1776 he was allowed to join the annual embassy to Edo to pay tribute to the shogun, and used every opportunity to run ahead from his 'anxious and panting' minders to pluck up plants and tuck them into his handkerchief. He was also given leave to visit a nursery, spending all he could afford on a collection of 'the scarcest plants and trees planted in pots' from more distant provinces. He produced a *Flora Japonica* in 1784, but his *Fauna Japonica* did not appear until after his death. It was completed in 1833 by Philipp Franz von Siebold, the third inquisitive European naturalist – none of them Dutch – to use his role as a doctor on Deshima to explore the botanical treasures of Japan.

Siebold (1796–1866) was born in Würzburg, Bavaria, into a distinguished family of physicians, and became an expert opthalmologist. Inspired by the adventures of his fellow-countryman Alexander von Humboldt in South America (see page 258), he joined the military arm of the Dutch East India Company to get passage to the East, and arrived at Deshima in August 1823. Here he was charged not only with medical duties, but also with collecting commercial, political and military intelligence for the Dutch Republic. Like Thunberg before him, he was able to establish good relationships both with his Japanese interpreters and with various Japanese men of science,

were allowed on Deshima, so it became customary to issue the Dutch with Japanese *tajoz*, or 'housekeepers'. But since the 16-year-old Taki had been summoned from the Nagasaki pleasure district of Maruyama, it seems clear that her duties were not much to do with dusting. They lived together for the six years that Siebold spent on Deshima, and Taki seems to have become genuinely attached to him. In a letter written just over a year after his forced departure, she wrote of her heartache, of her memories. 'There is no day,' she sighed, 'that I do not weep.' Their daughter Ine, she reported, asked for her father all the time. (Kusumoto Ine would grow up to become a leading obstetrician, and the first female doctor of Western medicine in Japan.) Taki signed herself 'Sonogi', her geisha name, but Siebold's pet name for her was 'Otakusa' or 'Otaksa', and when he found a particularly fine large-flowered hydrangea growing near his medical school, he named it in her honour. While *H. otaksa* is no longer regarded as a separate species but as a form of *H. macrophylla* (hydrangeas can be very variable), 'Otaksa' is prized by gardeners as a heritage cultivar, valued for its very large flowerheads and bright green foliage. On Siebold's herbarium specimen is inscribed the name 'Sonogi'.

Siebold watches a Dutch vessel being towed into Nagasaki Harbour. With him are his lover, Sonogi, and their baby daughter. Painting by Japanese artist Kawahara Keiga, who worked with Siebold on Deshima, recording plant and animal specimens.

On returning to Europe in 1830, Siebold settled in Leiden in the Netherlands, and with the 80 plants (including bamboos, azaleas, camellias, lilies and hydrangeas) that had survived the long journey from Nagasaki, he set up an exotic nursery in the town's celebrated botanic garden. His two-volume *Flora Botanica*, a collaboration with German botanist Joseph Gerhard Zuccarini, was published between 1835 and 1842.

In 1853, Commodore Matthew Perry, in command of a flotilla of American gunboats, forced the shogun to open Japan to trade with the West. Nagasaki opened as a treaty port in 1859, and later that year Siebold's banishment was rescinded and he returned to Japan to find Taki. In the 30 years that had elapsed, she had (re) married – but so had he; Siebold came accompanied by his strapping 13-year-old German son. Siebold promptly turned his attentions to another young woman, and soon made her pregnant – to the disgust of his Japanese daughter Ine, who would have nothing more to do with him. His plant hunting fared rather better than either his political ambitions (he had hoped for some official post) or his love-life: he returned crestfallen to Leiden in 1861, but bearing *H. paniculata*, Japanese crab apple (*Malus* x *floribunda*), baby's breath spiraea (*S. thunbergii*) and the gorgeous flowering cherry *Prunus* x *sieboldii*.

Today Siebold is remembered in a host of well-loved garden plants, including two handsome hostas, *Hosta sieboldiana* and *H. sieboldii*, the castor oil plant (*Fatsia japonica*), Japanese quince (*Chaenomeles japonica*) and the lovely silky wisteria, *Wisteria brachybotrys*, cherished in Japanese gardens for its lingering fragrance. He also has a less fortunate legacy. For it was Siebold who introduced the pernicious Japanese knotweed (*Reynoutria japonica* or *Fallopia japonica*), which without the natural predators that control its growth in Japan, has become a rampantly invasive weed in Europe and North America. All derive from a single female plant collected by Siebold.

Robert Fortune. The nurseries grew cutting flowers, rented out potted plants, and sold seeds and plants of many kinds, especially peonies, chysanthemums, orchids, camellias and azaleas. But what they could not be persuaded to do was to propagate the wisteria (or any other wild plant) unless Reeves gave them payment in advance.

It may be that Reeves layered the wisteria himself. He certainly grew on at least two cuttings and got them well established in the containers in which they would travel before trying to ship them. (This was his way with all the plants he collected, and he would succeed in sending back several hundred plants during the 18 years he spent in China, packing them carefully in cases glazed with oyster shell.) One rooted cutting was placed on board the East Indiaman *Cuffnells* under the care of Captain Robert Welbank, leaving Canton in late 1815 and arriving in England on 4 May 1816. A second arrived a week later, on 11th May, brought by Reeves himself aboard the *Warren Hastings*, captained by Richard Rawes. (Both these seamen would become botanical heroes, famed for carrying the first camellias to Britain.)

The first cutting was delivered to a keen London gardener, Charles Hampden Turner, who, when he moved to a country house in Surrey, took the plant with him. It is remarkable that it survived, for it was first grown in a peach house heated to 29°C (84°F) where it was all but destroyed by red spider mite, then moved to a gloomy spot where it was frozen through on at least three occasions. But by 1819 it was healthy enough to be illustrated in *Curtis's Botanical Magazine* – named as *Glycine sinensis*, though Reeves would argue it should be called *Wisteria consequana*, to commemorate his friend. And by 1825 one of its progeny was thriving so lustily in the Horticultural Society's garden in Chiswick, they boasted it was carrying over 500 bunches of bloom.

The other plant had an easier time. This one was passed on to Rawes' brother-in-law, Thomas Carey Palmer, who nurtured it in his Bromley garden, and by 1818 was able to give a propagated plant to nurseryman James Lee in Hammersmith. Around 1820, another famous nursery, Loddiges in Hackney, acquired a plant from Turner. The first wisterias sold for an eye-watering six guineas each.

By 1817 Reeves was on his way back to China. He had stayed just long enough to marry (though his wife remained in England) and to persuade the Horticultural Society that rather than send dried specimens, he should send them paintings that showed potentially desirable plants like the wisteria in all their glory. If the Society

Wisteria sinensis, from Kan-en Iwasaki,
Honzō Zufu, 1835–44.

liked the look of them, it could send out gardeners to secure them – which it did in 1821 (John Potts) and 1823 (John Dampier Parks). Reeves engaged a team of local artists, known to us only as Akut, Asung, Akan, Akew and Akona ('A' is a prefix denoting humble status), and between 1817 and 1831 sent back over 900 exquisite drawings. The tradition of accurately observed botanical art as practised in Europe did not exist in China, so Reeves had to instruct his team in an entirely new style of painting. During the summer months, when the traders were driven out of Canton, the artists worked in his quarters in Macao, creating images that in many cases became the types for species hitherto unknown in the West.

Reeves was not, in fact, the first Westerner to work with Chinese artists in this way. A generation before him, in 1767, another young trader with the East India Company, John Bradby Blake (1745-73), had arrived to spend a season in Canton. Here he made friends with a Chinese boy, Whang Atong (黃亞東, b.1753), who helped him with his study of Chinese plants and in mastering the Chinese language. Returning to live in Canton in 1769, Blake started work on 'a Complete Chinensis of drawings copied from Nature', engaging a local artist known as Mauk-Sow-U to prepare botanically accurate drawings under his supervision. Whang Atong helped him with the naming and uses of the plants. The project was cut short by Blake's premature death in 1773. However, Whang Atong travelled to England, where he was welcomed by Blake's father, and became enough of a celebrity to have his portrait painted by Sir Joshua Reynolds. Some of their drawings were given to Sir Joseph Banks, who had them copied as guidance for future collectors in China.

Reeves returned to Britain in 1831, by which time his wisteria was being enthusiastically cultivated in both continental Europe and North America. Indeed, the biggest wisteria in the world is believed to grow in a garden in California, while in several of the south-eastern states, wisteria has become a serious weed. Chinese wisteria (*Wisteria sinensis*) differs from Japanese wisteria (*W. floribunda*) in having anticlockwise climbing stems and unscented flowers, while the Japanese plant has clockwise climbing stems and fragrant flowers. In their native habitats, these species are geographically isolated. But allowed to meet in the garden, they can cross and produce incredibly vigorous hybrids, capable of reaching 20m (65ft) long with stems 30cm (12in) in girth, and heavy enough to topple the strongest forest tree.

Tea

Scientific name
Camellia sinensis var. sinensis

Botanist
Robert Fortune

Location
China

Date
1849

'THIS CELEBRATED country has been long looked upon as a kind of fairy-land by the nations of the Western world,' observed Robert Fortune, recounting his years in China, and by the mid-18th century in Britain, there was an insatiable appetite for the silks, ceramics and especially the tea of this fabled land. But despite the best efforts of a British diplomatic mission to tempt the Qianlong emperor in 1792, there was nothing the Chinese wanted in return. 'Our Celestial Empire possesses all things in prolific abundance and lacks no product within its borders,' wrote the emperor to George III. 'There is therefore no need to import the manufactures of outside barbarians in exchange for our own produce.' If the British wanted tea, they must pay for it in silver. And as the Chinese were the only suppliers, they controlled the price.

For the British East India Company, who held the monopoly on trade with China, this was a major setback. Clocks and telescopes might not be of interest to the Chinese, but there was one commodity that was – opium – produced in quantity in Bengal, smuggled into China, and commanding payment in much-needed silver. By 1840 there were 10 million addicts in China, and the Chinese were desperate to halt the illegal trade. And thus began the First Opium War – conducted by the British in defence of drug-trafficking, to the shame of the nation. The result, however, was all to Britain's benefit. Since 1757, foreign traders had been limited to one tiny, tightly guarded area of Canton (modern Guangzhou). Now Britain won control of Hong Kong for the next 155 years, along with access to four more 'treaty ports'. For China, however, the 1842 Treaty of Nanking marked the beginning of a 'Century of Humiliation', and anti-foreign feeling ran high.

It was into this tense political situation that the Horticultural Society of London decided to send a plant collector – armed with nothing more than a big

Camellia sinensis, from J. C. Lettsom,
The Natural History of the Tea-tree, 1799.

and women – in all of China? And so it was, disguised as an unusually tall Chinaman, dressed in local attire, with his head shaved and sporting a luxuriant pigtail 'of which some Chinaman in former days had doubtless been extremely vain', that Fortune set off on his perilous river journey, arriving in Suzhou in June 1844. He adopted the alias *Sing Wah*, meaning 'lucky flower'. Although there were fewer nurseries than he had hoped, Fortune returned with a new double yellow rose, a white wisteria and a 'Gardenia with large white blossoms like a Camellia'. And on returning to Shanghai he found, fluttering among the burial mounds by the old city wall, the graceful anemone, *Anemone hupehensis* var. *japonica*, now a staple in European gardens.

Having completed a spectacularly successful but difficult and dangerous year for the Horticultural Society, Fortune wrote very politely to ask for a pay rise. The gentlemen of Chiswick, no doubt all possessed of private incomes, would have none of it:

> …the mere pecuniary returns of your mission ought to be but a
> secondary consideration with you. By going to China as the Society's
> agent you have had introductions and facilities afforded you which
> many could not procure; and by your labours in its service will have
> acquired a distinction and status which you could hardly have attained
> in any other way…

Despite this snub, as well as bouts of malaria, further robberies and twice being involved in a shoot-out with pirates, he continued to collect assiduously, conducted the researches required by the Society into bonsai, enkianthus, bamboo, rice-paper and tea, despatched hundreds of plants and journeyed home in December 1845 with a further 18 cases of the ones he regarded most highly. The plant in which he took most pride was the handsome golden larch *Pseudolarix amabilis*. He also introduced some novel foodstuffs such as pak choi, kumquats and Chinese spinach, and was the first to find the Chinese gooseberry, *Actinidia chinensis* (later introduced to Britain by Ernest Wilson, where it is now better known as the kiwi fruit), as well as a brassica resembling oilseed rape.

Fortune's book of his travels, *Three Years' Wanderings in the Northern Provinces of China*, proved a great success, and he was appointed Curator of the Chelsea

Pseudolarix amabilis by unknown Chinese artist,
from the collection of Robert Fortune, Kew,
*c.*1850–60.

Physic Garden, breathing new life into the moribund institution. But by 1848 he was back on his way to China, this time in the employ of the East India Company, who increased his pay by 500 per cent. His mission was to obtain a stock of seeds and seedlings to form a nucleus for a new tea industry in India, along with skilled workers to teach cultivation methods and processing.

This venture has been characterized as a larcenous act of industrial espionage, and Fortune denounced as a spy, a cheat, a thief. Yet as his biographer Alistair Watt has pointed out, he could hardly have got over 20,000 seeds and seedlings out of the country, along with nine skilled workers, without co-operation from Chinese tea farmers and merchants. Having explored the areas where the finest teas, both black and green, were produced, Fortune had to secure seeds from a range of areas with different climactic conditions at the correct season, gather them at a shipping point and transport them successfully to the Botanic Garden in Calcutta, where they were to be grown on. He had to study how the tea was grown, and how it was processed. He was the first European to realize that black and green teas were not produced from different plants, as believed in the West, but came from the same species, now known as *Camellia sinensis*. It was the way the leaf was dried that made all the difference. And having learned this, he had to arrange for tea workers skilled in both methods, along with all their equipment, to take passage to India for three years, paying them four months' wages in advance. If he chose to travel in certain areas disguised as a mandarin from a province 'beyond the Great Wall', this was perhaps prudent in a country descending into vicious civil war, provoked at least in part by dismay at the Qing's failure to stand up to Britain.

It should also be remembered that Fortune was not the first to introduce Chinese tea seeds to India. Experimental plantings had been made in Calcutta as early as 1774, while George James Gordon (secretary of the colony's new Tea Committee) obtained a substantial consignment by 1836, from which some 40,000 plants were successfully produced. Meanwhile a different form of tea, *C. sinensis* var. *assamica*, as opposed to the Chinese *C. sinensis* var. *sinensis*, had been discovered in Assam in 1823, and it was this species that would later be widely grown in India, and supply the great British cuppa.

Fortune made two successful collecting trips before travelling to India to see how his seeds were coming on. He returned in 1852 to add to his collections, and

particularly to procure 'some first-rate black-tea makers for the experimental tea farms in India', of which he found 17. He was disappointed by the management of many of the East India Company's tea plantations, inappropriately sited in north-west India, often on land that was either too wet or suffered summer drought, or where the tea bushes were overpicked. Some excellent fragrant green teas are still produced in these areas from old Chinese stock, but the British (and Australian) taste for a strong black tea to which milk and sugar would be added was better served by a blend of *assamica* – and still is today.

Fortune returned to China briefly in 1858–9 to collect tea for the US government – an attempt to establish a tea industry in the southern states that was cut short by the American Civil War. His final trip was made in 1860–1. The outbreak of the Second Opium War having made China dangerous (the British destroyed the Imperial Summer Palace in October 1860), he travelled instead to Japan, where he found various *Osmanthus*, primulas, the non-variegated male form of *Aucuba japonica* (a spotty female clone was already in English gardens) and *Hosta fortunei* – now thought to be an old Japanese cultivar and not a new species at all.

In 1861, a lull in hostilities allowed Fortune to return to China, and finally to reach Peking. While he found little new in the way of plants, he did rather better with insects (21 insect species bear his name). He had also become something of a connoisseur of Chinese art and antiques, and these would provide him with a comfortable income when his collecting days were over. He died a relatively prosperous man – unusual for a plant hunter. And in our gardens he left innumerable riches – some 280 introductions in all, the warmer-climate ones thriving in Australia, while the chillier British garden embraced three mahonias, two forsythias, garden stalwarts such as winter jasmine (*Jasminum nudiflorum*), bleeding heart (*Dicentra spectabilis*, now called *Lamprocapnos spectabilis*), the snowball tree (*Viburnum plicatum* 'Sterile') and gorgeously scented *Lonicera fragrantissima* and *Trachelospermum jasminoides*.

Pride of Burma

Scientific name
Amherstia nobilis

Botanist
John Crawfurd, Nathaniel Wallich

Location
Myanmar

Date
1826

SENT AS AN envoy to Burma in the aftermath of the first Anglo-Burmese war, Scottish diplomat John Crawfurd was making his way up the Salween river in April 1826, when at a bend in the river he noticed a formation of strange conical hills. These were pierced with limestone caves, dedicated to the worship of the Buddha. Hundreds of statues filled the largest cave, each decked with handfuls of flowers. Surrounding the cave was a run-down monastery garden, and here he spied the source of the flowers – 'a tree about twenty feet high, abounding in long and pendulous panicles of rich geranium-coloured blossoms …too beautiful an object to be passed unobserved, even by the uninitiated in botany'. When, four months later, he showed the dried flowers he had collected to his friend Nathaniel Wallich, Superintendent of Calcutta's Botanic Garden, the botanist could barely contain his excitement: the tree, he declared, was a form of legume, but of an entirely new genus.

Wallich (1786–1854) returned to Burma the following year to search for the tree and found two cultivated specimens, both 'profusely ornamented with pendulous racemes of large vermillion-coloured blooms, forming superb objects, unequalled in the Flora of the East Indies, and, I presume, not surpassed in magnificence and elegance in any part of the world'. (The tree is no longer known in the wild.) Wallich named it *Amherstia nobilis*, in compliment to the Countess of Amherst, wife of the Governor General of India, and her daughter, Lady Sarah Amherst. The ladies were both keen botanists, responsible for introducing the white form of *Clematis montana* into cultivation.

Wallich's exploration of Burma was cut short by illness, and during the three years he spent recuperating in England he published a ground-breaking three-volume account of plants from the Indian sub-continent, *Plantae Asiaticae Rariores* (1830–2).

Amherstia nobilis by Indian artist
Vishnupersaud, from N. Wallich,
Plantae Asiaticae Rariores, 1830–2.

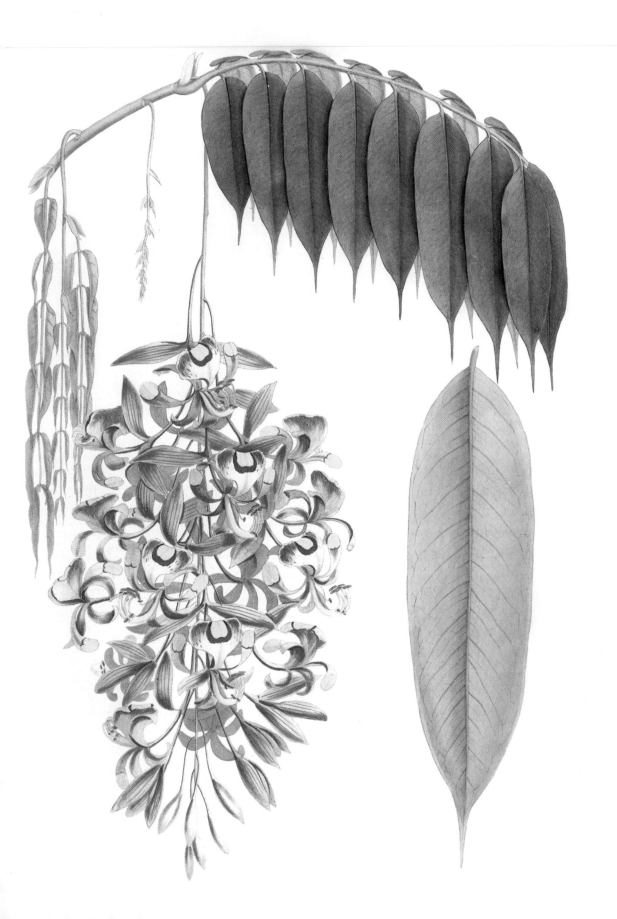

Over the course of the 1820s, he and his assistants had gathered nearly 10,000 different species for the herbarium in Calcutta (modern Kolkata), and the book introduced all manner of new marvels. The immense crimson inflorescence of *A. nobilis* caused a sensation; among the European collectors desperate to acquire it was the plant-mad Duke of Devonshire. But this was easier said than done. Wallich had managed to establish the *Amherstia* in Calcutta, but none of the seedlings he had sent back to Europe had survived. The duke and his gardener, the all-capable Joseph Paxton, therefore hatched a plan to send their own collector out to Burma.

The man chosen for the task was John Gibson, a 20-year-old under-gardener at Chatsworth, the duke's Derbyshire estate, who had never set foot outside the north of England. He was carefully prepared for the task, coached in turn by Paxton, by John Lindley, generally regarded as the premier botanist of the day, and by Loddiges, a nursery specializing in exotics that had enjoyed considerable success importing plants using the new technology of the Wardian case. Gibson set off to meet Wallich in Calcutta, bearing gifts for the botanic garden, arriving in the sweltering rainy season in March 1836.

Wallich, who was known for his irascibility and spent much of his career locked in combat with his botanical enemies, appears to have taken pity on the bewildered young man who arrived in a 'dreadfully miserable' state. He would send Gibson, he reassured him, to Cherrapunji in the Khasi hills, possibly the wettest place on the planet, but where he was certain to find all the orchids his master desired in addition to the *Amherstia*. And if Gibson failed to get to Burma to find the tree himself, there were a couple of spare saplings in Calcutta: Gibson could take one for the duke, and one for the directors of the East India Company, the owners of the Botanic Garden.

After months of frenetic collecting, Gibson set sail for England loaded with orchids, and with Wallich's two precious *Amherstias* in Wardian cases lashed to the deck. Then disaster struck: the *Amherstia* destined for the duke wilted and died. On hearing the news, the duke was inconsolable, and at once despatched a desperate letter to the East India Company, begging for the remaining specimen. 'Be assured there is not in England a gardener capable of rearing and propagating it so successfully as Mr Paxton,' he wrote. His confidence was misplaced. Even Paxton's miraculously green fingers could not persuade it to flower, and the plant eventually died, as did

the three specimens sent in 1846 to Kew, to the Duke of Northumberland at Syon House and to the Horticultural Society of London. It took a woman's patient care to coax it into bloom: in April 1849 the redoubtable Louisa Lawrence, a wealthy haberdasher's daughter much admired for her horticultural skills, cocked a snook at her lordly rivals by producing at least two lavish racemes from a sapling only 3.4m (11 ft) tall. The first was 'most fitly' presented to Queen Victoria, and the second to Kew for illustration in *Curtis's Botanical Magazine*, where it appeared alongside a detailed account of the complicated cultivation techniques she had employed. The little tree continued to flower steadfastly for Mrs Lawrence until 1854 – a year before her death – when it was dug up and transferred to Kew. Here it proved an inspiration to intrepid botanical painter Marianne North: 'It was the first that had bloomed in England and made me long more and more to see the tropics,' she wrote. Three years later it was moved to the Palm House, where it promptly died. Happily, another woman, the Marchioneess of Londonderry, was able to bring 'the rarest plant in England' into bloom in a 'new conservatory built purposely for its reception' – an event sufficiently noteworthy to be reported in April 1857 in the *Illustrated London News*.

Meanwhile, in Calcutta, Wallich's rare and beautiful trees had become a tourist attraction. This pleased Wallich, who was always happy to welcome visitors to the garden, but it was not at all the reason why the garden had been set up.

During the 19th century Calcutta became the greatest of all the colonial botanic gardens and an important scientific institution in its own right; but when the garden was established in 1786 by Lt Col Robert Kyd (1746–93), its intention was not to advance botanical knowledge but rather to relieve the people of Bengal of 'the greatest of all calamities, that of desolation by famine'. (The Great Bengal famine of 1770 was estimated to have wiped out a third of the population.) Kyd proposed:

> a Botanical Garden, not for the purpose of collecting rare plants (though
> they also have their use) as things of mere curiosity or furnishing
> articles for the gratification of luxury, but for establishing a stock for
> disseminating such articles as may prove beneficial to the inhabitants, as
> well of the natives of Great Britain, and which ultimately may tend to the
> extension of the national commerce and riches.

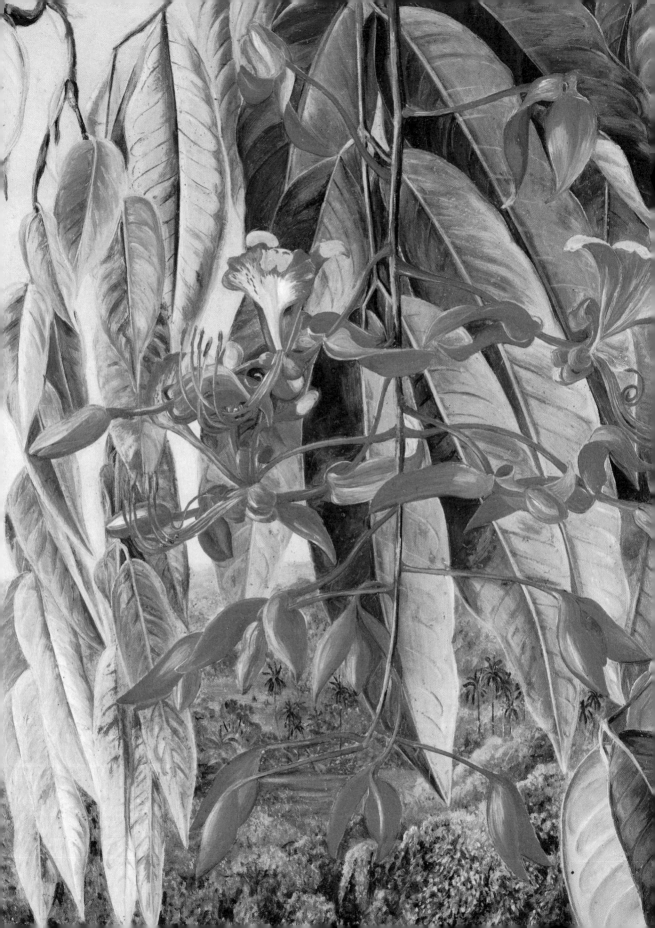

He suggested experimenting with staple crops from other lands such as dates, sago and breadfruit, and nutritious new fruits such as peaches, pears, lychees and mangosteens. He also wanted to grow teak for shipbuilding – it was already apparent that demand for hardwoods was outstripping supply.

The East India Company, which effectively ruled India until the Indian Mutiny of 1857, referred Kyd's proposal to its unofficial adviser, Sir Joseph Banks, who responded with enthusiasm, envisaging 'a network of colonial botanic gardens which would serve as bases for plant hunting and act as experimental gardens for crops...which might lead to colonial economic development'. Gardens had long exchanged plants out of scientific curiosity – now they might do so in a systematic way, importing plants from similar climate zones that might benefit both local populations and the Empire as a whole. Much of the wealth of Europe and its colonies derived from plants, and the Dutch had set up a garden in Cape Town to ease the passage of plants across the globe as early as 1694. The East India Company could see the commercial benefit – with cheap labour available, India could become a major supplier of raw materials, medicines, even lucrative spices such as nutmeg, cinnamon and cloves. There was also a political imperative: criticized for exacerbating the famine, the company could point to Kyd's humanitarian project as proof of its enlightened rule.

When Kyd died in 1793, he was succeeded by William Roxburgh (1751–1815) who, unlike Kyd, was a trained botanist. In a small garden in Madras he had already successfully introduced coffee, cinnamon, nutmeg, pepper, mulberry and breadfruit. Within a year he was distributing seeds of teak, hemp, indigo, coffee and tobacco to different parts of India, while Banks was urging further trials with sugar, vanilla and chocolate. While still cultivating spices and foodstuffs such as coconuts, Roxburgh steered the garden in a more scientific direction, and by the time he retired there were 3,500 varieties of plants in the garden, compared to 300 when he arrived. Over 30 years he compiled a vast catalogue of Indian plants, published after his death as the *Flora Indica* (1820–30). At the garden he left life-size colour drawings of no fewer than 2,542 of these plants: this spectacular legacy is now preserved at Kew. He was one of the very first Western botanists to work with local artists, appreciating how the exquisite skills of Indian miniaturists could be redeployed in pursuit of botanical accuracy. His successor Nathaniel Wallich followed suit: the

Foliage and Flowers of the Burmese Thaw-ka or Soka Painted at Singapore by Marianne North, 1876. It was the sight of an *Amherstia* that inspired Marianne North to travel to the tropics.

colour plates in *Plantae Asiaticae Rariores* are mainly the work of two Indian artists, known as Vishnuprasad and Gorachand, based at the Calcutta garden.

Wallich was Roxburgh's proudest find — a Danish surgeon who was taken prisoner when the British seized Serampore in 1808, and who swiftly made himself useful in the garden. He succeeded Roxburgh in 1815, and served the garden for the best part of 30 years, botanizing in Nepal, West Hindustan and Singapore (adding some of this material to Roxburgh's *Flora Indica*), sharing his vast collections of plant specimens with other institutions in Europe and North America, and working hard to establish new commercial crops in India, notably cinchona and tea. Many thousands of new plants were successfully distributed from the garden, both within India and further afield: the seeds of the first Himalayan rhododendron, *R. arboreum*, reached Europe packed in tins of brown sugar. Wallich also campaigned tirelessly against the pillage of India's forests for hardwoods, calling on the East India Company to adopt sustainable forestry practices and to fund state-run plantations of teak and a faster-growing alternative, sissoo wood (*Dalbergia sissoo*). They did neither.

In 1842 Wallich fell ill once more, and was obliged to take sick leave from Calcutta. He was appalled when his enemy William Griffith, a progressive young botanist who considered Wallich an anachronism, was appointed caretaker. His fears were justified: Wallich returned to find his shady groves of spice trees cut down, flowerbeds dug up, and an avenue of cycads that had been one of the glories of the garden entirely vanished. Griffith had decided the garden was insufficiently scientific, and set about creating three new demonstration gardens, two illustrating different systems of plant classification, contrasting the outmoded Linnaean system still favoured by Wallich with the more modern 'natural system' Griffith espoused. The third garden was devoted to Indian plants, so the *Amherstia* survived the cull — but was almost killed off by the baking of the soil over its now unshaded roots.

Wallich never recovered from the blow. He struggled on just long enough to claim his pension, then retired to Britain. In 1864, ten years after his death, a cyclone tore through Calcutta, carrying two ships into the garden on a tidal wave. Despite this further destruction, the garden recovered to become, by the end of the century, the leading imperial garden after Kew, as befitted the second city of Empire. The *Amherstia* remained one of its proudest exhibits, as it still does today.

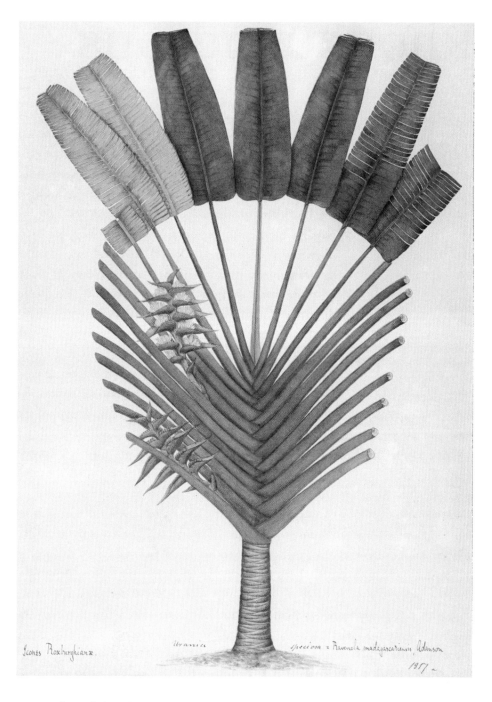

Iconis Roxburghianæ. *Urania* *speciosa* = *Ravenala madagascariensis* Adanson
1857 –

Among Roxburgh's paintings is this elegant tree, *Ravenala madagascariensis* (then known as *Urania speciosa*). Three trees were brought to Calcutta and planted in different soils and situations. Roxburgh noted that the tree planted in the dampest spot did best, and was the first to flower. William Roxburgh Collection, Kew, *c.*1800.

Rhododendrons

Scientific name
Rhododendron

Botanist
Sir Joseph Dalton Hooker

Location
Sikkim, India

Date
1849

'THE MONEY spent on rhododendrons during twenty years in this country,' exclaimed the English garden writer Shirley Hibberd in 1871, 'would nearly suffice to pay off the National Debt.' Gardening has always been a competitive sport, and for the industrial tycoons of the High Victorian era, the equivalents of today's tech-billionaires, the rhododendron was the perfect plant. Its flowers were plentiful, vividly coloured and large enough to be admired from afar. The fact that they were so fleeting was not an issue – gardens were not yet required to provide interest all year round, and besides, the shrubs that bore them were fashionably evergreen. Above all, the hefty price-tag, the novelty and exotic origins of the plant in the snowy Himalaya burnished the status of all who grew it. And within a very few years, the rhododendron became as eagerly sought after for the shrubberies of the new suburban middle classes as for the pleasure grounds of the super-rich.

The blame for rhododendronmania, which swept through northern Europe from the 1850s and North America soon after (despite that country having perfectly good rhododendrons of its own), may be laid at the door of Sir Joseph Dalton Hooker (1817–1911) who, from a four-year trip to northern India and the Himalayas in 1848–51, introduced 43 species of rhododendron, 25 of them new to science, principally from the kingdom of Sikkim. These plants adapted themselves triumphantly to every succeeding garden fad. First, they were grown in 'American' gardens, originally made to display Bartram's introductions (see page 222), then in more formal layouts as individual specimens or grouped in lawns. Following Hooker's account of his travels in 1854, gardens began to incorporate 'Himalayan groves' or even, where funds allowed, entire valleys. And when, towards the end of the century, a move back towards a more naturalistic style gave rise to woodland

Rhododendron hodgsonii, from J. D. Hooker, *Rhododendrons of the Sikkim-Himalaya*, 1849–51.

gardens, the rhododendron truly came into its own, providing a splendid variety of colourful underplanting.

Hooker was already a seasoned explorer by the time he set off to India in 1848. Aged just 22, he had joined the expedition of Captain James Clark Ross to locate the magnetic South Pole, serving as assistant surgeon and botanist aboard the *Erebus*. Over four years, as they charted what they could of the great Southern Continent, driving through the pack ice to discover unknown seas and mountains, smoking volcanoes and impenetrable cliffs of ice, Hooker collected flora and fauna wherever he could land, from New Zealand to the Falklands to Tierra del Fuego. And as he sat on a plant on some sub-Antarctic island (the best way to thaw it enough to chip it out of the frozen soil), he began to ask questions, as Humboldt had before him (see page 258), about how plants come to grow where they do.

This was a subject Hooker would debate tirelessly over the next 40 years with the man who became his closest friend, Charles Darwin. Soon after his return, Hooker was approached by Darwin to classify the plants collected on his voyage on the *Beagle*. It was in a letter to Hooker in January 1844 that Darwin first divulged his conviction that species 'are not…immutable' – a heresy that felt uncomfortably like 'confessing a murder', and the two continued to correspond as Darwin gathered evidence for his theory of evolution by natural selection. When, in June 1858, Darwin received a letter from Alfred Russel Wallace outlining a theory almost identical to his own, it was Hooker, together with Charles Lyell, who ensured that their papers should be read simultaneously at the Linnean Society. Hooker spoke in defence of Darwin at the historic 'evolution debate' held at the Oxford University Museum on 30 June 1860, and was one of the first (though he retained reservations) to support Darwin's theories in a work of science – in his *Flora of Tasmania*. So when Hooker set off for India, he was armed with a lengthy shopping list of things to find out (geological, zoological and botanical) for his friend.

The trip to India was instigated by Hooker's father, Sir William Jackson Hooker, who in 1841 had been appointed the first official Director of the royal garden at Kew. Like Banks before him, he was determined to turn Kew into a globally significant scientific establishment. He resembled his mentor also in his deftness in pulling official strings, and was able to secure funding to send out his son to collect on behalf of the garden. Both Hugh Falconer, who took charge of the Botanic Garden at Calcutta,

and Lord Auckland, First Lord of the Admiralty, who had sanctioned the trip (Hooker was still officially employed by the Navy), had suggested Sikkim as a destination – a remote Himalayan kingdom wedged between Nepal to the west and Bhutan to the east, as yet unexplored by any European. Hooker arrived in Darjeeling, in the foothills of the Himalayas, in April 1848, where he met Brian Houghton Hodgson (1801–94), an extraordinary man with 'the intellectual curiosity of a Renaissance scholar' – artist, ornithologist, ethnographer and linguist, an authority on Buddhism, collector of Sanskrit manuscripts and former British Resident in Nepal, where he had fallen out with his political masters and resigned. He had retired to a bungalow a little way from Darjeeling, with spectacular views of Kanchenjunga, then thought to be the highest mountain in the world. To Hooker's delight, Hodgson invited him to join him there, and was generous in sharing his knowledge. Many of Hooker's rhododendrons, such as *Rhododendron dalhousiae* (now *dalhousieae*) and *R. campbelliae*, were chivalrously named after the wives of officials who assisted him in his journey. Naming *R. hodgsonii* however, which Hooker pronounced the most characteristic tree or shrub of the valleys of Sikkim, was a genuine mark of respect for his 'excellent friend and generous host' whose scholarship he considered 'beyond all praise'. In *Rhododendrons of Sikkim-Himalaya*, the three-volume account of his rhododendron discoveries published in 1849–51, he describes its 'magnificent' outsize foliage, 'remarkable for its brilliant deep green hue', and 'the toughness and unyielding nature of the wood'. He notes that the wood is used to make cups, spoons, ladles and yak saddles, while the leaves serve as 'platters' and food containers: 'the accustomed present of butter or curd is always made enclosed in this glossy foliage'.

Getting into Sikkim was by no means easy. The political agent to Sikkim, Archibald Campbell (who was also to become a close friend), managed eventually to secure permission for Hooker to explore the high Tibetan passes in eastern Nepal and return by way of Sikkim. This journey furnished 80 porter-loads of specimens for Kew (though relatively little survived shipping through Calcutta). It was not until May 1849 that Hooker was able to embark on a longer expedition. The Rajah of Sikkim was wary of upsetting China, his powerful neighbour to the north which governed Tibet, and Hooker was no David Douglas (see page 228), who might slip into the country discreetly, but travelled with an entourage of over 50 people, including tree-climbers, shooters, porters and guards. Most essential were the trusty

Lepchas capable of constructing a 'waterproof house' equipped with 'a table and bedstead' every night within an hour, where he might comfortably review the day's finds over a glass of sherry. Following pressure from the British Governor General of India, the rajah reluctantly conceded, to the great disgruntlement of the dewan, the chief minister and effective ruler of Sikkim, who put every kind of impediment in Hooker's way. Villagers were instructed to refuse his party food and lodging, to remove bridges at vital river crossings and to do all in their power to deflect him from Tibet, which Hooker had undertaken not to enter. There were also all the natural hazards of the Himalayas to contend with – the relentless ascents and descents, razor-edge paths skirting terrifying abysses, the freezing nights and blinding snows. He suffered badly from altitude sickness, enduring 'headaches that do not go off for hours', which did not deter him from scaling the 5,880m (19,300ft) Donkia mountain – the highest any European had climbed at that time. Travelling in the rainy season, he was constantly wet, spent each day enveloped in cloud, and each night picking a hundred or more leeches out of his skin.

Campbell joined him in Sikkim in October, and while Campbell was negotiating with a border patrol, Hooker made a mad dash into Tibet, galloping away from pursuing guards in an adventure he would remember fondly for the rest of his life. This incursion, however, gave the dewan the ammunition he needed to arrest and torture Campbell, and while Hooker was not officially detained, he remained imprisoned with his friend for some weeks. When the British moved troops to the border and threatened invasion, the pair were hastily released, and some months later part of Sikkim was annexed by the British. Hooker was less concerned by the political fall-out than the loss of so many of his specimens. The map he made of the country was used by the military authorities in seizing the new territory: it would later be planted with cinchona and tea.

Hooker's last expedition in India was to the Khasi Hills of Assam, in the company of his old friend Thomas Thomson, for whom he named *R. thomsonii*. They would later collaborate on (and fall out over) a colossal *Flora of British India*. Here they watched in dismay as collectors ripped through the forest, filling hundreds of baskets with orchids.

Hooker left India in January 1851. His father was not altogether satisfied with his collections, but as Hooker testily pointed out, 'it is one thing to find these things and another to collect them alive. If your shins were as bruised as mine,' he complained,

'after tearing through the interminable rhododendron scrub of 10–13 feet you'd be as sick of the sight of these glories as I am.' He was much more excited to discover, at 5,790m (19,000ft), the self-same lichen he had last seen at sea level in the Antarctic. He noted how swiftly the plants changed as he travelled between entirely different climactic zones, sometimes in little more than a day. He was enthralled to observe, 'In travelling N. you come upon genus replacing genus, Natural Order replacing Natural Order. In travelling E. or W. (i.e., N.W. or S.E. along the ridges) you find species replacing species, and this whether of animals or plants.'

His father had already organized publication of *Rhododendrons of Sikkim-Himalaya,* with sumptuous illustrations by Walter Hood Fitch, based on Hooker's field sketches. In 1854 he published *Himalayan Journals,* which became a best-seller. The following year, his father secured him a post as assistant director at Kew, and ten years later he became director himself. Under his leadership, Kew became both the research centre and the botanical powerhouse of Empire that Joseph Banks had imagined (see page 33), moving economically important plants around the globe through a network of botanic gardens. Hooker famously oversaw the transfer of cinchona to India and Ceylon (modern Sri Lanka) and secured 70,000 seeds of the rubber tree, *Hevea brasiliensis,* from Brazil. These were germinated at Kew, and plantlets sent to Ceylon and Singapore, where just 22 seedlings formed the basis of the Malay rubber industry.

Hooker lived to become the Grand Old Man of British botany, spending 25 years working with George Bentham on *Genera Plantarum,* a prodigious attempt to describe all seed-bearing genera. He was decorated, knighted, appointed president of the Royal Society (the first botanist since Banks) and advised on Scott's mission to Antarctica. His final years were taken up with investigating the genus *Impatiens* (the family of balsams and busy lizzies), but it is for rhododendrons that he will always be remembered.

In 1848, when Hooker arrived in India, there were only 33 rhododendrons in cultivation, including the popular *R. ponticum,* much loved by sporting landowners for game cover, a handful of American species and scarlet-flowered *R. arboreum,* introduced by Nathaniel Wallich in 1827. Today there are over 20,000 named varieties. A hollow at Kew was turned into a 'Rhododendron Dell' to display the hardier of Hooker's treasures. They are still flourishing there today.

Rhododendron thomsonii, from J. D. Hooker,
Rhododendrons of the Sikkim-Himalaya,
1849–51.

Tab. XII.

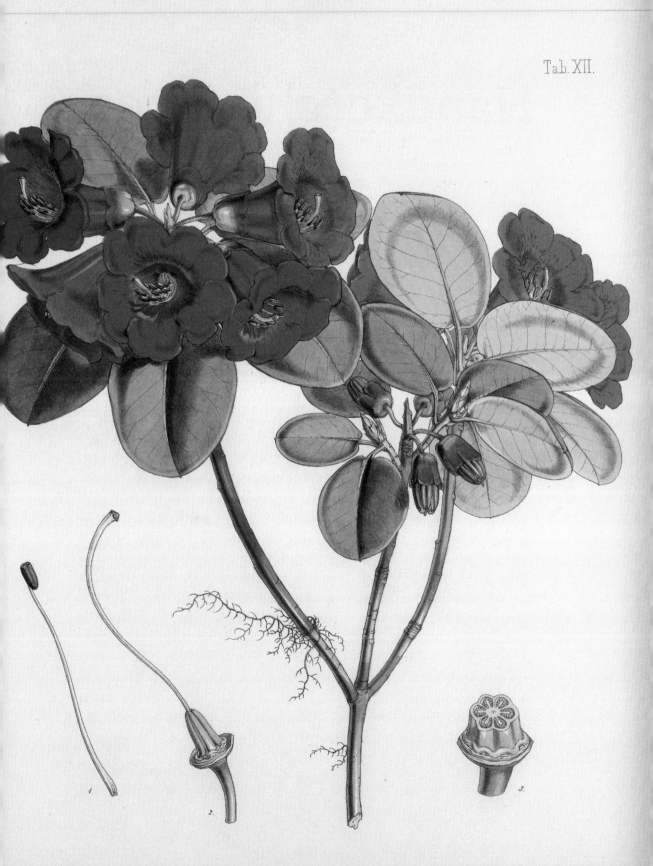

J.D.H. del. Fitch lith.

Reeve, Benham, & Reeve, imp.

Handkerchief tree

Scientific name
Davidia involucrata

Botanist
E. H. Wilson, Augustine Henry

Location
Western China

Date
1897/1901

DR AUGUSTINE HENRY (1857–1930) was beside himself with boredom. A young Irish physician and minor official of the Chinese Imperial Maritime Customs Service, he arrived in China in 1881, and was posted to the remote town of Ichang (Yiching) in Hubei Province, a thousand miles up the Yangtze river from the port of Shanghai, where his duties proved less than stimulating. While the Customs Service was nominally a branch of Chinese government (founded in 1854 to run the customs of the treaty ports that were now under foreign control), it was run by the British, and its officers were generally recruited from British public schools. As a diversion from interminable tennis and card parties, Henry turned to natural history. He studied the medicinal plants used by his Chinese neighbours, and became increasingly interested in the unexplored flora of the region. By 1885 he was devoting all his spare time to botany, had made two extended collecting trips into the mountains, and had plucked up the courage to write to Sir Joseph Dalton Hooker, Director of the Royal Botanic Gardens at Kew. He knew little of botany, he confessed, but was willing to send specimens if they might be of use. Besides, it was an excellent pretext for the sending and receiving of letters, 'the only stimulus of a healthy kind an exile has to cheer him in moments of depression…the only little joys we have'.

It was the start of an incredibly fruitful relationship: over the next 15 years Henry would send some 158,000 herbarium specimens, representing 6,000 species, of which nearly 2,000 proved new to science. Among them was a specimen of an unknown solitary tree he found in May 1888, in full and glorious bloom, 'waving its innumerable ghost handkerchiefs'. When autumn came, he added some hard green walnut-sized fruits from the 'handkerchief tree' and sent off his package to

Davidia involucrata by Matilda Smith, from *Curtis's Botanical Magazine*, 1912.

Kew, where it was examined with mounting excitement by Daniel Oliver, Keeper of the Herbarium. Oliver identified it as *Davidia*, a new genus discovered in 1869 by the French missionary Père Armand David, but almost a thousand miles away from Henry's example. It was worthy, he wrote, of 'a special mission to western China with a view to its introduction to European gardens'. Despite this encomium, either the seeds he already had were never sown or they failed to germinate.

Henry was very much of Oliver's opinion, later writing to William Thiselton-Dyer (Hooker's successor at Kew), that 'so great is the variety and beauty of the Chinese flora and so fit are the plants for European climate, than an effort ought to be made to send out a small expedition…' The job, insisted Henry, required a properly trained botanist, which he was not, and someone who, having identified plants of interest, had the time and skills to return to collect their seed, which he had not. 'I can see now,' he lamented, 'that there were hundreds of interesting plants which I might have noticed earlier in my plant collecting, if I had had the experience or genius or the teaching.' And time was of the essence. As Henry was moved from post to post, he became increasingly convinced not only of the untapped richness of China's flora, but of its fragility: thousands of rare plants were being wiped out daily by uncontrolled logging and charcoal burning. Close to the border with what is now Vietnam, he saw entire forests disappearing.

Henry made much the same arguments to Charles Sprague Sargent, Director of the Arnold Arboretum at Harvard University in Boston. The flora of China, he avowed, was 'by far the most interesting one on the globe & to an American must offer even more than to a European – as China in so many ways, its great rivers, mountains, climate, etc, seems to be a counterpart of the United States'. Sargent, who was eager for seeds, begged Henry throughout the late 1890s to lead an expedition himself, but Henry demurred. He wanted to go home: 'It may seem absurd; but it is difficult to bear up with the isolation, friendlessness and monotony of a place such as this.'

By this time he was in Szemao (Simao) in Yunnan Province. (He suspected he was sent to these remote outposts because his superiors knew of his interest in botany.) And it was here, just as he was about to leave China for good, that his long-awaited plant collector turned up. Kew had balked at the expense, and sold the idea to Harry Veitch, proprietor of Britain's most celebrated nursery, with a stellar history of plant hunting (see pages 56 and 236). While Veitch was certain

that all the best of China's garden-worthy plants had already been discovered, he agreed with Henry that the *Davidia* alone was 'worth any amount of money'. And so it was that Ernest Henry Wilson (1876–1930), a promising former student at Kew who was hoping to become a botany teacher, found himself instead en route to China entrusted with a mission cloaked in James Bond-like secrecy:

> The object of the journey is to collect a quantity of seeds of a plant the name of which is known to us. That is the object – do not dissipate time, energy or money on anything else. In furtherance of this you will first endeavour to visit Dr A. Henry at Szemao, Yunnan, and obtain from him precise data as to the habitat of this particular plant and information on the flora of central China in general.

This was easier said than done. In June 1899 Wilson arrived in Hong Kong to find it in the grip of bubonic plague. It took him three months to make his way to Henry in Simao, surviving close shaves both in river rapids and the dangerous political currents of the rising Boxer Rebellion, during which all foreigners became the hated enemy. Henry thoroughly approved of his young guest, certain he would do well, though he spoke not a word of Chinese, since he was 'even-tempered and level-headed, the main thing for travelling and working in China'. Henry passed on what tips he could, not least that the route to successful plant hunting in China was time and patience, a lesson Wilson took to heart. He also gave him, on a scrap of paper torn from his notebook, 'a sketch of a tract of country about the size of New York State'. In an area of some 50,000 sq km (20,000 square miles), a roughly pencilled cross marked the spot of a single tree.

Soon Henry sailed thankfully for England, where he spent some time sorting his Kew collections before embarking on a distinguished second career in forestry. Wilson, meanwhile, made his way perilously to Ichang, and set off in search of Henry's elusive treasure. Improbably, on 25 April 1900 he found his way to the tiny hamlet of Mahuanggou, where the villagers still remembered the curious 'foreign devil' who had gone into raptures at the sight of a tree. Obligingly, they led the new lunatic to the exact spot. Here Wilson, with a lurch of the heart, observed a smart new wooden house, and beside it, the stump of Henry's *Davidia*. He had travelled half-way across the globe for nothing.

What to do? He could journey the 1,600km (1,000 miles) west towards the Tibetan border where Père David had found his *Davidia*. Or he could carry on looking – Henry had been sure the forests would yield further examples. Meanwhile, ignoring Veitch's instructions, Wilson went on collecting, finding the beautiful peeling bark maple, *Acer griseum*; two popular clematis, *C. armandii* and *C. montana* var. *rubens*; and the fruiting climber we know today as kiwi fruit (*Actinidia chinensis* or *deliciosa*). Just three weeks later, on 19th May, he stumbled on a *Davidia* in full flower, and on 30th May, as night fell over the peasant's hut where he was lodging, he looked up to see on a precipitous slope above him a score of *Davidias*, glowing white 'as the shades of night close[d] in'. To reach them was no easy task;

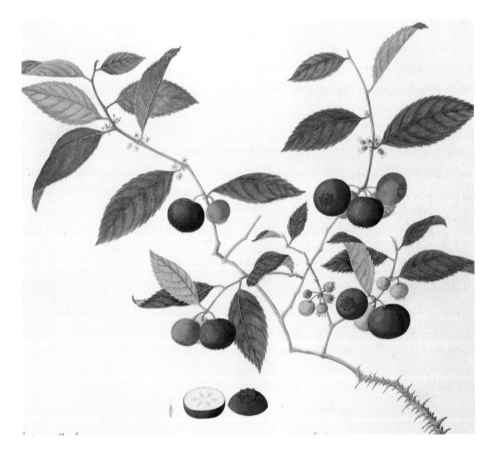

Actinidia sp. by unknown artist, from the William Kerr
Collection of Chinese plants, Kew, *c.*1803–6.

112

nor was climbing a neighbouring tree in order to photograph the tree's beautiful snow-white bracts. 'The wood...is brittle, and the knowledge of this does not add to one's peace of mind when sitting astride a branch about 4 inches thick with a sheer drop of a couple of hundred feet beneath. However, all went well, and we drank in the beauties of this extraordinary tree.' The bracts, he noted, came in pairs, one almost twice the length of the other, hanging down either side of the small red ball of the flower-head, 'and when stirred by the slightest breeze they resemble huge Butterflies hovering amongst the trees.' These flimsy, fluttering bracts were so plentiful that a tree in bloom appeared to be covered in snow. 'To my mind,' he concluded, '*Davidia involucrata* is at once the most interesting and beautiful of all trees of the north-temperate flora.'

When Wilson returned to London in April 1902 bearing seed of the 'handkerchief tree' (also known as the 'dove tree' or 'ghost tree'), Veitch was so delighted he presented him with a gold watch. However, he also had bad news: in an arboretum in Paris there was growing another *Davidia*, a single tree raised from 37 seeds collected by another French missionary, Père Paul Guillaume Farges, in 1897. And to add to Wilson's disappointment, the seeds he had sent to Veitch the previous year showed no signs of germinating. Veitch's champion propagator, George Harrow, had tried everything: some seeds soaked in hot water, some in cold, some abraded, a selection grown at different temperatures in hot-houses, all to no avail. Eventually, it was outdoor seedlings left to brave the winter frosts that came up trumps. (*Davidia* seeds can take up to 18 months, with alternating periods of heat and cold, before they deign to sprout; and even then, only a small percentage of fruits grow.) Harrow and Wilson potted up no fewer than 13,000 plantlets, the first of which flowered in May 1911.

Wilson married in June 1902, but by January 1903 was back on his way to China, this time in search of the yellow poppywort, *Meconopsis integrifolia*, and having succeeded in finding alpine meadows in Tibet ablaze with the golden flower, he went on to collect its even lovelier red cousin, *M. punicea*. The success of this arduous 20,900-km (13,000-mile) expedition, and particularly the negotiation of the treacherous journey up through the Yangtze gorges in which one man drowned, Wilson attributed entirely to the steadfastness and resourcefulness of his Chinese team: 'When we finally parted it was with genuine regret on both sides. Faithful,

intelligent, reliable, cheerful under adverse circumstances, and always willing to give their best, no men could have rendered better service.'

March 1905 saw Wilson back in London with seeds of 510 species, including *Primula pulverulenta*, *Viburnum davidii* and blood-red *Rosa moyesii* (along with over 2,400 herbarium specimens). He had done so well, he had done himself out of a job. Veitch's nursery was now awash with exotic Chinese specimens, and Harry Veitch decided to dispense with Wilson's services. Happily, Charles Sprague Sargent was waiting in the wings, and Wilson's last two forays to China (in 1907–9 and 1910–11) were made in the service of the Arnold Arboretum, no longer with a commercial object in view, but collecting purely for scientific knowledge.

However, Wilson still had an eye for a blockbuster garden plant. And this is what drew him to the remote Min Valley in Sichuan in search of a lily he had first encountered in 1903. Here, in this harsh and windswept landscape, the gorgeous, golden-throated *Lilium regale* thrived in 'hundreds, in thousands, aye in tens of thousands', perfuming the evening air, and he was determined that 'it should grace the gardens of the Western World'. He collected bulbs in 1908, but nearly all of them rotted before reaching America. He went back to re-stock in 1910 – and it nearly cost him his life. For in returning along a precipitous mule-track from a day's collecting, he was caught in a landslide, leaped from the sedan chair in which he was being carried seconds before it hurtled down to the river below, narrowly missed being decapitated by a rock and broke his leg in two places. A splint was hastily improvised from his camera tripod (Wilson was a skilled photographer, and always hired a porter just to carry his enormous Sanderson plate camera) but by the time he reached a hospital three days later, infection had set in. In the event, the leg was saved, but forever after he walked with a 'lily limp'.

After this, Wilson's missions were more sedate, and his subsequent trips to Japan, Korea and Taiwan were accompanied by his wife and daughter. He was hugely impressed by the standards of horticulture in Japan, and bowled over when he visited an azalea garden in Kurume, filled with magnificent cultivars over a century old. This was the source of 'Wilson's 50', a collection that comprised not 50 but 51 evergreen azaleas, which rapidly became a colourful staple in gardens of the southern states.

In 1919, Wilson was appointed Assistant Director of the Arnold Arboretum, but he continued to travel, including a whistlestop tour of South East Asia, Australia

and waded up west for nearly a mile, taking the utmost care when I got out to leave no track…This journey occupied the whole of the second night.'

On the third night Forrest tried another point on the ridge, but was again foiled by sentries. His only consolation was finding on the ground a handful of ears of wheat. 'These, eked out from day to day, was all the food I had for eight days.' Night after night he tried to escape; day after day he lay in hiding, at times no more than 45m (50 yards) from his pursuers. By the eighth day, now so weak he could hardly stand, he knew he must ask for help. 'In any case it was death if I did not do this, either by starvation or at the hands of the lamas.'

As he tottered into a tiny village, Forrest 'presented a most hideous spectacle, clothes hanging in rags, and covered in mud, almost minus breeches, face and hands scarred and scratched with fighting my way through scrub in the dark, feet ditto, and swollen almost beyond the semblance of feet, shaggy black beard and moustache, and, I have no doubt, a most terrified, hungry and hunted expression on my countenance.' He was in luck: the villagers were of the Lisu tribe, a different ethnic group from the Tibetans, and agreed to help him. The only escape was through dense bamboo and rhododendron forest, and then over high, snowy passes, which tore his bare feet 'to pieces and shreds'. 'Bitterly cold it was, sleeping out at such an elevation without covering of any sort. One night it rained so heavily that we had no fire, and had to content ourselves with only a very small quantity of rain water caught in a piece of pine bark.' To add to his woes, he was hobbling through a floral paradise, with acres of primulas and rhododendrons, 'surpassingly lovely' poppies and numberless magnificent flowers, none of which he was able to collect. Yet his sufferings were as nought compared to his erstwhile colleagues. Only one of his 17 helpers survived, while the priests were hideously tortured for days before suffering protracted and agonizing deaths. Forrest limped into Talifu (Dali) to find he had been declared dead: his family had gone into mourning before a telegram arrived in Scotland announcing he was safe and well.

That was perhaps an overstatement. He was still suffering from the after-effects of his starvation when he travelled to Tengyueh (Tengchong) to go collecting in the Salween district with his friend George Litton from the British Consulate. He had lost everything at Tsekou, and needed to start all over again. Forrest and Litton spent two months in the mosquito-ridden jungle. Litton died of malaria. Forrest fell ill, once again survived, and returned to Britain in 1906, richly laden.

Despite the terrors of this first trip, Forrest went back to China six more times. When he and Bulley later failed to agree terms, he worked for a series of syndicates, whose members included J. C. Williams of Caerhays in Cornwall, and Lionel Rothschild at Exbury, also in the south of England. Both were passionate collectors of woody plants, especially rhododendrons, and Forrest did not disappoint. A seedling of the beautiful *Magnolia campbellii* subsp. *mollicomata*, first glimpsed through deep snowdrifts, became Williams's famous cultivar 'Lanarth'. His *Camellia saluenensis* was crossed at Caerhays with *C. japonica* to create the free-flowering tribe of *Camellia* x *williamsii*. Bold scarlet *Rhododendron griersonianum* also proved outstanding breeding stock, becoming the parent of over 150 hybrids. It was not in fact Forrest but his collecting team, sent on ahead with a mule-load of seed, who found the majestic *R. sinogrande*, bearing leaves up to 1m (3ft) long with suede-soft undersides, which brought Forrest such acclaim. Together they collected 5,375 rhododendrons, of which over 300 were new species. Indeed, Forrest's last four trips were made at the behest of the Rhododendron Society, who were astonished to learn that rhododendrons, always considered an acid-loving plant, grew freely on limestone, 'many growing from the bare rock'.

But for all his success with trees and shrubs, Forrest never lost his delight in the exquisite jewel-like plants of alpine meadows. He brought back many desirable primulas, including the lovely *Primula littoniana*, named for his friend Litton but now known as *P. vialii*. For Bulley were named the candelabra primulas *P. bulleyana* and *P. beesiana* (Bees was the name of the seed company Bulley founded to fund his collecting habit). And from the summit of the Mi Chang pass he brought back *Gentiana sino-ornata*, the most spectacular of gentians (and also, conveniently, one of the easier ones to grow) with lapis-blue trumpet flowers up to 3cm (2in) long.

He found it on his second trip (1910–11), growing on boggy ground at a height of 4,270–4,570m (14-15,000ft),

del. J.N.Fitch lith.

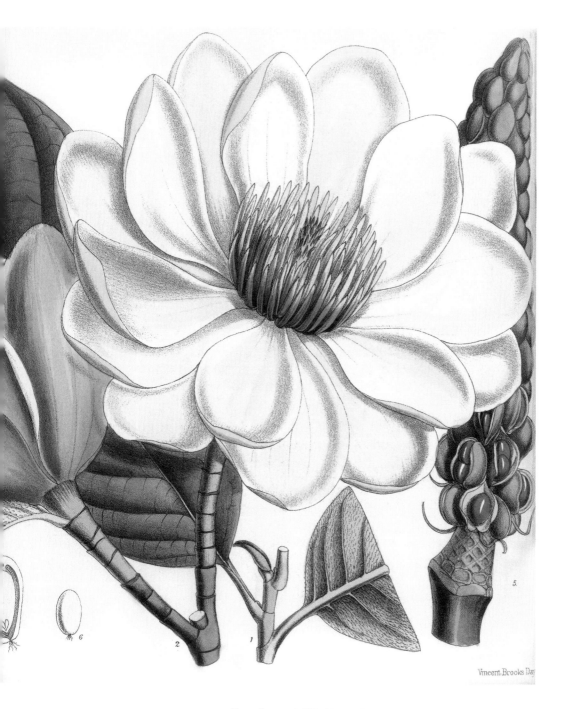

Magnolia campbellii by Matilda Smith,
from *Curtis's Botanical Magazine*, 1885.

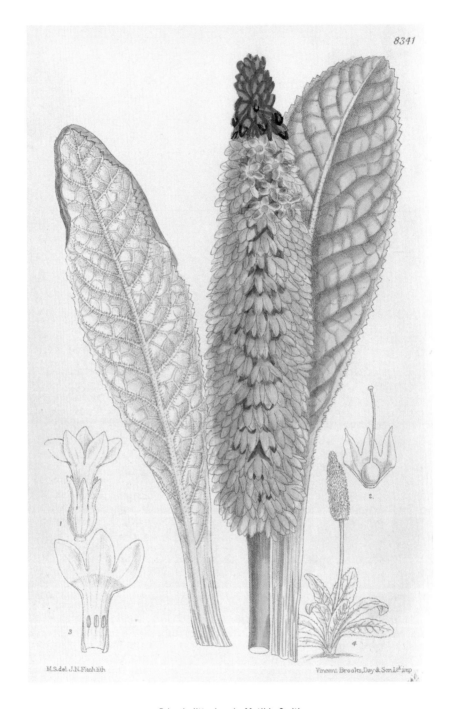

Primula littoniana by Matilda Smith,
from *Curtis's Botanical Magazine*, 1910.

making a mat of bright green foliage, the bold, striped blooms unmissable. The pigments that give gentians (and other plants) their vivid colour are the selfsame antioxidant anthocyanins that make purple fruit and veg so healthy. Gentians have long been used medicinally, especially for digestive disorders, and are still used to flavour bitter aperitifs such as Italian *Aperol* and French *Suze*. The genus name derives from the 2nd century BCE King Gentius of Illyria, who, according to the Roman naturalist Pliny, infused the leaves and roots of the plant to make a remedy for the plague.

In 1930 Forrest set out on what he vowed would be his final expedition, with the aim of collecting all the plants he had missed, in 'a rather glorious and satisfactory finish to all my past years of labour'. His plan was to retire to Edinburgh and write his memoirs, leaving further collecting in the capable hands of his chief collector Zhao Chengzhang. They had worked together since early 1906, when Forrest employed a team of local Naxi people to help him. The team included women, whose resilience and resourcefulness impressed him greatly, and they proved adept both at finding live specimens and at pressing and drying them in absorbent bamboo paper. Others prepared and packed vast quantities of seed. For the next quarter of a century Zhao marshalled a tight-knit team of well-trained plant hunters – mostly family and friends from his home village of Xuecongcun, organizing them into teams of four or five fanning out from various bases, while he and a hand-picked few took on the most challenging searches. By the 1920s he understood exactly what Forrest required, and carried on collecting between expeditions.

Forrest never wrote that memoir: in January 1932, while out shooting in the hills near Tenchong, he dropped dead from a massive heart attack. His legacy was prodigious – over 31,000 specimens (birds, mammals and insects as well as plants), more than 1,200 plant species new to science and more than 30 taxa bearing his name. There is no doubt that Forrest loved and respected the people of Yunnan. (He would prove as much by paying, out of his own pocket, for the inoculation of thousands of local people against smallpox, still a killer disease at that time.) And yet not one of 'Forrest's' plants commemorates Zhao Chengzhang, or any other of his helpers. This omission was made good in June 2020, when in a revision of the genus *Berberis*, a new species was named *Berberis zhaoi*.

Himalayan blue poppy

Scientific name
Meconopsis baileyi

Botanist
Frank Kingdon Ward

Location
Tibet

Date
1924

WHAT MAKES a man who is terrified of heights, almost as scared of snakes and truly detests the cold decide to become a plant hunter in the Sino-Himalaya, and spend five relentless decades getting lost in the jungle and enduring multiple privations in the lands of eternal snow?

In the case of Frank Kingdon Ward (1885–1958), it was simple necessity: plant hunting was the most practical way to fund his insatiable appetite for exploration.

To some extent, botany was in the blood: his father held the chair of Botany at Cambridge University and, enthralled by the pictures in his father's botanical texts, he had dreamt since childhood of exploring tropical forests. The first step, aged 22, was to get himself a job as a schoolmaster in Shanghai, then, when this proved rather less exotic than anticipated, to wangle a place on a zoological expedition to western China. Here he made a small collection of herbarium specimens, but more important, it was a good apprenticeship for the rackety life of a field naturalist. So when, in January 1911, a job offer came out of the blue, he accepted it 'with alacrity'.

The offer came from the plantaholic cotton magnate Arthur Bulley, who had previously employed George Forrest as a plant collector. Forrest having defected to a more generous sponsor, Bulley was looking for another man: Kingdon Ward might lack experience but at least he was already in China. 'Bulley's letter decided my life,' wrote Kingdon Ward, 'for the next 45 years.'

In those 45 years he would make no fewer than 22 expeditions, criss-crossing the borderlands of Tibet, China, Burma (Myanmar) and India, a fissured land of

Meconopsis baileyi by Lilian Snelling,
from *Curtis's Botanical Magazine*, 1927.

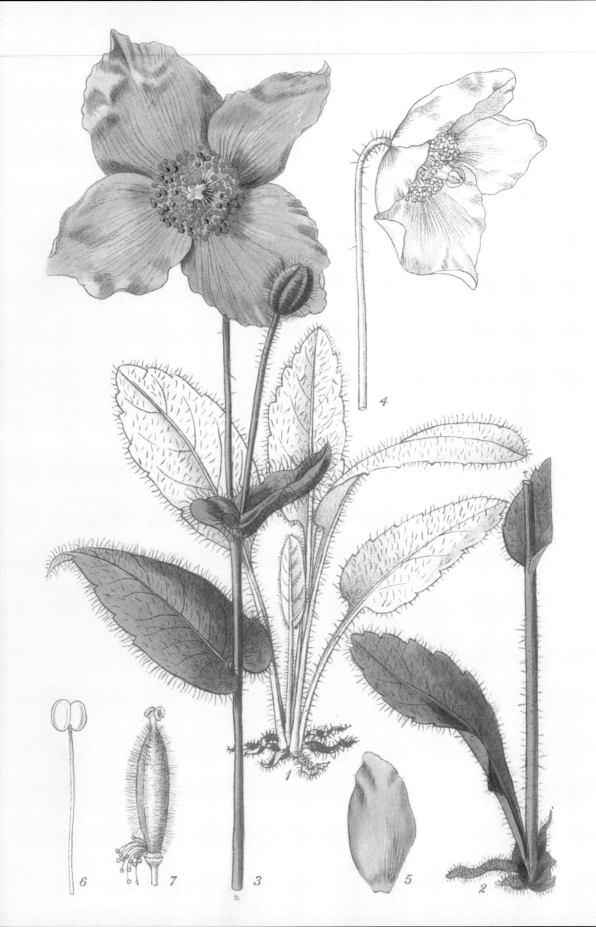

unimaginably high peaks and deep river valleys, where the flora can cover 'the whole gamut, from the tropics to the Arctic' in little over a day's march. In all he collected over 23,000 plants and described 119 new species, including 62 rhododendrons, 11 *Meconopsis* and 37 primulas, but his priority was always to find living plant material that would thrive in the new woodland gardens being created by his wealthy sponsors. Kingdon Ward endured many dangers: in spite of having a memory for place so uncannily exact that he could return to a noted plant many months later in order to collect its seed, even pinpointing it under a fall of snow, he would regularly manage to get lost for days at a time. He fell over precipices on at least two occasions (surviving one fall only because he was speared through the armpit by a bamboo spike), suffered repeated bouts of malaria and was subjected to attack from angry yak herders, Tibetan mastiffs, his drunken cook (whom he subdued by bending back his thumbs, 'ju-jitsu fashion'), even a falling tree. Nothing, though, could equal the terrors of the 1950 Assam earthquake. Caught near the epicentre on the Assam–Tibet border, he lay on the heaving ground, clutching hands with his young wife Jean and their two sherpas, certain they were all about to be pitched into the boiling interior of the earth. In the morning, a thick cloud blotted out the sun. They picked their way through the mudslides and the gloom to collect that most elegant of garden trees, *Cornus kousa* var. *chinensis.*

These adventures were related in 25 books and innumerable articles, accounts that vividly describe the ravishing landscapes through which Kingdon Ward travelled and the lives of the people he met along the way. While never less than scientifically sound, he is sometimes lyrical and often very funny; no other plant hunter has quite Kingdon Ward's pithy turn of phrase. In 1926 he had a best-seller: *Riddle of the Tsangpo Gorges* tells the tale of his 11-month expedition along an uncharted river hurtling through the world's deepest gorge in Tibet.

'Of the botany of this region, at the extreme eastern end of the Himalaya, practically nothing was known,' he wrote. But if he was honest, botany was not his real goal. What he really sought was a fabled waterfall that appears in Tibetan legend as the thundering gateway to Pemakö, the 'hidden land like the thousand petalled lotus' that was the sacred promised land of the Tibetan people. The course of Tibet's holy river, the Yarlung Tsangpo, had long been a mystery. Rising near the sacred slopes of Mount Kailash, it flowed eastwards across the bleak Tibetan plateau for 2,090km (1,300 miles) before plunging abruptly, from an elevation of over 2,740m (9,000ft),

There was no way on from here; no path could be made along those sheer walls of rock. Kingdon Ward turned back, concluding he had been in search of a chimera. But he had reduced the unexplored section of the gorges to a mere 10 miles, and in horticultural terms, the journey was a triumph. Despite the harshness of the terrain, 'wherever nature could get and keep a grip, trees grew', and he returned with masses of rhododendrons, berberis, iris, globeflowers and numerous primulas, including the stately Tibetan cowslip, *Primula florindae*, which he named after his first wife, Florinda. Another was named after his travelling companion, Lord 'Jack' Cawdor, a young Scottish nobleman who had partly funded the venture. Cawdor did not enjoy the trip, finding the food disagreeable (though he had taken the precaution of bringing along hampers from Fortnum & Mason) and the older man's pace frustratingly slow. 'It drives me clean daft to walk behind him,' he grumbled. 'If I ever travel again I'll make damn sure it's not with a botanist. They are always stopping to gape at weeds.'

But even Cawdor was impressed when they found within a 'spiteful, spiny thicket' a colony of sumptuous blue poppies, which Bailey had found in his exploration of 1913, and of which he had pressed just a single flower in his pocket book. While it was not the first blue poppy Kingdon Ward had found, he was certain it would be the best. For not only was it beautiful ('among a paradise of primulas the flowers flutter out from amongst the sea-green leaves like blue and gold butterflies'), but also he held out high hopes of it 'being hardy, and of easy cultivation in Britain. Being a woodland plant it will suffer less from the tricks of our uncertain climate; coming from a moderate elevation, it is accustomed to that featureless average of weather which we know so well how to provide for it; and being perennial, it will not exasperate gardeners.' In fact, it proved rather tricky to grow, though it thrives in cool gardens in Scotland and parts of East Coast America. It was brought into cultivation as *Meconopsis baileyi*, then in 1934 was deemed to be the same plant as that discovered in Yunnan by 1886 by the French missionary Père Delavay and therefore assumed the earlier name of *M. betonicifolia*. In 2009 it was proposed that these were in fact two different species, so Kingdon Ward's blue poppy once again celebrates F. M. Bailey, whose adventurous life as a soldier, explorer and secret agent made his own look tame in comparison.

In 1919 Kingdon Ward spent a few days in the company of Euan Cox, a young Scottish plant hunter then travelling with a famous collector of alpine plants,

Reginald Farrer. Cox's son Peter also became a plant hunter, as did his grandson Kenneth, who travelled to the Himalayas using Kingdon Ward's books as a guide, often following quite literally in his footsteps. Many species, he knew, had been mentioned in the books which Kingdon Ward, aware of his sponsors' priorities, had not troubled to collect, while others had failed in cultivation. Cox was sure there were still rich pickings to be had. Inevitably he was drawn to the Tsangpo gorges, where the mystery of the waterfall still remained to be solved...

It was here in 1996 that Kenneth fell in with a pair of American explorers, Ken Storm Jnr and Ian Baker. They were convinced that the waterfall existed, and they too were travelling through the gorges with a battered copy of Kingdon Ward's book as their guide, retracing his perilous journey to the Rainbow Falls. As luck would have it, their guide proved to be the grandson of the hunter who had guided Kingdon Ward, brought up on memories of the mad plant-hunting Englishman: as they reused his campsites and re-photographed his views, it often felt that he had passed that way only moments before. Returning in 1998, another hunter, Jyang, showed them a new route to the falls, which led to a new and higher vantage point. At their feet were the Rainbow Falls, half hidden in clouds of mist. And just beyond, the river darted to the left and exploded over another great drop. The fabled falls had been there all along, just a quarter of a mile away, hidden from view by a bend in the river. When Storm surveyed the falls, he found the first fall to be 21m (70ft) high – twice Kingdon Ward's estimate, while the new waterfall rose to over 30m (100ft) – the highest yet recorded on a major Himalayan river.

The first to hear the news was Kingdon Ward's widow. He had married Jean Macklin in 1947 when he was 62 and she was 26, and from that day forth she accompanied him on all his expeditions until his death in 1958, becoming an accomplished plant hunter in her own right. She was glad, she said, that 'Frank left something for you to find.'

The falls may not be there much longer. When a party of kayakers navigated the upper gorge in 2004, they learned that local villagers were about to be evicted to make way for a dam. It went into service in 2015, the first of 11 planned along the river. The Great Bend has been proposed for the site of the biggest hydropower project in human history – about three times the size of the Yangtze's environmentally catastrophic Three Gorges Dam.

Lilium mackliniae was named in honour of Kingdon Ward's second wife and fearless travelling companion, Jean Macklin. Painting by Stella Ross-Craig from *Curtis's Botanical Magazine*, 1950.

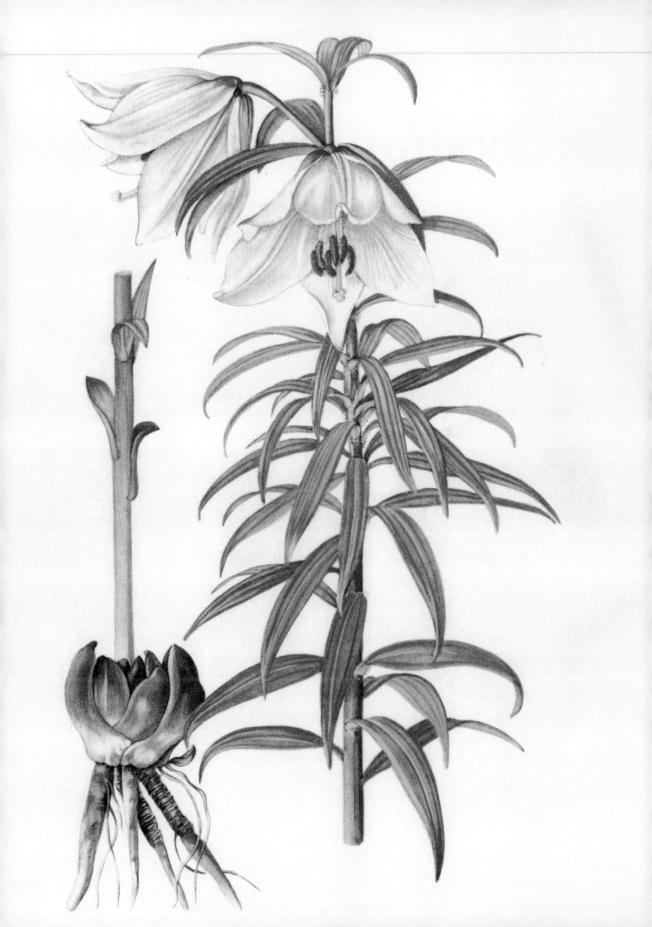

Tibetan tree peony

Scientific name
Paeonia ludlowii

Botanists
**Frank Ludlow and
George Sherriff**

Location
Tibet

Date
1936

Large tracts of the Himalaya still remain unmapped and unexplored; still larger areas offer virgin ground to the field naturalist…We felt pioneers and were thrilled at the thought. It was good to be living in an age when new lands and flowers and birds still awaited discovery.

SO WROTE Frank Ludlow in the *Himalayan Journal* in 1940. He had met George Sherriff in Kashgar in 1929, and the two had hit it off straight away, sharing a passion for natural history, Sherriff leaning more towards the flowers while Ludlow was especially keen on birds. Ludlow (1885–1972) had spent years in the Indian Education Service before moving to Tibet in 1923 to head a new elite English-style school. After three years of unremitting frustration he resigned and retired to Kashmir, but, crucially, he retained influential friends in Tibet, and so was able to obtain permissions to explore not granted to any other foreigner. Sherriff (1898–1967), a former soldier who had served as British Consul in Kashgar, was similarly well-connected, numbering among his friends the ruler of Bhutan. It was to Bhutan that they made their first expedition together in 1933. Having successfully collected over 500 plants, they formulated a plan to explore the little-known Himalayan region east of Sikkim, working systematically eastwards to the great bend of Tsangpo river, where a handful of previous explorers had suggested there would be unimaginable botanical riches to be found.

This they did over the next 15 years, joined on occasion by British botanists and by Sherriff's dauntless wife, Betty, and supported by a substantial local team of diverse ethnic origin – Bhutanese, Sikkimese and Kashmiri, led by Lepcha collector Tsongpen. The supremely organized Sherriff ensured that they were

Paeonia ludlowii by Lilian Snelling,
from *Curtis's Botanical Magazine*, 1927.

While assiduously amassing botanical specimens, they took the greatest pleasure in gathering seeds, for 'few save the expert,' wrote Ludlow, 'ever spend much time in herbaria' whereas 'the living plant, that grows in our gardens and parks, is a joy to all who behold it.' Among them was the magnificent yellow-flowered Tibetan tree peony. Originally thought to be a large-flowered variant of *Paeonia lutea*, *P. ludlowii* was recognized as a separate species in 1997. It grows in dense thickets on parched rocky slopes in south-east Tibet at 2,750–3,350m (9–11,000ft). While its glossy flowers and handsome divided foliage have made it a popular garden plant, it is now considered endangered in the wild.

Ludlow and Sherriff introduced at least 66 species of *Primula*, along with 23 *Meconopsis* and over 100 rhododendrons. Gardeners can also thank them for the beautiful silky-barked Tibetan cherry, *Prunus serrula*, and orange-tipped *Euphorbia griffithii*. But perhaps their most important work was as ethnographers. Sherriff was not only an excellent photographer, who enthusiastically embraced the new technology of colour film; he was also one of the earliest documentary film-makers. These films, preserved by the British Film Institute, not only reveal the rigours of their journeys, with knife-edge paths and terrifying river crossings, but record the everyday village life of an all-but-vanished Tibet. Women hang yak wool up to dry. Giggling children spin cotton on whirring wheels. There are religious rituals and village festivals, with dancers clad in elaborate traditional dress. Many botanists chronicled their travels, but none left so poignant a record as George Sherriff.

Rice-paper plant

Scientific name
Tetrapanax papyrifer 'Rex'

Botanists
Bleddyn and Sue Wynn-Jones

Location
Taiwan

Date
1993

IT WAS Mad Cow Disease that turned Welsh farmers Bleddyn and Sue Wynn-Jones into plant hunters. They had always been great travellers and now, freed from their beef herd, they joyfully donned their rucksacks and set off for Jordan. In the searing red desert of Wadi Rum they discovered an attractive slender-leaved Daphne growing on a rock. It was not, to be honest, a plant very likely to thrive on a wet Welsh hillside. But it embodied an idea – of a nursery like no other, that would offer entirely unfamiliar plants gathered from far and wide across the globe.

'We'd got the first qualification to be plant hunters,' says Bleddyn, 'we knew how to travel hard.' They set about acquiring the next – studying the floras of the places they wanted to go, poring over herbarium sheets at Kew and learning how to collect, clean and dry berries and seeds at Bangor Botanic Gardens. What they also learned was just how many familiar genera were under-represented in cultivation. In Taiwan, for example, the country they had selected for their next journey, there were at least 13 promising species in the hydrangea family, of which very few were known to the horticultural trade. E. H. Wilson (see page 108) had botanized there late in his career, but otherwise the highlands of Taiwan remained little known to outsiders: Bleddyn was sure he would find montane forest plants that would succeed in cooler conditions. Made welcome by the National Parks service of Taiwan, the Wynn-Joneses were astounded at the diversity they found there, most dramatically in the breathtaking Taroko Gorge.

Since that first journey in 1991, they have returned to Taiwan six more times, their second journey yielding the spectacular *Tetrapanax papyrifer* 'Rex'. A large evergreen shrub or small tree, it was immediately seized on by garden designers

Tetrapanax papyrifer, from W. J. Hooker,
*Hooker's Journal of Botany and
Kew Garden Miscellany*, 1849–57.

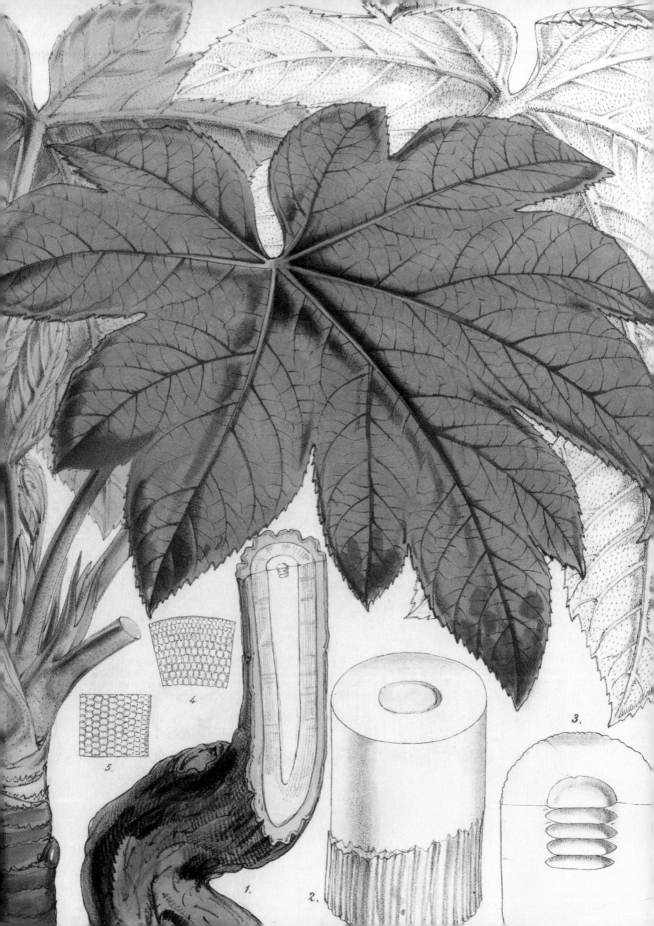

1. 2. 3.

4.

5.

all over Europe (despite its naughty suckering habit) as the ultimate in urban chic, having upright stems topped by vast, deeply lobed leaves up to a metre across. Later expeditions revealed forms of *Tetrapanax* that Bleddyn considers to be superior, not only taller-growing but much more hardy, having been collected from higher altitudes. Crûg Farm Plants now enjoys an international reputation among gardeners for introducing plants such as scheffleras from Taiwan, *Oreopanax* from South America and aspidistras from Vietnam that all look wildly exotic but will tolerate cool temperate climates. Some earlier finds, such as the gorgeously scented, waxy-flowered climbers *Holboellia latifolia* subsp. *chartacea* and *H. brachyandra* are now widely grown.

The pair have now visited nearly 40 countries, including Laos, Colombia, Guatemala and parts of South Korea and Vietnam that have never been extensively botanized. Every trip extends their knowledge. For example, when the Wynn-Joneses started collecting there were only 20 or so species of *Aspidistra* known to science; now there are nearly 200, several discovered by them. Since 2017 they have been working closely with Russian botanists, chiefly from Moscow's principal botanical gardens, to explore the genus *Ruscus*, familiar to florists as *Ruscus aculeatus*, or butcher's broom. This involved a hair-raising dash through a war-zone in Abkhazia – which is far from the Wynn-Joneses' only brush with danger: they cheerfully tell of being held up by bandits in Guatemala, threatened by Maoists in Nepal and hiding from gun-toting thugs guarding opium fields in Thailand.

Cluster of plants used for making pith paper, considered to be *Tetrapanax papyrifer*, from L. van Houtte, *Flore des Serres et des Jardins de l'Europe*, 1845-80.

They laugh off such hazards – but the one danger that really frightens them is climate change, the effects of which, in their view, pose an even greater threat to the plant kingdom than human pressures. The losses they have witnessed over 30 years have been profoundly shocking, particularly as a result of extreme weather events which they believe have become both more frequent and more savage.

'It's a race to get to plants and describe them before they vanish forever, destroyed by fires or floods, mudslides, earthquakes or typhoons. We've seen a metre of rain fall in a single night. We've seen forests where we have botanized destroyed by boulders the size of houses crashing through them.'

If the Wynn-Joneses can collect seed and propagate plants to survive elsewhere, that's all to the good. Very often they can't. Nine times out of ten, the plants are too difficult to propagate to be commercially viable: in truth, Crûg Farm Plants has always been more a living library than a money-making business venture. They work closely with scientific institutions and botanic gardens in the countries they collect in, sharing knowledge, specimens and seed. (Their policy is always to distribute their finds first to expert institutions, to ensure the plants' best hope for the future.) And to share the cost of their trips (they are entirely self-funded) they sometimes collaborate with other nurserymen: the legendary American plantsman Dan Hinkley has been a long-time collecting companion. A shared endeavour is not only more convivial but helps to shorten the odds on successfully introducing the plants.

'In seeking to bring new plants into cultivation,' explains Bleddyn, 'our aim is to conserve as much diversity as we can in the plants we are able to grow. The more threatened these plants become in the wild, the more urgent it is to find them safe space in gardens. It's not something we can afford to leave to scientists and botanic gardens – everyone has a part to play.'

Epimedium ogisui

Scientific name
Epimedium ogisui

Botanist
Mikinori Ogisu

Location
Sichuan Province, China

Date
1993

THE JAPANESE botanist Mikinori Ogisu (*b.*1951) is revered in his homeland as a Living National Treasure. Although no such honorific exists in the United Kingdom, much the same can be said of the much-loved octogenarian plantsman Roy Lancaster (*b.*1937), writer, broadcaster, lecturer and plant explorer, whose garden in the south of England boasts among its many wonders a selection of rare and beautiful plants introduced by Ogisu. The pair have been friends for nigh on half a century, and have botanized extensively together in Japan and China. They make an unlikely pair, for while the affable Lancaster is known for his bubbling enthusiasm and readiness to chat to anybody, Ogisu presents an altogether more austere figure, whose rigour and asceticism have earned him the soubriquet of 'The Green Samurai'.

It is a moniker that derives also from Ogisu's deep knowledge of, and admiration for, the flower-loving Samurai of Japan's Edo period (1603–1868). During these centuries of isolation from the wider world, a succession of shoguns encouraged the creation of a sophisticated gardening culture which saw extraordinary developments in plant breeding long before Mendel investigated plant genetics in the West, and fostered an exquisitely refined appreciation of certain plant groups such as camellias, chrysanthemums, maples and iris. Alarmed at the loss of this tradition in modern Japan, Ogisu (who is also a peerless horticulturist) started collecting these plants, and inspired a Japanese philanthropist, Seizo Kashioka, to fund a garden to protect these (horti)cultural treasures. Planted in 1978 with over a thousand varieties of the beautiful Japanese iris, *Iris ensata* var. *spontanea*, the garden expanded over the next decade to preserve other historic plant groups such as hostas, hydrangeas and evergreen azaleas, and a research institute was established on the site. In 1997 Ogisu published the fruits

Epimedium flavum by Christabel King, from
Curtis's Botanical Magazine, 1995, one of numerous
new *Epimedium* species discovered by Ogisu.

of his decades of research, his sumptuous 'Purple Book', (*History and Principles of Traditional Floriculture in Japan*), a study of 33 groups of ornamental plants particularly valued during the Edo period. Sadly, following Mr Kashioka's death, the research institute closed in 2012, leaving Ogisu with thousands of rare plants to find homes for – no easy task when so many of them require very exacting regimes of care. Some went to botanic gardens, the more robust remained in the Japanese Iris Garden, which was donated to the local city, while some 3,000 plants have been distributed among Japan's most expert nurserymen, where Ogisu continues to visit them several times a year, nurturing each plant with such tender care that it might be a favourite grandchild.

Ogisu fell under the spell of these plants when he was just ten years old, and sought out people who could teach him about them. Plants were already a solace to him: his upbringing was strict, calculated to foster in him the Zen virtues of self-discipline and self-reliance, and when he could no longer hold back tears, he would steal into the garden and hide under the comforting branches of a favourite tree. By 15 he had resolved on a career in horticulture, at 18 he began studying plant genetics, and at 20 he set off to study in Europe. (Roy Lancaster first spotted the shy young man taking copious notes during a student visit to the Sir Harold Hillier Garden in England.) This was followed by a postgraduate course at Sichuan University, under the supervision of the eminent Chinese botanist Professor Wen-Pei Fang. At that time it was not customary to award degrees to foreigners, so Ogisu had to make do with the title of 'honorary research scholar'. In the intervening decades, Ogisu's phenomenal contribution to Chinese botany has been recognized with numerous prizes and awards, including being inducted in 2017 into a Hall of Fame for the study of the flora of Sichuan Province – the only non-Chinese to receive this honour.

'It is fair to say,' summarizes Lancaster, 'that his knowledge of Chinese flora is unrivalled. He has travelled more miles in China than anyone else, seen more plants in more far-flung places than any other botanist of his age, and has found countless new species across a wide range of genera. But what is even more impressive is how deeply he cares about the people – not just the Chinese botanists he works with and the academic institutions with which he shares his findings, but the ordinary local people he meets during his explorations.' Scientists should be humble, Ogisu maintains, and not presume to know more about plants than the people who live

Flowers were greatly valued by the Samurai in Edo Japan, and this depiction of
Iris sanguinea comes from *Honzō Zufu*, 1835–44, by Kan-en Iwasaki, a samurai in
service to the Tokugawa shogunate. He recorded animals and insects as well as
plants, and was a respected horticulturist, an expert on plant propagation.

among them. Rather, they should approach with respect, to look, listen and learn.

Ogisu has also made a notable contribution to Western horticultural history, rediscovering the 'lost' wild China rose that was the first parent of generations of European cultivars. *Rosa chinensis* var. *spontanea* had not been seen by a foreign botanist since the 1920s, until Ogisu, urged on by the British rosarian Graham Stuart Thomas, tracked it down in 1983 to a hillside in Sichuan. It was his expertise in the flora of this region (one of the most biologically diverse outside the tropics) that first brought Ogisu to prominence, and particularly his exploration of the botanical hotspot of Emei-Shan (Mount Omei), which numbers over 3,700 plant species, of which he believes 106 to be endemic. This was a favourite hunting ground both of E. H. Wilson and Ogisu's mentor Professor Fang. (To this day Ogisu maintains a list of the mountain's flora begun by the late Professor Fang, adding new species and noting when others disappear.) The mountain is also famous for a curious weather effect – a huge rainbow ring of light that occasionally appears at the mountain's peak. This is known by Buddhist pilgrims as 'Buddha's Halo'; Emei-Shan is one of the four sacred mountains of China, home to 76 temples and strongly associated with the birth of the martial arts. Ogisu has made at least 30 visits to the mountain and introduced a variety of its plants to cultivation, including fiery honeysuckle, *Lonicera calcarata*; the unusually elegant white-flowered *Bergenia emeiensis*; and, representing two of his favourite genera, *Mahonia* x *emeiensis* and *Epimedium* x *omeiense*.

HERB. HORT. KEW.

四川植物 PLANTAE SZECHUANENSES

Epimedium sp.

1992. 2 April

Shuangfu, Luzhan Xian, Sichuan, alt. 900m

采集人: M. Ogisu 号数: 92003

鉴定人: 日期: 年 月 日

四川大学及植物系植物标本室

Herbarium specimen of *Epimedium ogisui*, collected
by M. Ogisu in China in 1992, held at the
Royal Botanic Gardens, Kew.

These last two genera, *Mahonia* and *Epimedium*, have occupied much of Ogisu's attention (though in recent years he has also embraced aspidistras, clematis and *Polygonatum*). He has discovered many new mahonias, of which some 15, including the statuesque *M. ogisui*, are long established in Lancaster's garden. Back in the late 1990s, knowing how many new epimediums Ogisu was finding in China, Lancaster introduced him to the world expert on the genus, William Stearn. Astonished at the unsuspected richness of the genus in China, Stearn immediately began work on a new definitive account, more than doubling the number of known species. No-one, declared the grateful Stearn, had contributed more to the understanding of this plant than Ogisu, and since then, the genus has grown and grown, bolstered both by Ogisu's finds (along with those of Massachusetts nurseryman Darrell Probst) and by an ever-growing flood of garden hybrids. There are now at least 65 named species of this small, shade-loving perennial, characterized by delicate dangling flowers that have been likened variously to spiders and to bishops' hats. Of the 52 Chinese species, 13 are Ogisu's discoveries; he is commemorated in both evergreen *E. ogisui*, with handsomely red-mottled foliage and large pure white flowers, and *E. mikinorii*, with purple and white flowers, while dainty *E. leptorrhizum* 'Mariko' was named by Ogisu after his wife.

Just like Augustine Henry more than a century ago, Ogisu is alarmed by the rate of habitat destruction in Western China. (This has been poignantly documented both by the Chinese botanist Professor Yin Kaipu and by British tree experts Tony Kirkham and the late Mark Flanagan, in two books comparing photographs taken by Ernest Wilson with their modern counterparts.) The man is never still, says Lancaster ruefully, but is 'always off somewhere to check on an epiphytic lily last seen by Kingdon Ward or a nomocharis last seen by Forrest, to find out if they're still there'. Lancaster worries that, like George Forrest, his friend will never get round to writing up all he has seen, all he knows, and the world will be the poorer. For Ogisu, believes Lancaster, is 'up there with the Wilsons and the Forrests – he is truly one of the greats. He has discovered no fewer than 80 new species. He has single-handedly rescued a noble tradition of floriculture. He has been described as "the Japanese Linnaeus", and I firmly believe he is of that stature.'

There is as yet no sign of a memoir, but maybe all is not lost. For amazing new plants are regularly spotted on Ogisu's Instagram feed.

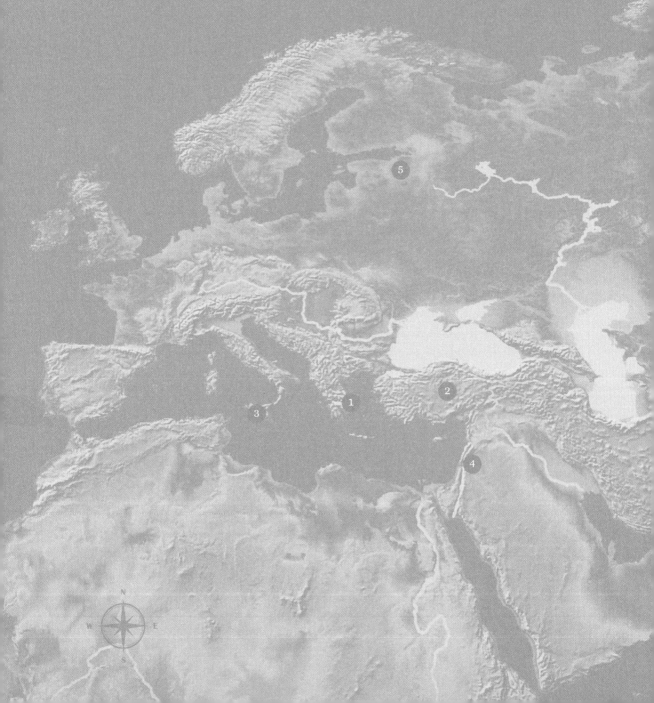

EUROPE AND THE MEDITERRANEAN

FOR CENTURIES, PLANTS were spread across Europe by wars or by trade. The Roman Empire grew to include territory from chilly Britannia and Germania in the north to North Africa in the south, and most of the countries surrounding the Mediterranean Sea. Plants were among the commodities that travelled across this vast empire, and some were preserved, along with scraps of plant knowledge, in Christian monasteries when the Empire fell. From its fragments in western Europe was created the Holy Roman Empire, and towards the end of the 8th century, the Emperor Charlemagne did his bit to promote the spread of plants by drawing up a list of plants that he decreed should be grown throughout his dominions. It obliged various Mediterranean plants to take their chances in northern Europe.

For the best part of a thousand years, the learning of the classical period was largely lost to Europe. Much more, however, was preserved in the Islamic world. Many Greek and Latin texts were translated into Arabic, including Dioscorides' *De Materia medica,* the most important record of the medicinal uses of plants in ancient times, made by a surgeon in the Roman army in the first century CE. This text, rediscovered in the Renaissance, would prompt the first European plant hunters to try to identify the listed plants – an endeavour that was still continuing in the 1780s. But the Umayyad physician Ibn Juljul had got there centuries before, and added to his edition in 983 a supplement of useful plants unknown to Dioscorides. When the Moors ruled southern Spain, they brought their botanical learning and garden traditions with them. And when the Normans conquered Muslim Sicily in the 12th century, it seems likely that plants travelled back to Normandy along with the Islamic habit of creating hunting parks. On the whole, though, the Christians were resistant to learning from their Muslim foes: there is little evidence of Crusaders bringing back plants, save for the red damask rose, *R. gallica* 'Officinalis'.

By the 16th century, Christian Europe had seen the wisdom of pursuing diplomatic relations with the mighty Ottoman Empire (which at its height would reach to the gates of Vienna), and an influx of bulbs from Turkey and the Near East was enthusiastically received in northern Europe.

These made their way to the newly founded botanic gardens that were springing up across Europe, most famously Pisa and Padua in 1545. While these were intended as tools for physicians to learn their trade, they legitimized the study of botany - studying plants as plants, not just as remedies. As more and more of these gardens were founded throughout Europe, they became centres for the collection and exchange of plants and plant knowledge, which was also shared with individual scholars, as shown by the story of the sweet pea.

Saffron crocus

Scientific name
Crocus sativus

Location
Greece

Date
Before 2400 BCE

THE HISTORY of the saffron crocus, *Crocus sativus*, is lost in time: traces of saffron have been found in the prehistoric paints used 50,000 years ago in cave art in modern-day Iraq, and it has been domesticated so long that its wild origins have been forgotten. But two recent (2019) studies make a convincing case that this crocus originates from an area close to Athens in Greece, though it seems to have first been cultivated in Persia (modern Iran). Cultivated *C. sativus* is a descendant of the autumn-flowering *C. cartwrightianus*, selected over millennia to have longer and longer stigmas – the female parts of the plant that are plucked and dried to produce saffron. As each plant produces only three of these filaments, so delicate they can only be picked by hand, saffron remains, as it has always been, the most costly of spices: it is estimated it takes 170,000 flowers to produce a single kilo of saffron.

The saffron crocus is infertile and does not produce seed; it therefore depends on human intervention to perpetuate it. It was already widely cultivated by the Bronze Age: frescoes dating from the Aegean island of Thera (modern Santorini), created before 1500 BCE, depict Minoan women gathering the crocus harvest.

These frescoes suggest that the crocus was not only a valuable commercial crop, used for dyeing, cosmetics and perfumery, but was also of ritual significance to women. The harvest is overseen by a goddess, and assisted by blue monkeys – which regularly appear as divine attendants in Minoan art. (A blue monkey gathering crocuses was repainted as a boy by 19th-century 'restorers' at Knossos in Crete.) The frescoes also show a woman treating a bleeding foot with saffron: the spice was something of a cure-all in the Ancient World, used for everything from stomach upsets to bouts of melancholy, but was most often recommended for easing the pain of childbirth and menstrual cramps.

Crocus sativus by Pierre Joseph Redouté, from P. J. Redouté, *Choix des Plus Belles Fleurs*, 1827–33.

Saffron is threaded through the history and myth of the Ancient World. Sargon, founder of the Akkadian empire in the 24th to 23rd centuries BCE, is said to have been born in Azuparino, a 'City of Saffron' on the banks of the Euphrates. The Persians wove saffron threads into carpets and funeral shrouds. Cleopatra sprinkled it into her baths with erotic intent; Alexander the Great did likewise, but hoping it would heal his wounds. The Greek poet Ovid wrote of the nymph Smilax turning her lover Crocus into a flower. More prosaically, Roman writer Pliny the Elder recommended saffron for renal complaints. Traders carried the precious corms, as well as the spice, across the globe: saffron was growing in Kashmir by the 6th century BCE, from where it spread throughout the Indian subcontinent, and by the 3rd century CE saffron had reached China.

While saffron virtually disappeared from Europe after the fall of the Roman Empire, it reappeared, along with much long-lost human knowledge, after the Moorish conquest of Spain. Demand (and prices) soared during the Black Death pandemic (1347–50), leading to a tussle between merchants and aristocrats to control the market, which escalated into a 'Saffron War' lasting nearly four months. As a result, the Swiss city of Basel elected to grow its own supplies and became a centre for saffron trading. It was soon overtaken by Nuremberg, where the ferocious 'Safranschou code' was established to regulate the purity of this valuable commodity: felons found guilty of adulterating the spice could be put to death by fire.

Saffron continued to grow in popularity throughout medieval Europe. Monks used it as a substitute for gold in illuminating manuscripts; royal cooks prepared feasts of saffron-gilded swan; fashionable ladies dyed their hair with it. For two centuries the crocus was widely grown in France and in eastern parts of England (the Essex town of Cheppinge Walden changed its name to Saffron Walden), and by the 1730s Swiss and German settlers had introduced saffron to America. However, as exciting new flavours such as vanilla, cocoa and coffee became increasingly available during the 18th century, saffron lost its allure.

Today, 90 per cent of the world's saffron is produced in Iran, and enjoyed in dishes from Persian pilafs to Cornish buns. There is also increasing interest in its anti-inflammatory and antioxidant properties, while early trials have vindicated its centuries-long use as an anti-depressant. Claims have also been made for saffron's beneficial effects on cardiovascular disease and cancer, but these have yet to be proven.

Crocus sativus by unknown artist,
from the Royle Collection, Kew, 1828–31.

Tulip

Scientific name
Tulipa

Botanist
Ogier Ghiselin de Busbecq

Location
Turkey

Date
1540s

It would be hard to overestimate the importance of the tulip in human culture. It has marked the pathways of trade and of religious persecution, inspired new genres of art, undermined economies and brought down kings. It has been a symbol of beauty, of martyrdom, of the divine (the same Arabic characters spell out Allah and *lale,* the Turkish word for tulip) and of sophisticated pleasure. A tulip bulb might serve as portable capital, hidden like a gem in the pockets of a refugee fleeing religious persecution. Or a young man wooing his mistress in 17th-century Persia might present her with a flower, thereby giving her to understand 'by the general colour of the flower, that he is on fire with her beauty, and by the black base, that his heart is burned to coal'. No other flower has an entire period of history named after it.

While the tulip is most strongly associated with Turkey, and it is from here that it was disseminated to the rest of the world, it has a wide natural range, with 120 species growing from the rocky shores of southern Europe to the Tien Shan mountains of Central Asia, and also in the Caucasus mountains, between the Black and Caspian seas. Turkey is thought to have 16 indigenous species. Others, such as the familiar lady tulip, *Tulipa clusiana,* are thought to have been brought from Central Asia along ancient trader routes, and rapidly adopted as garden flowers: tulips were cultivated in Constantinople by 1055. It was here that the French naturalist Pierre Belon saw tulips, which he likened to red lilies, growing in the late 1540s, noting that there was scarce a garden without them and observing the Turks' delight in flowers, including the practice of tucking a single choice bloom into their turbans.

This, it appears, is what gave us our name for the tulip. It was Ogier Ghiselin de Busbecq (1522–92), Ambassador from the Holy Roman Emperor to the court

The red tulip, with its coal-black base, denoted a lover's passion. *Tulipa eichleri* by Mary Grierson, Kew Collection, 1973.

impact of these vivid, early-flowering blooms on drab European gardens can only be imagined. Planted in narrow domed flower beds in the formal gardens of the time, these treasures were displayed like jewels in a box.

In 1593, at the age of 67, Clusius was invited to lay out a botanic garden for the new university at Leiden in the Netherlands. He took many of his tulips there with him, but — perhaps because of his reluctance to share his rarest bulbs — they were repeatedly stolen. Tulips were already becoming a marketable commodity. A painting by Flemish court painter Joris Hoefnagel shows a Clusiana tulip alongside an exotic seashell — both perceived as objects of desire as early as 1561–2. Tulips began to feature in European florilegia — a new kind of plant book that appeared in the early 17th century, celebrating the beauty of each flower rather than describing its usefulness.

For collectors, the charm of the tulip was its unprecedentedly wide colour range: tulips could be uniformly yellow, red, white or purple, or sometimes a mixture of these hues. Clusius had already noted the tulip's capacity to 'break', when a previously plain flower would emerge gloriously patterned with streaks and flames of a second colour. He had observed that this seemed to weaken the plant, stunting the growth and distorting the leaves, so that this ravishing display was invariably offered to the grower as a 'last farewell'. It would not be understood until the 1920s that this patterning was caused by a virus, carried by aphids, which affects the distribution of pigments in the flower, suppressing the top layer of colour to allow the underlying colour (always white or yellow) to show through. Growers spent many fruitless years trying to replicate this effect, even mixing paints into the soil.

Tulips probably reached Britain with Huguenots fleeing persecution in Flanders and France, and by the time the English barber-surgeon John Gerard wrote his celebrated (if shamelessly plagiarized and often wildly inaccurate) herbal in 1597, he could describe 14 categories of tulips; to try to detail all the individual varieties, he protested, would be 'to number the sandes'. Dutch Protestants settling in New Amsterdam — now New York — carried tulips across the Atlantic: others travelled in the opposite direction to new Dutch colonies in South Africa.

By this time, tulip growing was well established in Flanders and France, and was gaining ground in the increasingly prosperous Dutch Republic, where, by the

1620s, flowers that displayed desirable patterns of streaks and flames were already fetching high prices. The most famous of these was the rare red-and-white striped 'Semper Augustus' (only 12 bulbs were known to exist), which by 1623 could already command 1,000 florins. (The average annual income was 150f.) As the country was seized by 'tulipomania', the value rose to 10,000 florins – the price of a house on one of Amsterdam's swankier canals. By 1636, it was reckoned (albeit by a scandalized pamphleteer horrified that such sums should be spent on anything so frivolous as a flower) that the 2,500 florins paid for a single 'Viceroy' bulb could have bought 27 tons of wheat, 50 tons of rye, 4 fat oxen, 8 fat pigs, 12 fat sheep, 2 hogsheads of wine, 4 barrels of beer, 2 of butter, 3 tons of cheese, a bed with linen, a suit of clothes and, last but not least, a silver beaker. As prices soared, a painting of a covetable tulip became an increasingly popular substitute for the real thing, giving rise to a whole new genre of art.

The craze for tulips that gripped the Netherlands between 1634 and 1637, creating the first futures market as bulbs were sold before they were lifted, has been compared to the speculation in financial derivatives that precipitated the 2008 financial crash. Seeing fortunes being paid for the rarest bulbs, more and more growers entered the market until, in February 1637, the market abruptly collapsed. Yet tulipomania appears to have been rather less disastrous than most histories recount. Some individuals did indeed lose money, but the Dutch economy, it now appears, was never seriously threatened. The rarest tulips even held their price, and the tulip continued to be the flower of choice throughout the 17th century in Europe, not losing its cachet until the English landscape style displaced the fashion for formal, flowery gardens. Even then, the tulip continued to be treasured by specialist growers known as 'florists', who competed to grow the most perfect, intricately patterned blooms.

As the tulip's fortunes waned in the West, they rose in Ottoman Turkey, particularly during the reign of Sultan Ahmed III (r.1703–30), which came to be known as the Tulip Era. In truth, Turkey had never fallen out of love with the tulip. After the conquest of Constantinople in 1453, Turkey enjoyed a great flowering of garden culture: the first Ottoman Sultan, Mehmed II (1432–81) had no fewer than 12 gardens, packed with tulips, and a staff of 920 gardeners. Süleyman the Magnificent (1494–1566) who expanded the Ottoman Empire from Morocco and

Tulipa by Joseph Constantine Stadler, after a painting by Peter Henderson, from R. J. Thornton, *The Temple of Flora*, 1799–1804.

boggling: 100 bunches in 10 different shades, or 48 bunches in 36 varieties. Sweet peas became one of the defining flowers of the Edwardian era – clambering through fashionable 'scented gardens', carried in posies and decorating dining tables, causing plantsman E. A. Bowles to complain that they ruined the taste of fish. In 1911, English newspaper *The Daily Mail* offered a prize of £1,000 for the best bunch of sweet peas, and attracted 35,000 entries.

By this time the colours were legion, but no-one, despite prodigious efforts, had yet managed to produce a yellow sweet pea. This remained an elusive hope until Dr Nigel Maxted, botanizing in Anatolia in Turkey in 1987, came upon just that – a spectacular new species of *Lathyrus*, with a tawny veined standard and bright yellow wings, which he named *Lathyrus belinensis*.

L. belinensis is very closely related to *L. odoratus*, and Maxted managed to get funding for three years to set up a breeding programme. But at the end of those three years, no stable yellow had been produced, so Maxted passed on seed for various nurserymen to try. None has yet been successful.

Seed of *L. belinensis* itself is now sold commercially – but Maxted is very worried about the wild population. When he returned to the discovery site in 2010, he found that most of the hillside had been levelled to build a massive new police station. Only about 20 per cent of the original 8,000 plants remained, and when he attempted to photograph them he was arrested. On a third trip in 2018, he could find only 50 plants. In 2019 *L. belinensis* was classified on the IUCN Red List as critically endangered, but there is no plan in place to protect it, and by now Maxted fears it may well be extinct in the wild.

Cedar of Lebanon

Scientific name
Cedrus libani

Location
Lebanon and Syria

Date
1636

On Mount Makmel in northern Lebanon is a grove of ancient cedars, maybe 1,200 trees in all, known as the Cedars of God. It is a sad remnant of the great cedar forest, thousands of kilometres in extent, that once covered the highlands of Lebanon and Syria. Today only 17sq km (6.5 square miles) remain, scattered in isolated groves. The Cedars of God (some say this is where the resurrected Christ revealed himself to his disciples) have been, since 1998, a UNESCO World Heritage Site, protected from felling and grazing. But legislation can't protect them from climate change or from a voracious sawfly that appeared that same year, both of which are wreaking havoc with the trees.

The natural range of *Cedrus libani* is at elevations of 1,300–3,000m (4,265–9,840ft) above sea level, distributed across the coastal mountains of Lebanon, the Alaouite mountains in Syria and the Taurus mountains in Turkey, where trees can grow up to 35m (115ft) and live to a thousand years old. Very few ever have – the timber of the cedar of Lebanon has been prized since antiquity. Indeed, the desecration of the forest forms part of our oldest-known work of literature: in the Sumerian epic of Gilgamesh, inscribed on tablets around 2100 BCE, the warrior-king Gilgamesh seeks out the demon Humbaba in the cedar forest, strikes off his head, and cuts down his trees to build a city.

Successive civilizations continued the deforestation. King Solomon is said to have built his temple from cedar wood (though Joseph Hooker pooh-poohed the suggestion). In Ancient Egypt the wood was so valuable it was a constant target for grave robbers. (The resin was also used for embalming.) The Phoenicians built their ships with it, the Assyrians, Greeks and Romans their temples. In 8th-century Jerusalem, the al-Aqsa mosque had a dome constructed of cedar. Later, French

Cedrus libani by Pancrace Bessa, from H. L. Duhamel du Monceau, *Traité des Arbres et Arbustes que l'on Cultive en France en Pleine Terre*, 1800–19.

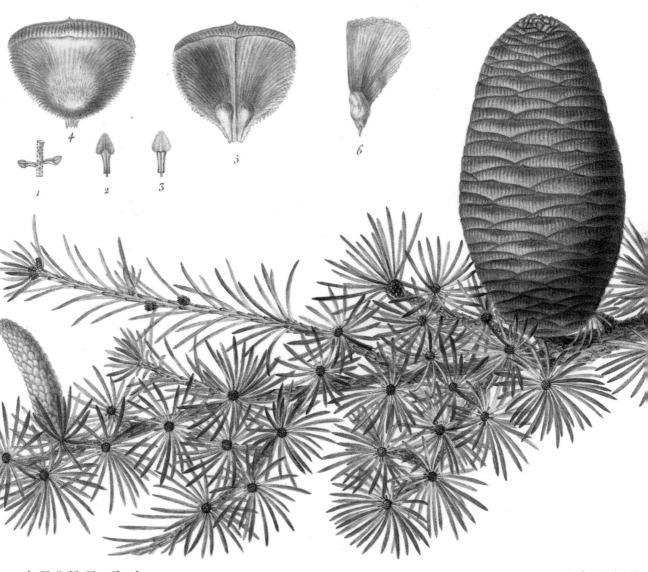

ABIES Cedrus.

SAPIN

ssa pinx.

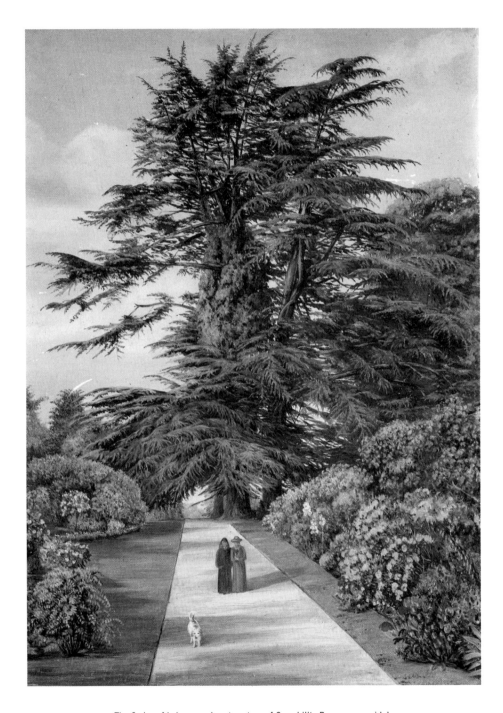

The Cedar of Lebanon, signature tree of Capability Brown, was widely
planted in the 18th century. A hundred years on, in *Cedar Path, Alderley
Garden, Gloucestershire* (*c.*1875–85) by Marianne North, the mature cedar
has become the quintessential aristocratic tree.

and British colonisers cut down the trees for railway sleepers. And yet the noble cedar remained a symbol of strength and beauty. In *The Song of Solomon* the tree represents the comeliness of the beloved: 'His countenance is as Lebanon, excellent as the cedars.' The cedar is mentioned in the Bible no fewer than 103 times.

The tree is thought to have been brought back to France in the 12th century by Louis VII and Eleanor of Aquitaine following the Second Crusade. Naturalist Pierre Belon is known to have collected it for his garden in Le Mans in the 1540s. It did not reach Britain till the 1630s, when Edward Pocock, chaplain to the Turkey Company at Aleppo, retired to Oxfordshire and became Rector at Childrey, where he planted a tree in his garden. It still survives. Two more trees were grown at Wilton, where his brother was chaplain to the Earl of Pembroke. When one was felled in 1874 the rings were counted (286), indicating a planting date around 1638.

The diarist John Evelyn, a keen promoter of evergreens, was an early enthusiast in the 1670s, and about this time, four seedlings obtained from Leiden Botanic Garden were planted at the Chelsea Physic Garden in London. But it is not until these early plantings began to bear cones some 40–50 years later that the cedar was widely adopted. Its distinctive silhouette, with layers of wide-spreading branches, made it very suitable for the fashionable new landscape parks that would soon transform the gardens of Europe. For the greatest of these landscapers, Lancelot 'Capability' Brown, the Cedar of Lebanon became a signature tree, and it would grow to become an indispensable part of the English country-house aesthetic. The opening credits of the popular British TV series *Downton Abbey* makes it easy to see why: even the most hideous building is lent dignity by an aristocratic cedar.

Highclere Castle, where the series was set, is the home of the Earls of Caernarvon, who also owned Bretby Hall in Derbyshire. Here a great cedar, planted in 1677, survived until 1953. Despite its grandeur, and the durability of the fragrant timber, the standing cedar is quite brittle, and it is common for old trees to lose limbs in a storm. At Bretby the legend grew up that the shedding of a branch would foretell a death in the family. And so it proved in 1823 when the 5th Earl, a keen Egyptologist who had financed the excavation of Tutankhamun's burial site, dashed to Egypt to see the opening of the tomb. Within weeks he was dead, struck down by the 'Curse of the Pharoahs'.

Wheat

Scientific name
Triticum aestivum

Botanist
Nikolai Ivanovich Vavilov

Location
Leningrad, Russia

Date
1921

ON 26 JANUARY 1943, a disgraced Soviet scientist died of starvation in a prison camp in Saratov in the western USSR. It was a common fate for prisoners under sentence of death. But it was particularly cruel for Nikolai Ivanovich Vavilov, whose mission in life had been to try to rid the world of hunger. Vavilov was born in November 1887 to a prosperous bourgeois family – a fact that would later be held against him by Stalin. Vavilov's father, however, had grown up in a poor rural village afflicted by frequent crop failures. Having experienced food rationing as a child, he did not permit his family to forget the fragility of plenty.

Vavilov had known happier times in Saratov, a university city on the banks of the Volga, where he had served as a professor of agronomy during the Russian Civil War (1918–21) and carried out extensive research. His interest was in plant breeding. Influenced by the work of plant geneticist Gregor Mendel (revered as 'the father of modern genetics'), Vavilov became convinced that the cure for plant diseases was to be found in genetic engineering. He travelled to England to study with leaders in the field, but was forced to return to Russia when war broke out in 1914 – narrowly escaping death when his ship was blown up by a mine. More hair-raising adventures followed in 1916, when he set off for Iran to study the genetic variability of cultivated plants, in particular the cereals that provide the staple foods for most of humanity.

Principal among them is the genus *Triticum*, or wheat, a grass grown worldwide for its grain. There are dozens of species, but the most widely grown are the bread wheat *Triticum aestivum,* which accounts for around 95 per cent of global production, *T. durum*, the hard wheat traditionally used for pasta, and spelt, *T. aestivum* var. *spelta.* There is evidence of wheat cultivation in the Fertile Crescent as long ago as 9600 BCE. Today, the largest producer is China.

Triticum aestivum, from O. W. Thomé, *Flora von Deutschland Österreich und der Schweiz*, 1886–9.

Over the coming years, Vavilov would identify eight (later seven) 'centres of origin' of cultivated plants, places in which the greatest diversity of forms of a crop could be seen. These very often overlapped with the sites of early civilizations, leading him to believe that these genetically super-charged areas, with their exceptional wealth of varieties, were the centres from which all crop plants descended. By gathering crop plants and their wild relatives from these areas, by studying the qualities that might have led to their selection (such as resistance to drought, disease or particular pests), and their evolution over centuries, he would learn how to refashion these historic processes in order to alter plants.

By 1920, Vavilov's work had come to the attention of Lenin, who appointed him head of the All-Union Institute for Plant Breeding in Leningrad (now St Petersburg). By spring 1921, Russia was in the grip of yet another famine, which killed five million people. To find reliably high-yielding crops adapted to local challenges from desert drought to Siberian snows, and above all able to prosper in the short growing season of continental Russia, was clearly the highest national priority. Vavilov began by speeding to the United States, where experiments in improving grain yields were well advanced, returning with 61 boxes of seeds.

Between 1923 and 1940, Vavilov and his colleagues carried out some 180 collecting missions, 140 within Soviet territory, the others exploring centres of origin worldwide, gathering plants of economic importance – 36,000 accessions of wheat, over 10,000 of maize, nearly 18,000 vegetables, 12,650 fruits, over 23,000 of legumes and a similar number of forage crops. Their aim was nothing less than to secure the full genetic repertoire for each species, which might then be exploited as required to create new and better varieties.

By 1940, Vavilov had gathered some 250,000 plants to create the world's first global seed bank in Leningrad. These crops were planted out and assessed at more than 400 research stations scattered across the various climatic zones of the USSR. Some had as many as 200 workers: in 1934, Vavilov had more than 20,000 people working on crop research, testing each variety in many different growing conditions to find those best suited to particular locales.

This great enterprise was brought to an end by one of his students, Trofim Lysenko, who was impatient of Vavilov's painstaking approach to crop improvement – a slow and laborious process of identifying useful genes, hybridization, testing

and further selection. Lysenko instead maintained that plant cells could at certain critical times be modified by environmental factors, and that this modification would be passed on – in practical terms, that by chilling seeds in winter, they could be induced to crop speedily and prolifically in spring, thereby ensuring non-stop harvests of grain. This had no basis in fact (and indeed had catastrophic consequences for Soviet agriculture), but Lysenko had gained the ear of Stalin, who had succeeded Lenin in 1924. Lysenko's theories fitted neatly with Stalin's world view: the Soviet people would be improved by the better environment created by Marxism, and this improvement would be passed to subsequent generations. Vavilov's Mendelian approach, by contrast, was all about nurturing inborn class differences. Besides, Lysenko was of untutored peasant stock, whereas the urbane Valivov was widely cultured, fluent in at least five languages, had friends worldwide and was universally regarded as charming. In short, he made Stalin feel intellectually inferior.

To add to his crimes, Vavilov was suspiciously highly regarded by the scientific establishment of the West, and not only had the temerity to maintain links abroad independently of the party, but to ignore diplomatic directives if they interfered with his research. Year by year Vavilov was stripped of his responsibilities, and in 1939 was forbidden to attend the 7th International Congress of Genetics in Edinburgh (and forced to resign his position as president). He was represented at the congress by an empty chair. In June 1940, while on a collecting expedition in Ukraine, he was arrested, charged with spying for America, and sentenced to death.

While Vavilov starved in Saratov, Hitler's army advanced on Leningrad. Within hours of the invasion, staff at Leningrad's Hermitage Museum had started evacuating the collection, moving half a million works of art to safety in the city of Sverdlovsk. No such plan existed to rescue Vavilov's seed bank, although 20 truckloads were successfully smuggled across German lines into Estonia by scientists posing as peasants wishing to selling grain to the troops. As the Germans closed in, scientists hid as many seeds as they could in the basement, hoping to protect them from both enemy bombing and the threat of attack from a desperate populace. But no such attack came. Along with around a million others (at least a third of the city's population), nine of the scientists guarding the seeds starved to death rather than cook and eat the precious genetic resources. Typical was rice expert Dmitry Ivanov, who died at his desk, surrounded by thousands of packets of rice.

Triticum aestivum (as *T. vulgare*), from O. W. Thomé, *Flora von Deutschland Österreich und der Schweiz*, 1886–9.

After the war, as Lysenko rose to power, the seed bank fell into neglect. Vavilov's colleagues were arrested or dismissed, and Vavilov's name was expunged from the official scientific record until his rehabilitation in the mid-1960s. By the time of the break-up of the Soviet Union, Vavilov's 400 research stations had dwindled to a mere 19, of which 6 were located in newly independent countries beyond Russia. And Vavilov's theory of centres of plant evolution had been superseded: while the places he had identified were without doubt centres of diversity, the domestication of plants had been shown to be more random and convoluted than he imagined.

Yet Vavilov's work has never been more relevant. For as we face up to the threats posed to our food security by population growth, global pandemics affecting both people and plants, environmental degradation and above all climate change, it has become clear that there is an urgent need to adapt our agriculture to these rapidly changing conditions. To feed the world's people at all – let alone to alleviate poverty and hunger – we will require new and improved crop varieties. It is already clear that there is an immediate need for varieties that can cope with heat, drought, flood and other extremes of weather. With ecosystems collapsing around us, there is a pressing need for crops that can be grown without recourse to damaging pesticides and herbicides, and excessive amounts of fertilizer and water. Meanwhile, globally important crops are being ravaged by diseases such as stem rust (wheat) and xylella (olives), for which there is no known treatment. The only solution is to breed resistant varieties. So it has never been more important to recognize and preserve genetic diversity.

A century on from Vavilov's pioneering gene bank, there are now more than 1,700 seed banks around the world. But the fate of his collection showed just how vulnerable they can be – to war, to politics, to neglect and underfunding – let alone natural disasters such as earthquake or flood. This was the impetus behind the Svalbard Global Seed Vault – conceived as the ultimate safety net for the world's seed banks, storing millions of duplicate seeds to ensure the survival of every important food crop on earth, along with its wild relatives. The seeds are stored deep inside a mountain on a remote island in the Svalbard archipelago, safely above sea level to protect from flooding, and naturally cooled by the island's permafrost. (The island of Spitsbergen lies just 1,100km/700 miles from the North Pole.) So far, more than 983,500 varieties of seeds have been conserved; there is room for 4.5 million–2.5 billion seeds in all. They may be viable for anything from 2,000 to 20,000 years.

We may think of it as Vavilov's stupendous legacy.

AFRICA AND MADAGASCAR

AFRICA HAS THE LONGEST history of plant hunting of all the continents – the first plant hunting expedition in recorded history took place in the Horn of Africa, in search of the mysterious *ntyw* tree. Coffee, according to legend, was discovered by a goatherd in 9th-century Ethiopia, and was at some point taken from Ethiopia by Yemeni merchants anxious to cash in on a lucrative trade: by the early 16th century, coffee was the beverage of choice throughout Turkey, Egypt and the Middle East. By the next century, a flood of ornamental plants was pouring from South Africa into Europe via the new Dutch settlement at the tip of the continent, and the botanic gardens of Leiden and Amsterdam became major centres for disseminating African plants for the next hundred years. By the 1690s, slave ships departing the African west coast were also carrying plant specimens for collectors like Hans Sloane in Jamaica whose collections would later form the basis of the British Museum. The Cape, with its Mediterranean climate, also provided rich pickings for some of the earliest British plant hunters; and when, from the mid-19th century, colourful bedding became all the rage in European gardens, it was South Africa that provided the latest must-have plants.

Most of Africa's flora, however, remained unexplored. Napoleon employed a botanist on his Egyptian campaign (1798–1801), and a few brave souls, such as the mid-19th century German botanist Gustav Mann, ventured into West Africa, all too accurately known as the 'White Man's Grave'. But it was not really until the mid-20th century that a systematic effort was made to botanize the tropical regions of Africa – one that has gained impetus in recent decades, as it has become better understood how important the tropics are to global biodiversity. Kew's latest State of the World's Plants and Fungi report, published in 2020, assesses two in every five of the world's plant species to be at risk of extinction: in Africa, with so many species-rich habitats still to be studied, the odds are even shorter.

Today's plant hunters are no longer looking for ornamentals: their task is rather to find the many new species believed to exist (especially endemics) before they are wiped out. The first step – in which Kew is playing a major role – is to work with local botanists to identify, map and conserve their plant resources. Centuries of colonial rule followed by long periods of conflict and political instability have stood in the way of developing scientific botany in many African countries: Guinea, for example, until 2005 had no national herbarium – the starting point for the study of any nation's flora.

As long ago as 1771, the French naturalist Philibert de Commerçon wrote of the island of Madagascar, recognized today as a biodiversity hotspot, as a naturalist's promised land, full of unusual and marvellous forms at every turn. The young botanists of Guinea and Cameroon, Angola and Mozambique are already suggesting their rainforests will prove no less exciting.

Frankincense

Scientific name
Boswellia

Botanist
Hatshepsut

Location
Somalia

Date
1470 BCE

THE FIRST EVER recorded plant collecting expedition was masterminded by a woman. The great Egyptian Pharaoh Hatshepsut is only the second known female monarch, and in around 1470 BCE she sent a force to the fabled Land of Punt in search of incense trees – most likely *Boswellia sacra*, or frankincense. Scholars disagree as to where the Land of Punt might have been – possibly in modern Eritrea or Somalia. (*Boswellia* species are most common in the coastal mountains of northern Somalia, which support dense woodland.) But wherever they went, her collectors returned with 31 living trees, which are believed to have lined the avenue to the magnificent tomb complex Hatshepsut built for herself at Deir el-Bahari in ancient Thebes.

The trees, however, were not intended merely for ornament. Aromatic resins such as myrrh and frankincense were important in Egyptian ritual and medicine, and especially in the practice of mummification. Hatshepsut's mission was intended not only to open up useful maritime trading routes, but to establish a source of this valuable commodity within Egypt – the earliest known example of economic botany.

Hatshepsut was sufficiently pleased with the expedition to have it recorded on the walls of her tomb. A series of paintings and reliefs shows five ships setting off, arriving in Punt and returning with a cargo of 'lovely plants from the god's country', their roots carefully balled in baskets, along with heaps of myrrh, gold rings, ebony and elephant tusks.

Later, frankincense would become important to the Christian faith as a symbol of Christ's divinity at the Epiphany, and a continuing part of Christian worship: the sweet smoke of burning frankincense resin provides the odour of sanctity at the Roman Catholic, High Anglican and Greek Orthodox mass. It is also valued by

A number of *Boswellia* species produce fragrant resins, including *B. carteri*, which grows alongside *B. sacra* in northern Somalia. Painting from F. E. Köhler, *Köhler's Medizinal-Pflanzen*, 1887.

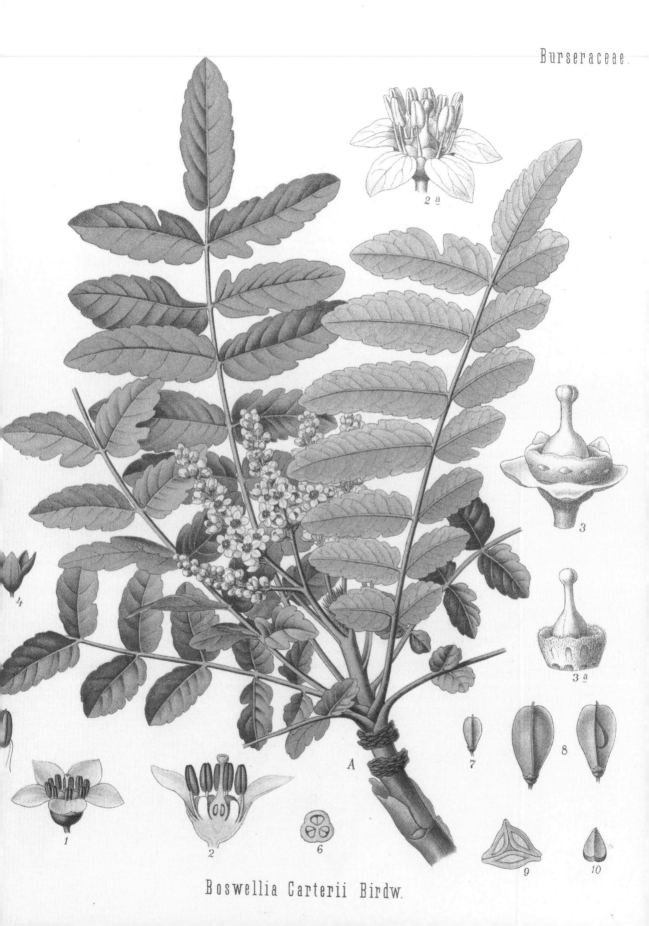

Boswellia Carterii Birdw.

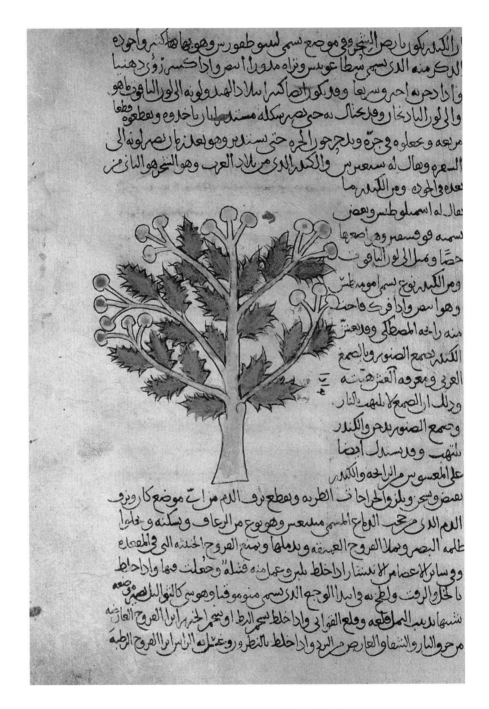

Boswellia in an Arabic version of Dioscorides'
De Materia Medica, 987–90.

perfumiers and is becoming increasingly sought after in alternative medicine, where frankincense oil is purported to cure everything from arthritis to melanomas. It has long been a remedy in traditional Chinese medicine, while the Roman naturalist Pliny the Elder believed it to be an antidote to hemlock poisoning.

For millennia, frankincense was sustainably harvested by cutting into the trunk of the tree and scraping out the oozing sap, which hardens into 'tears' of golden resin. This could be repeated nine or ten times over the life of the tree without ill effect. Over the last decade, however, over-tapping has left many wild populations dangerously vulnerable to disease and infestation, and led commercially grown *Boswellia* species to the verge of extinction. Trees across Ethiopia, where most commercial frankincense originates, are dying at an alarming rate. More alarming still, an investigation published in July 2019 estimates that the number of frankincense-producing trees will drop by 50 per cent over the next 15 years. Scientists examined 23 populations of *Boswellia* over its geographic range, and found that in three quarters of them, there had been no natural regeneration for decades – the saplings either damaged by forest burns or eaten up by cattle, while mature trees, exhausted by over-tapping, were less and less able to produce viable seed. They concluded that without a concerted conservation effort, including fencing off trees from cattle, cutting firebreaks and tapping trees more carefully, half the world's production of frankincense will go up in smoke within the next 20 years.

Herbarium specimen of *Boswellia sacra* collected in Somalia, held at the Royal Botanic Gardens, Kew.

Starfish flower

Scientific name
Stapelia

Botanist
Francis Masson

Location
South Africa

Date
1796

THE CITY OF CAPE TOWN on Africa's Cape of Good Hope began as Kaap – a victualling station for the Dutch East India Company, established to service the company's spice ships travelling to and from the Dutch East Indies. Among the passengers in 1624 was a Dutch missionary, Justus Heurnius (1587–1653), who made the first known drawings of Cape plants, including a curious, evil-smelling, star-shaped succulent which came to be known as *Stapelia*.

It was nearly 50 years later that the German-born botanist Paul Hermann (1646–95) visited the Cape; years after his death, his books were bought by Joseph Banks. It may have been these, or it may have been his own fleeting experience of Cape flora on his way back to England aboard the *Endeavour*, that made Banks determine that the first official plant hunter to be sent to gather plants for the royal garden at Kew should begin collecting in South Africa.

The man he chose was Francis Masson (1741–1805), a 'Scots garden hand' employed as an under-gardener at Kew. Landing in Cape Town in October 1772, Masson found he had arrived in a floral paradise. Today, the Cape Floral Kingdom so eagerly explored by the astonished Scot is recognized as a World Heritage Site, the smallest and richest of the world's six floral kingdoms. No other country comes close to South Africa for the beauty, wealth and diversity of its flowers. Of the 22,500 species which grow there, some 16,500 grow nowhere else; the Cape World Heritage Site alone boasts 9,600 species (of which 70 per cent are endemic), the highest known concentration of plant species in the world. (Its nearest rival, the South American rainforest, has only one third the number of species.) Here Masson would collect some of the most spectacular plants ever seen – red hot pokers and agapanthus, colourful heaths and stately proteas, startling turquoise-flowered *Ixia viridiflora* and the exotic *Strelitzia reginae,* the Bird of Paradise flower, which Banks

Stapelia, now Orbea variegata, from H. C. Andrews, Botanist's Repository for New and Rare Plants, 1816.

Pl 139

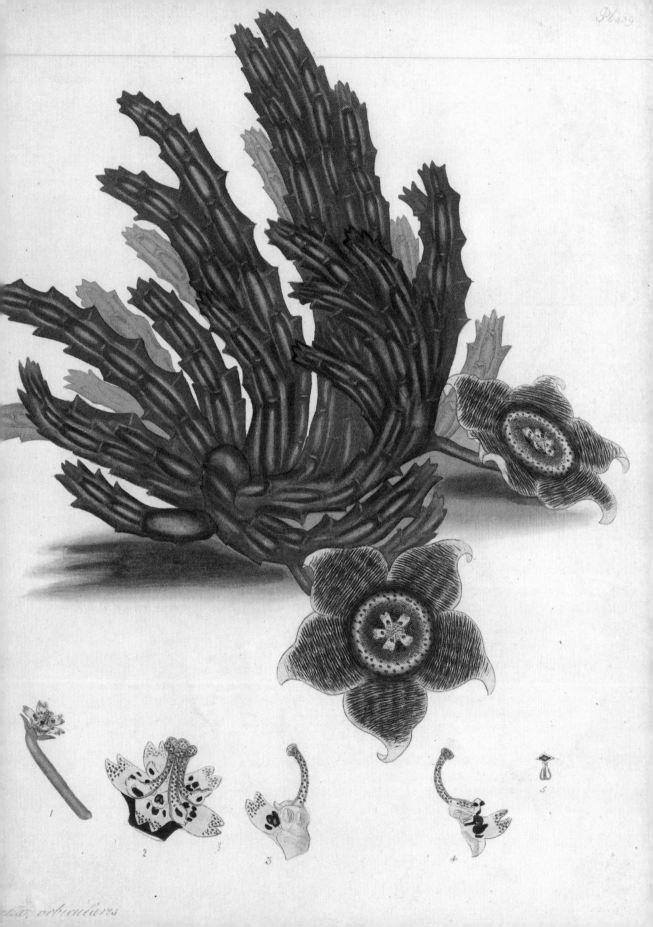

orbicularis

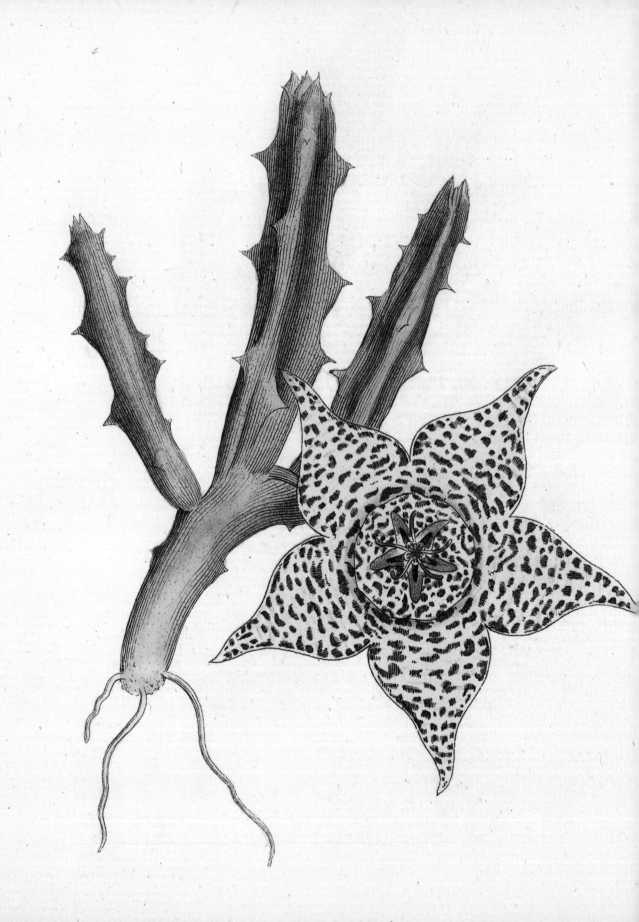

astutely named after George III's queen, formerly Princess Sophie Charlotte of Mecklenburg-Strelitz.

Even more unusual were the 'palms' Masson discovered in the forests of the Eastern Cape. One had a stout stem and was 3.6m (12ft) high. 'The other sort had no stem, with the leaves a little serrated, and lying flat on the ground, which produced a large conical fructification about eighteen inches long, and a foot or more in circumference.' These were his first sightings of cycads, primeval plants dating back millions of years before the advent of flowering plants. The example he gathered of the prone cycad, now known as *Encephalartos altensteinii,* is still thriving in Kew's Palm House, and is thought to be the oldest pot plant in the world. The one and only time it has produced a cone was in 1819, prompting the ailing Banks to make his final visit to Kew in order to see it.

In the space of three years, Masson made three gruelling journeys into the interior, the second two in the company of the irrepressible Carl Peter Thunberg, a Swedish botanist who had studied with Linnaeus. In 1775, Thunberg sailed on towards Japan (see page 70), and Masson returned to England, bearing a mighty haul of plants gathered from foggy mountaintops and parched deserts, from barren hills that were miraculously 'painted' in winter and verdant plains 'enamelled with the greatest number of flowers' he had ever seen. A laconic report published the following year in the *Philosophical Transactions of the Royal Society* revealed how narrowly they had avoided being eaten by lions, drowning in hippo holes, falling over precipices or dying of thirst after days in the desert without water. It was also the first detailed description of the plants of the southern and southwestern Cape.

Banks was ecstatic with this 'profusion of plants', noting that by means of Masson's efforts, 'Kew Garden has in great measure attained to that acknowledged superiority which it now holds over every similar Establishment in Europe.' Masson's finds started a craze for Cape plants which spilled over from the hothouses of the wealthy to the windowsills of the poor: within a few years of his death the rare pelargoniums that had once been collectors' items now adorned 'every garret and cottage window' while 'every greenhouse glows with the innumerable bulbs, plants and splendid heaths of the Cape.'

In 1778, Banks sent his star collector off in the other direction, via Madeira, Tenerife and the Azores to the Caribbean. Masson returned empty-handed, having

Orbea variegata (as *Stapelia variegata*) by James Sowerby, from *Curtis's Botanical Magazine*, 1816.

been imprisoned by the French when they invaded Grenada in 1779, then lost everything in a hurricane that devastated St Lucia. A third trip two years later to Portugal, Spain and North Africa fared much better, but by late 1785 he was back on his way to the Cape. There still remained, he knew, 'a great treasure of new plants in this country, especially of the succulent kind'.

On arrival, Masson was greeted with suspicion. Relations between the British and the Dutch had become strained and, suspected of being a spy, Masson found he was debarred from exploring anywhere within three hours of the sea. This was a frustration to Banks, who sent letters commanding him to stick to the coast, but did not discourage Masson who, on his previous expeditions, had become intrigued by the peculiar flora of the arid zones. He had noted how the settlers maintained large flocks of sheep in areas devoid of grass, and learned that 'their sheep never ate any grass, only succulent plants, and all sorts of shrubs; many of which were aromatic, and gave their flesh an excellent flavour.' Little was known about succulents, 'which cannot be preserved but by having good figures and descriptions of them made on the spot'. This Masson had been unable to do on his last journey; needing to hurry on before the oxen pulling his wagon collapsed from dehydration, he had collected only 'what we found growing along the road side, which amounted to above 100 plants, never before described.' It was enough to fall under the spell of stapelias, which enchanted him with their intricately patterned starfish flowers.

Masson spent the next nine years in South Africa, during which he became an authority on the genus. He sent specimens back to Kew, followed by anxious letters enquiring after their health, and on his return to England in 1795 was delighted to find them growing sturdily. Over the next two years he published a four-part book on the genus, *Stapeliae Novae,* describing 41 species, 39 of them new to science, each illustrated with a hand-coloured plate derived from his own drawings.

The genus has been added to and subdivided since Masson's day: today *Stapelia* consists of some 29 African species, found chiefly in the arid regions of Namibia and South Africa, most frequently in mountainous terrain. The flowers attract blowflies by masquerading as rotting carcasses covered with fine hairs similar in texture to animal skin, and emitting a putrid stench of decay, which has earned them the local name of 'carrion flowers'. So convincing is the deception that the flies frequently lay their eggs in the flowers. (There are some species such as

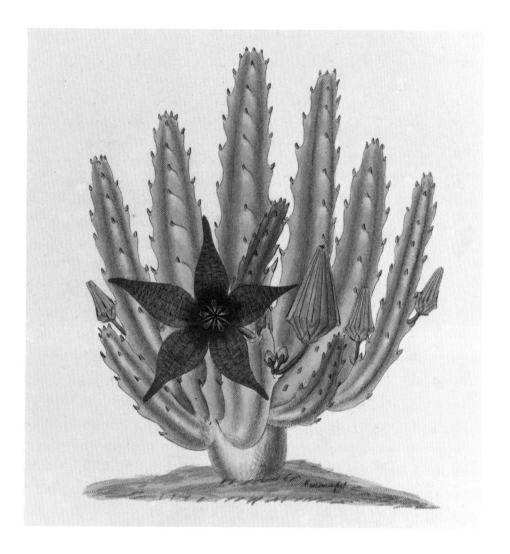

S. erectiflora and *S. flavopurpurea* that have sweetly scented flowers, but they are rare.) The five-pointed flowers are frequently very large: the flowers of *S. grandiflora* can reach 25cm (9¾in) across. The attractive marbled patterns displayed by the flowers have, despite the maggots and offensive odour, made stapelia popular houseplants – at least among collectors of succulents. The hard-working Masson, who died in a bitter Canadian winter, still plant hunting at the age of 65, was certainly convinced of their charms.

Stapelia hirsuta var. *vetula*, from F. Masson,
Stapeliae Novae, 1797.

Living stones

Scientific name
Lithops

Botanist
William John Burchell

Location
South Africa

Date
1811

Usually plant hunters have to search long and hard for interesting specimens. But sometimes they just trip over them. This was what happened to William John Burchell, botanizing in South Africa's Northern Cape Province in 1811. Stumbling over 'what was supposed a curiously shaped pebble', he picked it up from the ground and found it to be a plant. But 'in colour and appearance [it] bore the closest resemblance to the stones, between which it was growing.' This chameleon-like capacity to blend in with its surroundings, was, he concluded, a clever ploy on the part of Nature to allow 'this juicy little Mesembryanthemum' (for so he believed it to be) to 'escape the notice of cattle and wild animals'.

Burchell (1781–1863) had marvelled at the glamorous proteas of Table Mountain, the dazzling tribe of leucospermums and the jewel-like fynbos bulbs, but these tiny living stones, which he named *Mesembryanthemum turbiniforme,* were to his mind every bit as worthy of attention. For,

> In the wide system of created objects, nothing is wanting, nothing is superfluous: the smallest weed or insect is as indispensably necessary to the general good, as the largest object we hold…Nothing more bespeaks a littleness of mind, and a narrowness of ideas, than the admiring of a production of Nature, merely for its magnitude, or the despising of one, merely for its minuteness: nothing more erroneous than to regard as useless, all that does not visibly tend to the benefit of man.

Burchell, clearly, was no ordinary plant hunter, concerned with the usefulness or garden-worthiness of what he found. Travelling 'solely for the purpose of acquiring

Two cultivated living stones, *Lithops fulviceps* (as *Mesembryanthemum fulviceps*) and *Conophytum bilobum* (as *Mesembryanthemum elishae*), from *Curtis's Botanical Magazine,* 1818.

quartzite pebble pavements to dry, stony slopes, mountain crevasses or patches of open grassland. They can survive months without rain (some appear to get all the moisture they need from desert fogs or dews) and tolerate both extremes of heat (above 42°C/108°F) and sub-zero winter temperatures (-5°C/23°F).

Each plant consists of two thick semi-translucent leaves, joined at soil level and tapering to a carrot-like root. To conserve water (and also help to hide from grazing animals), they grow almost completely embedded in the ground, exposing only a small oval 'window' in the leaf tip to the sun. This underground lifestyle obviously presents a challenge to photosynthesis, but in *Lithops* the light passing through the leaf window is concentrated on chloroplast-containing cells lining the inside of the leaves, achieving maximum penetration of light with minimum exposure to a hostile environment.

Once a year during the rainy season, vivid yellow or white daisy flowers emerge from between the leaves, sweetly scented to attract bees and flies. After flowering, the body shrivels and breaks open to reveal a new pair of fleshy leaves.

The seeds that are produced are equally well adapted to desert life, kept safe for years at a time in 'hydrochastic' seed capsules, meaning they open only when wet. The seeds are released only in response to rain, and then germinate rapidly, taking advantage of the briefly favourable conditions.

Conophytum truncatum (as
Mesembryanthemum truncatellum),
from *Curtis's Botanical Magazine*, 1874.

Coffee

Scientific name
Coffea

Botanist
Dr Aaron P. Davis

Location
Ethiopia

Date
Ongoing

While there is still a determined handful of plant explorers scouring the planet for new ornamental plants for our gardens – notably Ken Cox, Dan Hinkley, Roy Lancaster, and Bleddyn and Sue Wynn-Jones (see pages 139, 140 & 136) – most plant hunters working today are scientists working for botanic gardens, universities or other research institutions, seeking to understand, catalogue and rescue what they can from the threats posed by climate change, water shortage, disease and wholesale habitat destruction. High on the list of priorities are the wild relatives of crops of global economic importance – vital if we are to keep the planet supplied with food.

Curiously, perhaps the most economically important plant in the world is more widely used as a drink than as a foodstuff. Coffee is an internationally traded commodity supporting a multibillion-dollar global industry and supplying a livelihood for around 100 million people worldwide. However, the future of the coffee industry is under threat from accelerated climate change, causing drought, flood, changes in seasonality and potentially catastrophic rises in temperature, all contributing to the spread of pests and diseases. Leading the charge to save the world's favourite drink – and thereby the economy of several tropical countries – is Kew Senior Research Leader Dr Aaron P. Davis, who is currently working with partners in Madagascar, Ethiopia and other parts of Africa to find a sustainable way forward.

Coffee comes from a genus of small, usually evergreen trees called *Coffea*, of which there are 124 known species. Just two, however, dominate the global coffee market. Sixty per cent of the world's commercial coffee crop is *Coffea arabica*, which originates from the cool-tropical, high-altitude forests of Ethiopia and South Sudan. It has been farmed in these regions from at least the 16th century, and has probably

Coffea arabica, from J. J. Plenck, *Icones Plantarum Medicinalium*, 1788–1812.

Tab. 130.

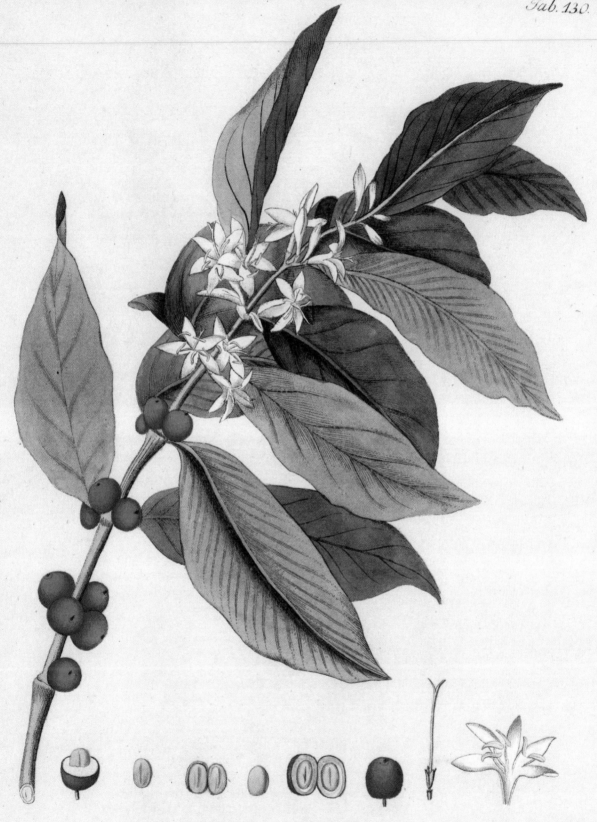

COFFEA ARABICA L.

Der Arabische Caffee.

been gathered from the wild for millennia. Arabica is generally considered the finest coffee, with a subtle flavour, delicious aroma, natural sweetness and moderate caffeine content. This is the coffee we generally use for whole bean or ground coffees.

The other 40 per cent is chiefly Robusta (*C. canephora*), which comes from the lowlands of tropical West and Central Africa. This species was not identified until 1897, but was rapidly adopted by farmers worldwide, being more adaptable, more productive and more disease resistant than Arabica, especially to the plague of coffee leaf rust. Robusta is also much higher in caffeine. While usually held to be inferior in taste, it is often blended into espresso to give it extra body and boost the *crema*, the froth that appears on the top. Robusta is the species that provides our instant coffee. A third species, *C. liberica*, also from tropical Africa, is cultivated worldwide and used as a grafting rootstock for Arabica and Robusta. While it is very popular in the Philippines, it is negligible in terms of global trade. It was widely planted in Asia in the late 19th century for its resistance to disease, but was supplanted by the more flavoursome and more easily grown Robusta.

Most of our important crops have been cultivated for many thousands of years. But as Davis points out, Robusta coffee amply demonstrates the extraordinary

Flowers and beans of *Coffea arabica* by Manu Lall, an example
of Company Art commissioned from Indian artists by the British
East India Company, Kew Collection, 19th century.

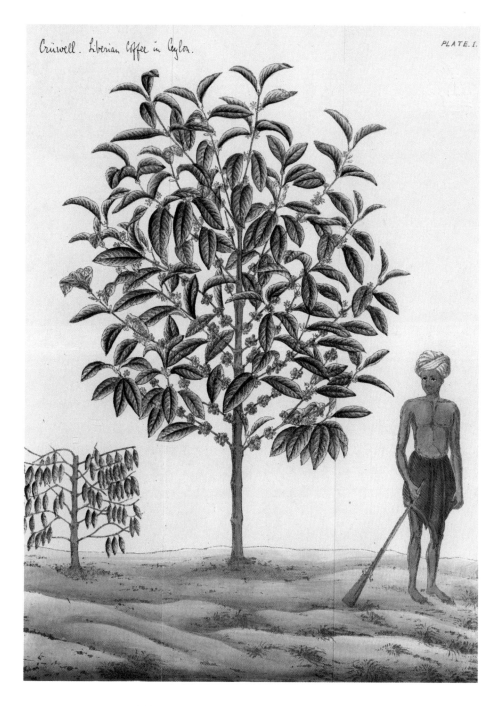

Crüwell. Liberian Coffee in Ceylon.

PLATE. I.

Coffea from G. A. Crüwell, *Liberian Coffee in Ceylon*, 1878.

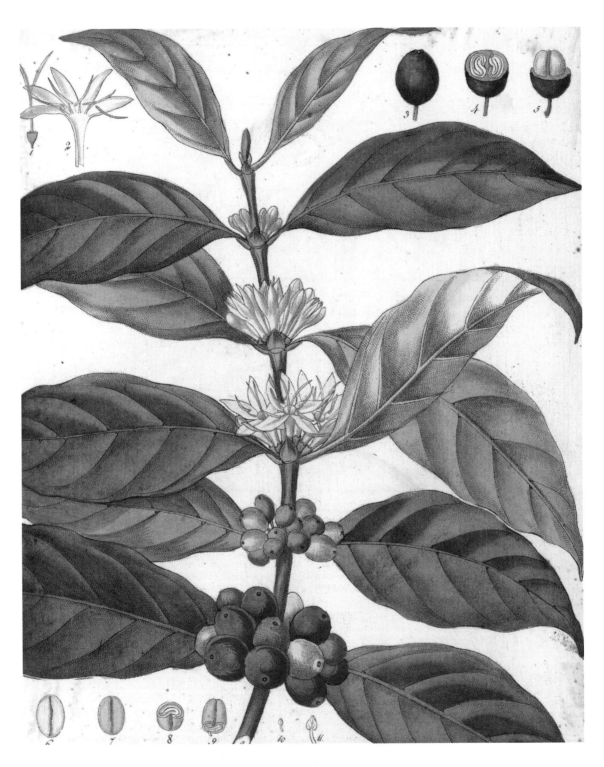

Coffea arabica, from F. G. Hayne, *Getreue Darstellung
und Beschreibung der in der Arzneykunde Gebräuchlichen
Gewächse*, 1825.

potential that lies in exploring wild species – a wild plant, or at best a small-scale village crop species, that has become a major global player in just 120 years. Who knows what benefits the other 121 little known coffee species might have to offer? They might have helpful traits of resistance to disease, heat or drought, which could be introduced into breeding programmes to make cultivated coffee more resilient. Or they might simply taste delicious. In an increasingly sophisticated market, new premium speciality coffees could provide a valuable extra income stream for poor countries such as Ethiopia, in which coffee is the single largest source of household income. Some 20 million people (a quarter of the population) are thought to depend on coffee, which currently accounts for a third of Ethiopia's export earnings.

It was early 20th-century accounts of the fabulous flavour of *C. stenophylla* that led Davis to go hunting for it in the lowland forests of Upper West Africa – a species that was once cultivated commercially in Sierra Leone and neighbouring countries, but had not been seen in the wild since 1954. He and fellow botanists Jeremy Haggar and Daniel Sarmu eventually found two tiny wild populations (one a single plant) in Sierra Leone in 2018. The following year, Sarmu found *C. affinis* nearby in Sierra Leone, another reputedly outstanding 'lost' coffee, previously found only in Guinea and Ivory Coast and last seen in the wild in 1941. Both species were in immediate jeopardy from logging and mining.

This was no surprise to Davis, whose research team at Kew has established that at least 60 per cent of the world's coffee species (75 out of 124) are threatened with extinction. This includes *C. arabica*, which now appears on the IUCN Red List of Threatened Species as 'Endangered'. Both the wild and cultivated populations are at risk, as this climate-sensitive species, at home in cool, humid montane forests at 950–2,000m (3,116–6,560ft), struggles to cope with rising temperatures and reduced rainfall. Indeed by 2088, it is predicted that Ethiopia's wild population will have been wiped out by the effects of climate change alone. This is not to factor in the hazards that imperil all species of coffee – habitat loss or degradation (coffee is very picky about where it grows, and will not readily regenerate in less than optimal conditions), the felling of trees for timber or fuel, and the fragmentation of forests by human encroachment, leaving populations too small and isolated to be viable. Cultivated Arabica is also under threat, for while over 30 countries grow it,

there are only a very few cultivars available. (A cultivar is a cultivated variety, usually selected for some desirable characteristic.) This lack of genetic diversity leaves the crop extremely vulnerable to pests and diseases, and with few defences against deteriorating climatic conditions and extreme weather events. Worse still, there is no safety net, since it has not proved possible to store coffee seeds successfully in conventional seed banks. So it is imperative to conserve plants as a living resource.

Time, insists Davis, is of the essence. For many of the wild species that he believes might be most useful in developing more resilient coffee varieties are among those at highest risk of extinction. Several have not been seen for a century or more and may already have perished. Davis has something of a track record for discovering (and rediscovering) coffee species – 20 in Madagascar alone. The credit, he insists, properly lies with his African colleagues, more skilled than he at spotting unusual coffee trees in the dense jungle. His long-time collaborator is Malagasy botanist Dr Franck Raotonasolo, who thought nothing of taking a 960-km (600-mile) bus trip, followed by a half-day jungle hike, to secure a specimen of long-lost *C. ambogensis* – a plant not seen since 1841. When his bus overturned on the way home, the injured botanist's first concern was to rescue the plant and get it to Kew for identification. It was indeed *C. ambogensis* which, along with another Madagascar discovery, *C. boinensis,* has the world's largest coffee beans, more than twice the size of *C. arabica.*

The flavour of coffee is determined by processing as much as by its inherent qualities. Coffee trees produce small red (or sometimes yellow or purple) fruits known as 'cherries', which in most places are still picked by hand. Inside the fruit are two seeds embedded in a soft, sweet, sticky pulp (in botanical terms, the 'mesocarp'), and each seed is encased in a crispy coat known as the parchment (or 'endocarp'). The skin, pulp and parchment are removed by drying or milling (the pulp is edible), leaving the green bean-like seeds, which are washed, dried and graded. These are roasted to produce our familiar aromatic brown coffee beans.

Roasting is considered an art as subtle as the making of wine; indeed, coffee connoisseurs can talk about their favourite blends as passionately as wine buffs. Coffee experts use a descriptive sensory language every bit as complex as wine tasters – and the finest coffees, like the finest vintages, can command astonishing prices. For the coffee novice, faced with a bewildering array of styles, a journey of discovery awaits!

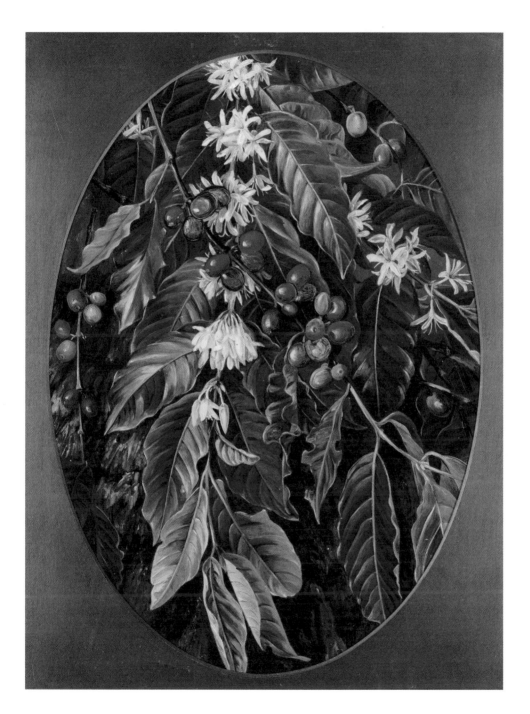

Foliage, flowers and fruit of the Coffee, Jamaica
by Marianne North, 1873.

Flamboyant tree

Scientific name
Delonix regia

Botanist
Wenceslas Bojer

Location
Madagascar

Date
By 1829

THE ISLAND OF Madagascar, the fourth-largest island in the world, is perennially described as the hottest of the world's biodiversity hotspots. Its landmass separated from continental Africa 160 million years ago, and from India between 70 and 90 million years ago, and the effect of this long geographical isolation has been the development of a unique fauna and flora. The island's exceptional variety of geological, geographical and climatic conditions and habitats has offered species of many kinds the opportunity to evolve and diversify in isolation, giving rise to a wildlife of extraordinary richness, of which the vast majority is found nowhere else on Earth.

At the last count (for new species are discovered all the time) there were nearly 11,300 native species of plants in Madagascar. Roughly one in every ten is an orchid. Of the island's plants, 83 per cent are endemic, including five entire families of woody plants and 306 genera. It is especially rich in palms, boasting three times more palm species than the whole of continental Africa, while of the eight known species of the otherworldly baobab tree (*Adansonia*), six are endemic to Madagascar. (The baobab has been nominated as Madagascar's national tree.)

Inevitably, as many of these plants have such limited distribution, many are under threat, primarily from deforestation for slash-and-burn agriculture. (Indeed the most newly discovered plants have frequently been at risk of extinction at the moment they have been described.) The forest is torched, the wood turned into charcoal for cooking, and the rest of the vegetation is burned to fertilize the soil, usually to grow corn or rice. After a few years the soil is depleted of nutrients, so the farmers move to the next woodland patch. The vegetation continues to be burned to maintain grassland for grazing zebu, the local cattle. But this is by no means the only peril. The sudden death of populations of baobabs is thought to be a consequence of climate

Delonix regia by Masumi Yamanaka, from *Curtis's Botanical Magazine*, 2020. © Masumi Yamanaka.

change, while researchers are concerned for the fate of plants that no longer appear to have any means of dispersing their seed. Madagascar is curiously short of fruit-eating birds, this ecological niche having been filled by lemurs. But some plants, including some of the palms and baobabs, produce seeds too large for the lemurs to eat. It is thought that these were once spread by creatures now extinct, such as giant sloth-like lemurs, pygmy hippopotamuses, outsize tortoises and the legendary elephant bird, an ostrich-like creature last seen in the 17th century.

Kew has been researching the plants of Madagascar since the 1880s, and a century later set up the Kew Madagascar Conservation Centre (KMCC) in the capital Antananarivo. This is actively engaged in a wide range of conservation projects, from encouraging farmers to grow more yams, to conserving seed as an insurance policy against extinction in the wild. Some 7,000 seed collections (representing 3,000 species) have so far been stored in a seed bank in Antananarivo, backed up by duplicates at Kew's Millennium Seed Bank in the UK. However, some rainforest species have proved all but impossible to raise from seed, so for these it is necessary to conserve living plants in botanic gardens – a living reservoir from which the island's forests may be restored in the future.

Happily, not all Madagascar's plants are in danger. The fittingly named flamboyant tree, *Delonix regia*, was illustrated in 1829 by Czech botanist Wenceslas Bojer (1795–1856), who made collections in Madagascar, and by the end of the 19th century was widely distributed throughout the tropics. It is easy to see why: it is a magnificent shade tree, growing 9–12m (30–40ft) tall with a broad-spreading, umbrella-like crown that can reach 18–21m (60–70ft) across. The tree will drop its ferny, mimosa-like leaves in climates that have a dry season or cool winter, but is otherwise evergreen. But its chief glory is its flowers – a mass of showy scarlet flowers, each a good 10cm (4in) across, that entirely smothers the canopy in a blaze of bloom. These give way to enormous, flattened, hanging seedpods, up to 60cm (2ft) long.

The tree has long been widely cultivated in Madagascar, but wild populations were rediscovered only in the 1930s in the western dry forests of the island – an increasingly fragmented habitat. This much-loved tree (except in Australia, where it is considered a weed) is now naturalized in many tropical and sub-tropical locations. But just to be sure, its seeds are among those conserved in Madagascar.

The original (and 'Type') illustration of *Delonix regia*,
after a drawing by its discoverer Wenzel Bojer, from
Curtis's Botanical Magazine, 1829.

Linsonyi

Scientific name
Talbotiella cheekii

Botanist
Xander van der Burgt

Location
Guinea

Date
2017

HOW CAN IT be that a giant rainforest tree, 24m (79ft) high, with a stately buttressed trunk reaching 83cm (33in) in diameter and bearing huge clusters of dazzling red and white flowers, could be unknown to science until 2017? Not least since it was not a single specimen, but growing in a dense patch of trees only yards from a major road and virtually in the suburbs of the country's capital city?

It is a case that highlights the conundrum at the heart of plant hunting. For the tree, of course, was perfectly well known to the people of Guinea's Conakry area, where it is known in the Susu language as *Linsonyi*. It also bears the more descriptive name of *Wonkifong wouri khorohoi*, meaning 'Tree with hard wood from Wonkifong' – which is rather how all plants were described before 1753, when Linnaeus invented the economical binomial naming system used by scientists today. Its scientific name, bestowed in 2018 by Kew researcher Xander van der Burgt, is *Talbotiella cheekii*. Burgt named it after his boss, Martin Cheek, Head of the Africa & Madagascar Team at Kew, who has been studying the flora of Guinea and Cameroon for the last two decades and is heavily involved in trying to set up new protected areas to conserve its fast-vanishing flora. Only when a plant has been officially 'discovered' and described is it possible to enter it on the IUCN red list and give it a conservation status. And only then is it possible to enact any kind of management plan.

Like a startling percentage of Guinea's flora, *T. cheekii* has been classified as 'Endangered'. Guinea is one of the most botanically diverse countries in West Africa, with around 4,000 vascular plant species. Over 270 are currently at risk of extinction, including all 74 species known to be endemic (that is, growing only in Guinea). Many plants are destroyed by open-cast mining: Guinea produces 15 per cent of the world's bauxite (95 per cent of Africa's share), and also mines for iron,

Herbarium specimen of *Talbotiella cheekii* collected by Xander van der Burgt in Guinea in 2017, held at the Royal Botanic Gardens, Kew.

Leguminosae-Detarioideae

Talbotiella cheekii Burgt

Det by: X.M. van der Burgt, 9 December 2017

Guinea, Coyah Préfecture, at the checkpoint near Pont KK.
Lat.Long: 9° 45' 05.5" N, 13° 21' 27.6" W Alt. 150 m
Vertical sandstone cliff, 50 m above stream.

Tree, 12 m high, stem 63 cm diameter at 1.3 m. Stem fluted.
Flower sepals white, pedicel pink. At least 10 trees present
here, on the vertical cliff. This is the only tree seen in flower;
the tree was badly damaged by fire, most branches were
dead, the last living branches were flowering. Wood sample at
K: a section of a 6 cm thick branch.

Burgt, X.M. van der 2188

With Laura Jennings, Gbamon Konomou, Pepe Haba

9 December 2017

Dups: B, BR, G, HNG, K, LISC, MO, P, PRE, SERG, WAG
Additional material: Photos *See wood sample*

copper, uranium, diamonds and gold. By 1992, it was estimated that 96 per cent of Guinea's rainforest had already been destroyed by unsustainable slash-and-burn agriculture or cleared for cattle ranching. Only a few fragments remain in the lowland area where *T. cheekii* was found – clustered in a dozen steep rocky gullies that have so far escaped development for housing. The Kew team uses Google Earth to scan these forest remnants for clues before they go out hunting.

Cheek believes that 35 of Guinea's rarest plant species, including 25 endemics,

Talbotiella cheekii drawn by Xander van der Burgt, 2018.
© Xander van der Burgt.

are probably already extinct, such as the rubbery 'orchid of the falls', *Inversodicraea koukoutamba,* found at Koukoutamba Falls in 2019, just in time to be destroyed by a hydro-electric project. A similar fate is thought to have overtaken an entirely new genus discovered in 2018 in neighbouring Sierra Leone. *Lebbiea grandiflora,* another specialized waterfall plant, specially adapted to cling to bare rock in a crashing torrent, was discovered during an environmental impact assessment for a new dam. It did not save it. A second population was found a year later – but sadly at the ill-fated Koukoutamba Falls.

It is important to find these plants before they vanish, not just out of scientific curiosity, insists Cheek, but because they may have benefits for mankind. He points to *Kindia gangan,* an attractive small shrub with bell-shaped white flowers recently found growing high on sandstone cliffs near Kindia in Guinea. Its bright orange pollen has been found to contain more than 40 different triterpenoids, chemical compounds known for having anti-cancer properties.

Talbotiella cheekii is not yet known to have medicinal properties – though it is traditionally recommended 'to remove the magical powers from confessed sorcerers'. It is a member of the pea family, remarkable for being found so far west of the rest of the genus, which grow mainly in Cameroon and Gabon. It is by no means the first large tree that Xander van der Burgt has discovered in the rainforests of Africa: he has found even more titanic pea relatives in Cameroon. *Berlinia korupensis is* twice the height of *T. cheekii,* producing pea pods a foot long, while *Gilbertiodendron newberyi* can grow over 50m (164ft) high, with a trunk approaching 2m (6½ft) in diameter. Like *Talbotiella,* these species spread by 'ballistic' seed dispersal, meaning the drying pods explode open, sending the seeds flying at high speeds in all directions.

In collaboration with local botanists, van der Burgt has now described no fewer than 14 new rainforest trees. It is harder than you might think. To identify trees where the leaves are growing so high above his head requires fearless mountaineering-style climbing skills. Also, a firm identification cannot be made without seeing the flowers, which can be frustratingly fleeting – in *T. cheekii*'s case, appearing all at once at the end of the dry season, and lasting only four or five days.

NORTH AMERICA
AND MEXICO

AT THE TIME of the Spanish conquest of what was to become Mexico in 1519, the Aztecs dominated the southern part of North America. The invaders discovered not only a terrestrial paradise of tropical vegetation, but also sophisticated methods of agriculture (including chinapas, or floating islands), vast royal hunting parks, and clean and orderly cities ornamented with luxuriant parks and gardens, including botanical gardens. All this they systematically destroyed, but random food crops such as maize, tomatoes and potatoes, and ornamentals such as marigolds, passionflowers, runner beans (originally grown for their flowers) and the fragrant tuberose, started trickling back to Europe almost immediately. In England by 1597, the herbalist John Gerard claimed to be growing a 4m (14ft) sunflower – native to South America but widely grown in Aztec Mexico. By 1627, the London apothecary John Parkinson could write of *Canna indica*, daturas (*Brugmansia*) and prickly pears. And by the end of the century, the tuberose had become a favourite to fill the parterres of Louis XIV's Versailles.

Meanwhile, John Parkinson's good friend, John Tradescant the Elder, was receiving his first consignments of seeds from the new English colony of Virginia, founded in 1607 on the eastern seaboard of North America. His son would later visit the colony, and they would introduce some of Europe's best loved garden plants. But it was not until the early 18th century that North American plants really made an impact in Europe, as American trees and shrubs were eagerly sought to furnish the newly fashionable gardens in the English landscape style. These were principally the flowering shrubs associated with eastern American peaty swamps, such as dogwoods, kalmias, liquidambars, magnolias and the first rhododendrons, and these were initially distributed, as plants so often are, through networks of friends, in this case members of the Religious Society of Friends, or Quakers. Having excluded from their lives all music, drama, most visual arts and 'pernicious' books such as novels and romances, natural history and gardening offered questing minds an acceptable source of both beauty and intellectual pleasure. American plantsmen from the Quaker colony of Philadelphia shared seeds with English collectors such as Peter Collinson (1694–1768) and Dr John Fothergill (1712–80), reaching a new and rapidly growing nursery trade through London nurseryman James Lee.

The expansion of the new United States led to the botanical exploration of the lands west of the Mississippi by Lewis and Clark in 1804, opening up the Pacific north-west. From here would come the lofty conifers that would change the look of European landscapes once again, not only in terms of gardens but also commercial forestry.

Dahlia

Scientific name
Dahlia

Botanist
Francisco Hernández

Location
Mexico

Date
1577

IT CAN BE hard to believe that today's modern dahlias, so dazzling in colour and so various in form, ranging from the daintiest daisies to elaborate pom-poms the size of a cauliflower, originate from just three species that grew as weeds in the Mexican highlands. They are part of the daisy family, Asteraceae, closely related to *Cosmos, Coreopsis* and *Bidens*, numbering 35 species spread across Central America. Most are medium-sized perennials growing on open ground, but *Dahlia imperialis* can grow as tall as 6m (20ft), while rare *D. macdougalii* is a rainforest epiphyte (a non-parasitic plant that grows upon another for physical support). Their hollow stems are believed to have been used to carry water, and it has been claimed their starchy tubers were eaten by Amerindians as food, but as the ever-curious Francisco Hernández described them as smelly and bitter to the taste, this may have been only in times of extremity.

For centuries it was thought that the first botanical description of the dahlia was made by Hernández (*c.*1514–87), the personal physician of Philip II of Spain, and the first trained naturalist to visit the Americas in 1570. Indeed, this was the first time any ruler had sent a mission abroad with a purely scientific purpose: Hernández was charged with gathering both plants and local knowledge that might prove to be of medical value to Spain. For seven years Hernández scoured Mexico, collecting and investigating specimens, working in hospitals and studying indigenous medicine with local shamans and healers, sometimes testing their remedies on himself. Hernández taught himself Nahuatl (the language of the Aztecs), and as most of the 3,000 plants he collected were entirely unfamiliar, he did not attempt to fit them into any European system, but classified them as the Aztecs did as simply woody or not woody, and gave them their Nahuatl names. He described the therapeutic uses of guiacium, balsams, sassafras, datura,

The lofty daisy-flowered *Dahlia imperialis* by Matilda Smith, from *Curtis's Botanical Magazine*, 1899.

peyote, tobacco and cacao – every one of which would be (albeit briefly) hailed as a wonderdrug in Europe. Hernández has been credited with introducing corn, vanilla, tomatoes and chillies to the European diet. With him travelled three local artists employed to paint the deluge of new plants, as well as many new animals, including the first depiction of an armadillo.

Both the 'acocotli' and the 'cocoxochitl' Hernández describes appear to be daisy-flowered double dahlias. However, it is impossible to be certain, for of the 16 folios of detailed observations Hernández brought back to Spain, only fragments remain. King Philip had the colossal manuscript bound up into six mighty volumes, which disappeared into the royal library, where they remained unpublished and were eventually consumed by fire in 1671. Fortunately, random sections of the manuscript had been copied, and some of these found their way into print after Hernández's death, but it was not until 1651 that a more complete version was printed in Rome, assembled from snippets gathered from across Europe and New Spain, and with illustrations rearranged and redrawn. Nonetheless, it became the definitive guide to Mexican plants for subsequent botanists.

However, in 1929 another long-buried and even earlier source came to light, when an Aztec manuscript herbal dating from 1552 was discovered in the Vatican Library. The authors were Martin de la Cruz, an Aztec physician, who wrote and possibly illustrated the text, and Juannes Badianus, who translated it into Latin. The herbal describes a range of traditional remedies for everything from nosebleeds to lightning strikes, and among the healing herbs illustrated is the red-flowered 'Couanenepilli', possibly *D. coccinea*.

Why Philip II chose to ignore the work he had commissioned from Hernández is unclear. It may be that the botanist's work was considered heretical, for only God had the power to name living things. Or maybe the king was distracted by other things, such as plotting the invasion of England. At all events, it took over 200 years for a second expedition to follow up on Hernández's findings. It was only then, in 1789, that dahlia tubers successfully crossed the Atlantic, sent from the Botanical Garden newly established in Mexico City to Antonio José Cavanilles at the Royal Botanical Garden in Madrid. By 1791, Cavanilles had flowered a double form, purple *D. pinnata*, followed, by 1796, by single pink *D. rosea* and single scarlet *D. coccinea*. From these, over the next 200 years, thousands of new forms would be developed.

It was Cavanilles who named the new genus after Andreas Dahl, a Swedish botanist. However, he died in 1804, just as Alexander von Humboldt and his botanical helpmeet Aimé Bonpland were returning from the Americas (see page 258), bearing quantities of seed which they distributed around Europe. Some went to Kew, some to Germany, some to Paris and some to the Empress Josephine at Malmaison. As these began to flower, they looked very different from the flowers described by Cavanilles. Meanwhile, in Berlin, a German botanist reclassified Cavanilles' plants as a new genus, *Georgina*, a name by which dahlias are still known in parts of northern and eastern Europe.

The variability of dahlias, and their readiness to hybridize, makes them thrilling to gardeners, but the despair of botanists. While taxonomists were tearing their hair out trying to classify them, Josephine was delighting in this unpredictable new flower at Malmaison near Paris, where she appointed Bonpland as director. There is a story that the dahlias were Josephine's pride and joy, and that she tended them so jealously that when she discovered that one of her ladies had stolen a tuber, she destroyed the entire collection rather than have it sullied by unworthy hands.

Meanwhile, plant material was spreading around Europe. The dahlia's arrival in London in 1804 has been attributed to the equally colourful society hostess Lady Holland, and the flamboyant flowers soon became fashionable. First to seize on them were the florists, amateur enthusiasts who rejoiced in breeding and showing flowers to a state of strictly codified perfection. By 1820, around 100 dahlia varieties had been cultivated; by the 1840s, that number had risen to over 2,000 and both Europe and North America were in the grip of 'dahlia mania'. Dahlias grew even more various after 1872, when a Dutch breeder named J. T. van den Berg Jr claimed to have saved, from a shipment from Mexico gone rotten in transit, a single viable tuber, which he named *D. juarezii*. He described it as poppy-red, with 'fine, pipe-like rolled up flower petals'. It was the progenitor of today's spectacular cactus dahlias.

After 200 years of selection and hybridization, dahlias exhibit more variety of colour and form than almost any other genus. There are now over 58,000 varieties, arranged in 19 categories, such as 'waterlily', 'fimbriated' and 'collarette'. More are added every year. There is still no blue dahlia – despite prizes being offered for the first. But surely it is just a matter of time…

Dahlia from E. G. Henderson, *The Illustrated Bouquet*, 1857–64. By the 1850s, pom-pom forms of dahlia were well established.

Tulip tree

Scientific name
Liriodendron tulipifera

Botanist
John Tradescant the Younger

Location
Virginia, US

Date
*c.*1638

IT CAN BE tough following in the footsteps of a famous father. Certainly John Tradescant the Younger (1608–62) found it a struggle. 'He is altogether not taking after his father,' one commentator acidly remarked, 'nor does he have in him one single vein of his father's testicle.'

John Tradescant the Elder (*c.*1570–1638) was a hard act to follow – royal gardener, pioneering plantsman, compulsive collector and the first in a great tradition of British plant hunters. His origins were obscure, but by 1610 he was gardener to Robert Cecil, First Minister to King James I of England and the most powerful man in the land. Tradescant's first plant-hunting mission was relatively modest – travelling to Europe with a budget of £10 to buy fruit trees for Cecil's magnificent new garden at Hatfield House. A second trip took him to the Low Countries, to the new Botanic Garden at Leiden, to Brussels in search of vines, and to the court of the 'Gardener King' Henri IV of France where he met the great plantsman Jean Robin. They became friends, writing and exchanging plants for the next two decades, part of a growing network of plant pioneers across Europe. After Cecil's death, Tradescant joined a diplomatic mission to Russia in 1618 – a country barely known in western Europe till only 60 years before. While the politics were unsuccessful, the enterprising gardener returned with the European larch and sweet-smelling 'Muscovy' rose. Two years later he was on his way to North Africa, ostensibly to fight Barbary pirates. This expedition also failed, but gave him three profitable months collecting in the Mediterranean, and the chance to secure an especially delicious apricot.

Tradescant's next employer was the infamous favourite of the king, the Duke of Buckingham, whom he accompanied to Paris and the disastrous siege of La Rochelle, gathering plants along the way. By the time Buckingham was murdered

Liriodendron tulipifera, from W. P. C. Barton,
Vegetable Materia Medica of the United States,
or, Medical Botany, 1817–18.

in 1628, Tradescant was sufficiently well off to lease a house with a few acres of land in Lambeth by the Thames in London. Here he created a botanical nursery, displaying not only the rarities collected on his travels, but also entirely new plants from across the Atlantic. In 1617 he had taken shares in the Virginia Company, an ambitious venture to establish a new colony in North America. Having paid for the transport of 24 settlers, he was entitled to buy 486 hectares (1,200 acres) of land there. He waived this right, and never made the journey, instead arranging for seeds and bulbs to be sent to him.

His son, however, did make the trip. Scholars disagree on whether John Tradescant the Younger visited Virginia one, two or three times. What we do know for sure is that by 1634, father and son were growing 770 different plants in their Lambeth garden. There was certainly good reason to slip out of the country in 1642: in 1630 Tradescant the Elder had been appointed 'Keeper of Gardens, Vines and Silkworms' at Oatlands, favourite palace of Charles I's queen, and on his death, his son had inherited the position. But following the outbreak of the English Civil War, being a royal gardener suddenly no longer seemed a shrewd career move. Virginia, by contrast, proved rich in opportunity, providing him with around 200 new plants.

Many of their American introductions would become indispensable to European gardens – phlox, michaelmas daisies, the ancestor of our modern lupins, and vivid *Aquilegia canadensis,* a technicolour version of our native columbine. There was the invaluable Virginia creeper (*Parthenocissus quinquefolia*), which would become ubiquitous in polluted post-industrial Britain, as 'it endures the Smoak better than other plants'. There was the lofty swamp cypress (*Taxodium distichum),* the smoke bush (*Cotinus obovatus*) and *Platanus occidentalis*, which would hybridize with *P. orientalis* to create the London plane (*Platanus* x *hispanica*). But perhaps their most admired introduction was the beautiful tulip tree, *Liriodendron tulipifera.* Prized in its homeland as a timber tree (and by the Cherokee nation for building canoes), in Britain it became at once the most desirable of ornamentals, with its distinctively shaped leaves, glamorous cupped flowers and brilliant autumn colour – a feature yet to be appreciated in 17th-century Europe.

Native to the east side of North America, the tulip tree is found from Ontario in the north to the Gulf of Mexico in the south, although fossil records show that prior to the last Ice Age it once grew in Europe. In its American habitat it appears

Liriodendron tulipifera, with a Baltimore oriole,
from Mark Catesby, *The Natural History of Carolina,*
Florida and the Bahama Islands, 1754.

to grow twice as tall as in Europe – sometimes as high as 60m (197ft). Many early specimens came to grief by being grown in greenhouses, but by the early 18th century the tulip tree was relatively common around London. The first in England to flower was in Fulham in 1688.

As well as seeking out plant material, the Tradescants also collected any curiosities they considered of interest – shells, birds' eggs, a stuffed dodo and mysterious 'things changed to stone' (fossils) along with intriguing artefacts such as shields, crystal balls, Inuit snowshoes, Henry VIII's stirrups and a ceremonial cloak said to belong to the father of Pocahontas. Through Buckingham, who served as Lord Admiral of England, sea captains were requested to bring home 'All Maner of Beasts & Fowels & Birds Alyve', but their strangest booty from the sea was surely the object enigmatically described as 'the hand of a mermaid'. These were put on display at Lambeth, open to all at a charge of 6d: 'Tradescant's Ark' became the first public museum in Britain, and a popular London tourist attraction.

So great was the interest in Tradescant's collection that he was persuaded to compile a catalogue – in effect the world's first-known museum catalogue – which appeared, after many delays, in 1656. Helping him in this enterprise was the lawyer Elias Ashmole. He proved a false friend, swindling Tradescant out of his collection while he was drunk; and after Tradescant's premature death, so harassing his widow that she was found dead in her garden pond. Ashmole then presented the collection to Oxford University, where it formed the basis of what is now the Ashmolean Museum. His bequest was not well looked after, and very few of the original artefacts survive. Among the saddest losses is the fleece of the Tartary Lamb – a curious blend of plant and animal. The lamb was supposed to grow on a stalk and graze on the grass around it. Once it had eaten up all it could reach, it starved to death. It was pictured in a book by John Tradescant the Elder's good friend, the botanist John Parkinson. But alas, this strangest of plants has never been found, anywhere on the planet…

Platanus occidentalis, with a summer tanager, by Mark Catesby. His *Natural History* was the first published account of the flora of North America, and stimulated a great desire to acquire these plants among collectors in Europe.

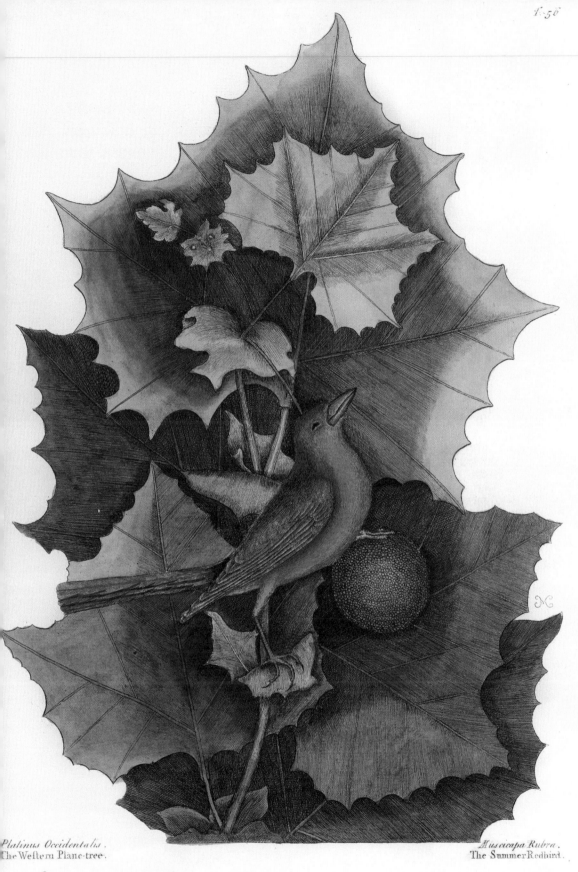

Platinus Occidentalis.
The Weſtern Plane-tree.

Muscicapa Rubra.
The Summer Redbird.

Platanus occidentalis
Willd. sp. pl. 4 p 474
Ait. hort. Kew ed. alt. 5 p 305

Southern bay

Scientific name
Magnolia grandiflora

Botanist
John Bartram

Location
Carolina, US

Date
By 1737

THROUGHOUT AUGUST 1737, a fleet of carriages trundled out of London to Parsons Green on the outskirts of the city, carrying all the luminaries of British horticulture in a state of the highest excitement. For in the garden of Sir Charles Wager, First Lord of the Admiralty, a young, evergreen tree from North America was producing its first bloom. And what a bloom! A huge white waxy goblet, redolent of lemon and vanilla, described by the passionate plant collector Peter Collinson (1694–1768) as of 'water Lillie figure, but as large as the Crown of one's hat'. The painter Georg Dionysius Ehret (who could not afford a carriage) walked every day from his home in Chelsea to sketch it, as it swelled from a 'button to its full unfolding'. His 'perfect botanical study' was published in 1743.

It is difficult to exaggerate the impact of *Magnolia grandiflora* in a country that had only four native evergreens (holly, box, yew and Scots pine) – especially an evergreen that grew quickly and had such bright, lustrous foliage. In reality, the Parsons Green magnolia may not have been the first to flower – it was probably pipped to the post by another belonging to Sir John Colliton in Exmouth, on the south coast of England, which also flowered in the summer of 1737. For many years it provided Sir John with a handy extra income, for so great was the demand for the tree that he would hire it out, a branch at a time, to local nurserymen on a rotational basis. For a colossal fee of half a guinea (they could sell the progeny for five) they were allowed to propagate the tree by layering, supporting tubs of soil on scaffolding that surrounded the tree. Despite this treatment, it grew splendidly, and had achieved a girth of 46cm (18in) when it was cut down by mistake in 1794.

The origin of both these trees is unknown. The date of introduction to Britain

Magnolia grandiflora by Georg Dionysius Ehret, from C. J. Trew, *Plantae selectae Quarum Imagines ad Exemplaria Naturalia Londini*, 1750–73.

and Bartram came to an arrangement. Bartram would send regular shipments of bulbs, roots and seeds which Collinson would distribute among fellow enthusiasts, many eager to include American plants in the gardens they were making in the new natural landscape style. In time, the boxes were standardized – each priced at five guineas and containing seeds of 105 species. For the first time, American seed was available in quantity. Incredibly rare trees like Tradescant's tulip tree (see page 216) could now be planted by the dozen. And the showy *M. grandiflora* became a favourite specimen tree.

So modern and exciting to 18th-century botanists, *M. grandiflora* is in fact a very ancient tree: fossil records reveal that magnolias were among the first flowering plants, widespread in Europe as well as North America and Asia over 100 million years ago. They are pollinated by wingless beetles, which existed many millions of years before winged insects. Curiously, DNA investigations have revealed that one of the magnolia's closest relatives is the humble buttercup.

The native distribution of *M. grandiflora* is in a broad band stretching from North Carolina south to central Florida, then west to eastern Texas. It is an adaptable tree, happiest on the fertile edges of swamps and lakes and along the bluffs of the Lower Mississippi. Growing as a forest tree, it can reach a graceful 27m (90ft) high, but it also grows squatly as scrub on coastal dunes. It now, of course, grows all over the world, from the Italian Lakes to Guangzhou in China, where Robert Fortune (see page 84) saw it employed as a street tree in the 19th century. But it is surely most strongly associated with the great plantation gardens of the American South, arranged in stately avenues of huge dark trees dripping with Spanish moss. There was also, for many generations, a famous example at the White House, planted by President Andrew Jackson in memory of his wife. It was axed in 2018 by Mrs Melania Trump.

Magnolia grandiflora, from H. L. Duhamel du Monceau, *Traité des Arbres et Arbustes que l'on Cultive en France en Pleine Terre*, 1750–73.

Douglas fir

Scientific name
Pseudotsuga menziesii

Botanist
David Douglas

Location
British Columbia, Canada

Date
1827

THERE ARE PEOPLE who are born lucky. Scotsman David Douglas was decidedly not one of them – though he has been lauded as one of the greatest plant explorers who ever lived.

He started well enough. Born the son of a stonemason in Perthshire in 1799, he was apprenticed as a garden boy at ten years old, and impressed successive employers sufficiently to get a job by the age of 20 at the Botanical Gardens of Glasgow University. Here he attended the botany lectures given by William Jackson Hooker, who would later become Director at Kew. The two became friends and botanized together in the Highlands, 'where his great activity, undaunted courage, singular abstemiousness, and energetic zeal at once pointed him out as individual eminently calculated to do himself credit as a scientific traveler'. Hooker recommended him to the Horticultural Society of London, and in 1823 Douglas set out on the first of three missions to North America.

His first trip was to the East Coast and was judged a huge success: in less than a year Douglas collected many new varieties of apples, pears and plums, and all at gratifyingly small expense. The following year, he was despatched to the Pacific Northwest, where his discoveries would both transform European forestry and change the face of the 19th-century garden.

This was a region still virtually unknown to Europeans, save for the hardy fur trappers of the Hudson Bay Company, under whose protection Douglas travelled. It had been explored in 1792 by a British ship captained by George Vancouver (see page 272), and botanist Archibald Menzies had brought back descriptions and dried specimens of many species – including the tree that would become known as the Douglas fir – but no seeds or living plants. Lewis and Clark, leaders of the legendary transcontinental expedition commissioned by Thomas Jefferson in 1804, had also noted the gigantic

Pseudotsuga menziesii, from P. Mouillefert,
Traité des Arbres & Arbrisseaux Forestiers, 1892–8.

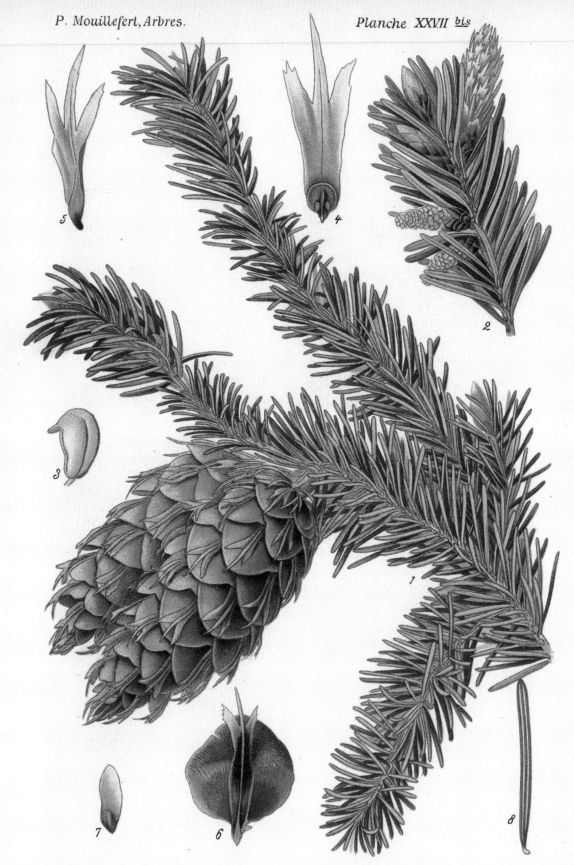

Faux-Tsuga de Douglas. Pseudotsuga Douglasii Carr.

Pseudotsuga menziesii, from E. J. Ravenscroft, *The Pinetum Britannicum*, 1863–84. Douglas's shapely pines were eagerly embraced in fashionable Victorian gardens.

tree, straight as a flagpole, up to 106m (350ft) tall, and collected sprigs of the Oregon grape (*Mahonia aquifolium*) that Douglas would also introduce to cultivation.

It took eight and a half gruelling months to get to the mouth of Columbia river – the last six weeks spent trying to land. 'The hurricanes of North West America', Douglas noted in his journal, were 'a thousand times worse than those of the noted Cape Horn.' On arrival, he found the Hudson Bay Company had transferred their headquarters upriver 145km (90 miles) to the new settlement of Fort Vancouver. There followed two arduous days paddling upstream in an open canoe. This would become the norm: over the next three years, he would travel, he calculated, nearly 11,300km (7,000 miles), either on foot or by canoe, always travelling light, so that often his canoe also served as a shelter.

For two years Douglas ranged through primeval forest and barren upland – often cold, wet and hungry for days at a time, his canoe smashed in a storm, or the settlement he had relied on for provisions deserted, threatened sometimes by angry warriors and sometimes by grizzly bears, or simply stranded in the wilderness with nothing to eat but the roots and berries he had collected. He was often in pain: he had pierced his knee on a rusty nail, and the wound continued to trouble him. But he was creative in adversity: after a spectacularly unfortunate excursion in which he had nearly frozen to death, 'my return up the Columbia was effected by means of my cloak and blanket, which I used as sails.'

His companions were generally tribesmen of the local Chinook villages, who shared with him their knowledge of plants. (He first came across the seeds of the sugar pine, for example, carried as a snack in the tobacco pouches of his guides.) Douglas initially had reason to be suspicious of local guides – on an early excursion one had run off with all his belongings while he was up a tree – but he developed a deep respect for the resourceful hunters he travelled with. To them he was 'the Grass Man' or '*Olla Piska*' a curious, possibly malevolent, species of fire spirit capable of drinking fiercely boiling liquids (in reality he had downed an effervescent health drink), apparently fearless in the face of warfare (he confessed to being more afraid of his host's fleas than the prospect of battle) and a crack shot who could blast a flying eagle from the air.

After a second winter in Fort Vancouver, in March 1827 Douglas joined a party of traders on the annual company 'Express' to Hudson's Bay. This was nothing less

Tab. XVIII.

I. Pinus occidentalis. II. Pinus leiophylla. III. Pinus Monticola.

Pinus monticola, from F. Antoine, *Die Coniferen*, 1840–1.

than a five-month transcontinental march, mainly on foot, sometimes by canoe, made at breakneck speed over the Canadian Rockies to Lake Winnipeg and Grand Rapids, and on to Fort York on Hudson's Bay. From here he would be able to board a ship for England. And as if the trek were not already hard enough, he took a side trip high in the Rockies to scale a 2,790-m (9,156-ft) peak in just five hours, naming it Mount Brown after the eminent botanist Robert Brown, erstwhile keeper of Joseph Banks's library, while a second peak he named Mount Hooker. For 3,210km (2,000 miles) he tramped, with Billy, his dog, and carrying another beloved pet, a young calumet eagle. On meeting the famous Arctic explorer John Franklin, who invited him to share his canoe to cross Lake Winnipeg, Douglas entrusted the bird to the rest of the party. He arrived at Fort York to find it dead, strangled by its own jesses. For once, his customary fortitude deserted him. 'What can give one more pain?' he mourned in his journal. He soon learned. Rowing back from a visit to the ship on which he was to sail home, his small boat was caught in a storm and swept 112km (70 miles) out to sea. Douglas and his companions survived – just – but he was prostrated for the entire journey home.

Douglas returned to England in October 1827 to a hero's welcome, but was unable to settle, and almost exactly two years later boarded ship for Port Vancouver once again. He arrived to find the area ravaged by fever. 'Villages, which had afforded from one to two hundred effective warriors are totally gone; not a soul remains. The houses are empty and flocks of famished dogs are howling about, while the dead bodies lie strewn in every direction on the sands of the river.'

He set off south to California, where between 1830 and 1832, despite his failing eyesight, he saw the lofty coastal redwoods and found three new pines. Now *Pinus sabiniana*, *P. coulteri* and the Monterey pine *P. radiata* augmented the impressive tally of conifers he had collected from the northern forests – not only the Douglas fir but also the Sitka spruce *(Picea sitchensis)*, the grand fir *(Abies grandis)*, the noble fir *(A. procera)*, the sugar pine *(P. lambertiana)*, the western white pine *(P. monticola)* and ponderosa pine *(P. ponderosa)*. 'You will begin to think shortly I manufacture pines at my pleasure,' he wrote to Hooker.

These finds could not have been more timely. For gardens in Europe were starting to change, moving away from naturalistic landscape parks towards a new style that no longer sought to conceal the hand of man. This concept, termed the

'Gardenesque' by 19th-century British garden guru John Loudon, rapidly evolved into the notion that a garden should be a work of art in which plants were displayed to their best advantage, rather like pictures in a gallery. Nothing could have been more suitable for this display than Douglas's newly arrived conifers, planted singly in smooth lawns where all their novelty of shape, size and colour could be appreciated from every angle. And so it was that conifers came to dominate the 19th-century garden, while at great estates such as Chatsworth, a *pinetum* became the latest fashionable feature – an arboretum devoted exclusively to evergreens.

After a trip exploring volcanoes in Hawaii, Douglas returned to Port Vancouver, hoping to make his way to England via New Caledonia, Alaska and Siberia. But unable to reach the point on the coast where he had hoped to take ship for Alaska, he was obliged to turn back. Coming down the Fraser River, he was caught in a whirlpool, his canoe 'dashed to atoms', and lost all his supplies, his journal, his botanical notes and all his specimens. 'The collection of plants consisted of about four hundred species…a few of them new. This disastrous occurrence has much broken my strength and spirits.'

It was enough, even for his stubborn soul. By Christmas 1833 he was back in Hawaii. It would be his last journey. On 12 July, 1834, his faithful terrier Billy was discovered sitting on his coat, and Douglas's terribly maimed body was found in the bottom of a pit trap, trampled and gored by a wild bull. The last person to see him alive was a shady ex-convict who subsequently disappeared, and it was widely assumed Douglas had been murdered.

David Douglas was just 34 years old. In only a decade he brought back 254 plants to Britain, many of them still favourites in British gardens today – the flowering currant *Ribes sanguineum,* handsome silky-tasselled *Garrya elliptica,* papery California poppies, jewel-coloured penstemons and the ancestor of most modern lupins. Trees originally grown for ornament – the Douglas fir and Sitka spruce – have become the dominant timber species in both Britain and the United States. Indeed, it is claimed that no tree in the world produces more wood products for human use than the lofty Douglas fir.

Pinus lambertiana, from E. J. Ravenscroft,
The Pinetum Britannicum, 1863–84.

Giant redwood

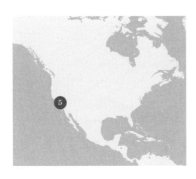

Scientific name
Sequoiadendron giganteum

Botanist
William Lobb

Location
California, US

Date
1852

IN 1852, a decade after securing the monkey puzzle seeds that would grow into the most hotly desired trees in the Victorian garden (see page 272), plant collector William Lobb returned from his next expedition bearing an even more remarkable cargo. His employer, nurseryman James Veitch, was surprised to see him – he had been sent in search of conifers in North America, and was not expected home for another year. But while in San Francisco, Lobb had learned of an extraordinary tree growing in the foothills of the Sierra Nevada in California. A hunter named Augustus T. Dowd, in pursuit of a grizzly bear, had stumbled upon a grove of the most gigantic trees ever seen – the now famous North Grove in the Calaveras National Park. And branches of these towering trees had reached the city – sent to American botanist Albert Kellogg for identification. Lobb dropped everything and set out to find them – discovering in due course some 90 specimens of a veritable 'vegetable monster', which he recorded as 76–97m (250–320ft) in height and measuring up to 6m (20ft) in diameter. He scooped up as many cones, shoots and branches as he could carry, and set off post-haste for Britain – a country already in the grip of conifer mania – where he was certain these monumental trees would make a killing. Within the year, Veitch was offering seedlings of 'the monarch of the Californian forest' at £3/2/0d each, or a guinea each for two dozen. An avenue of 'Wellingtonia' soon became the latest fashionable status symbol in Victorian Britain, not just for the super-wealthy like James Bateman at Biddulph Grange (see page 292) but even for a relatively modest villa.

The Americans were outraged – not least the unfortunate Kellogg, who had planned to publish the tree under the name of *Washingtonia gigantea* in honour of the first president of the United States. John Lindley, of London's Horticultural

This image of *Sequoiadendron giganteum*, from E. J. Ravenscroft, *The Pinetum Britannicum*, 1863–84, shows the previously unimaginable stature of these giant trees.

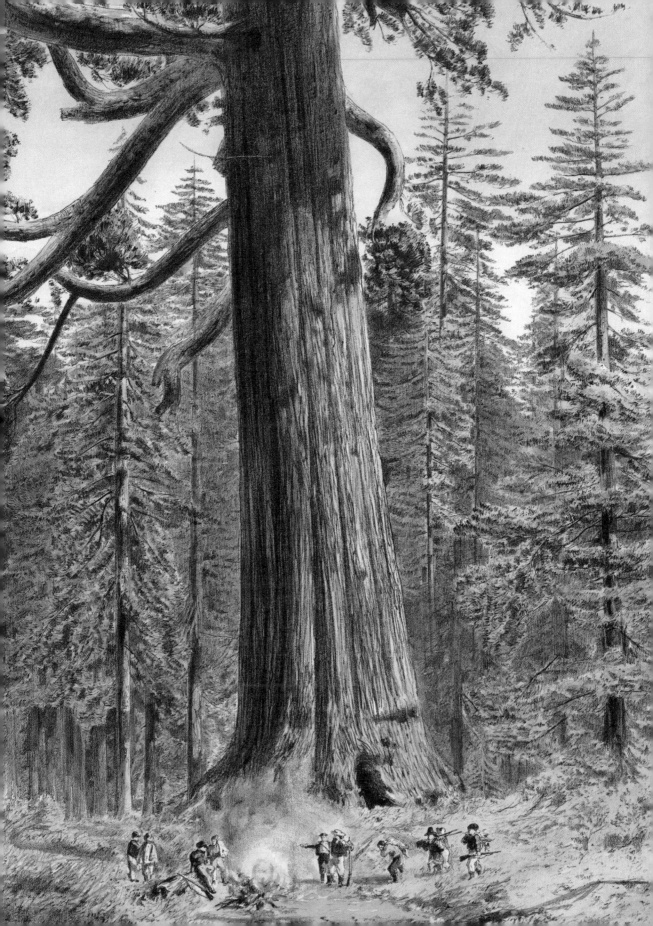

WELLINGTONIA GIGANTEA Lindl.

Society, had pipped him to the post, naming the tree *Wellingtonia gigantea* after the recently deceased Duke of Wellington. In the end, neither name proved valid, and the giant redwood, or 'Big Tree', as it was fondly known, became *Sequoiadendron giganteum*. Perhaps this too was less than ideal: its near relative, the coastal or California redwood, *Sequoia sempervirens*, is generally taller (although the former is greater in volume). Not that the giant redwood is less than impressive: today's tallest specimen, growing in Kings Canyon National Park in California, is taller than a 20-storey building, at an awe-inspiring 94.9m (311.4ft).

Dowd's 'discovery' (the trees were of course well known to the local First Nation population while at least two Europeans had recorded them before) proved disastrous. Within months the largest of the trees was felled. Tourists flocked to view the giant stump and log, now reinvented as a dance-floor, bowling alley and bar, while a section of the hollowed-out trunk became a touring exhibit, accommodating piano recitals for up to 40 people. In 1854, a second tree, known as the 'Mother of the Forest' was stripped of 35m (116ft) of bark, which was reassembled first in New York and later in the Crystal Palace at Sydenham, where it remained until the building burned down. This too was the fate of the tree – defoliated and dying by 1861, and burned to a stump in 1908.

These and further indignities prompted the founding of the national parks system in the United States, led by John Muir, but the trees were not really adequately protected until the 1930s, and today are classed as endangered. Without human interference, the giant redwood can live for 3,000 years – in part because it has evolved so successfully to withstand fire. Indeed, fire is essential to assist propagation, as fires clear the forest floor of competing vegetation while their ashy residue provides optimum conditions for germinating seedlings. The mature trees, with their branches high above the ground and their trunks protected by deep coats of spongy bark (up to 1.2m/3.9ft thick at the base) full of watery sap, are well protected from the flames, while the sudden heat opens the cones and encourages the seed to drop.

Sequoiadendron giganteum, from L. van Houtte,
Flore des Serres et des Jardins de l'Europe, 1845–80.

SOUTH AMERICA

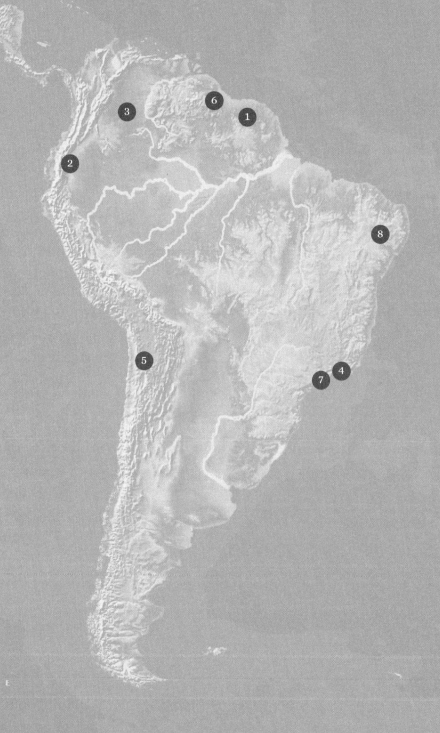

THE AMAZON RAINFOREST in South America is well known as the largest and most biodiverse of the world's tropical rainforests, home to at least 40,000 plant species. The Amazon basin, however, is only the start of South America's botanical riches, found in habitats ranging from boundless wetlands and tangled mangrove forests to salty deserts, tropical jungle, wind-lashed Patagonian steppe and high-altitude Andean habitats. The lowland forests are among the most species-rich on Earth, and the mountain forests and moorlands (*páramos*) of the Andes harbour a wide range of endemic and highly specialized species, including remnants of forest reaching back 300 million years to the age of the dinosaurs, when South America was part of the southern super-continent of Gondwanaland. Indeed, this most bounteous of continents, reckoned to support around 60 per cent of global terrestrial life, has no fewer than five biodiversity hotspots located outside the Amazon rainforest, defined as areas exceptionally high in endemic species and at immediate risk of destruction.

Many plant hunters travelled South America with specific targets in mind – exotic orchids worth their weight in gold, or plants of medicinal value. The great explorer Humboldt went in search of knowledge and adventure, and the incredible diversity of that vast continent, spanning such variety of geography, geology and climate, allowed him to formulate new theories about the distribution of species and the interdependence of all life on earth. For intrepid painters like 17th-century German Maria Sibylla Merian, Victorian globetrotter Marianne North and 20th-century environmentalist Margaret Mee, it was the strange and colourful flora of the rainforest that captivated them. Bold colour was also the attraction of flowers such as petunias and verbenas, which became staples of European summer bedding. In the year 2000, plant hunters Tom Hart Dyke and Paul Winder were captured by guerrillas and held hostage in the jungle for nine terrifying months during an ill-advised orchid-hunting trip in Colombia. Orchid collecting continues to be a contentious issue.

Most plant hunters active in South America today, however, are engaged in conservation programmes, trying to obtain protections for species ranging from monkey puzzle trees to rare grasses, variously threatened by agricultural expansion, new roads, mining and infrastructure projects, and the associated pollution.

In Brazil, home to the richest flora in the world, once described by Brazilian artist, landscaper and plant hunter Roberto Burle Marx as 'the land of enchantment for the botanist', the outlook is particularly bleak.

Peacock flower

Scientific name
Caesalpinia pulcherrima

Botanist
Maria Sibylla Merian

Location
Suriname

Date
1700

IN AUGUST 1699, Maria Sibylla Merian arrived in Paramaribo, the hot, humid and notoriously violent capital of the Dutch colony of Surinam (now Suriname), with a plan to record the region's abundant insect life and the unknown plants that supported it.

Merian (1647–1717) was a very remarkable woman. In an age where few people ever ventured more than 10 miles from home, she had made a perilous sea journey of nearly 8,000km (5,000 miles). At 52 she was, for her time, a woman of advanced years (she took the precaution of making her will before she left) and, scandalously, she was a woman alone, a divorcee, travelling without the protection of any man, with only her 21-year-old daughter for company. To fund the journey, she had sold most of her possessions (although she had been granted a small stipend from the city of Amsterdam). The result would be a book that would astonish Europe with its vivid illustrations and first-hand accounts of tropical jungle wildlife: *Metamorphosis Insectorum Surinamensium* or *Metamorphosis of the Insects of Suriname*.

When Frankfurt printmaker Matthäus Merian was lying on his deathbed in 1650, it is said he predicted a great future for his three-year-old daughter, Maria Sibylla. Just how great, he could not have imagined. For despite the limitations of her gender, her lack of wealth and formal education, and the hostility of men scandalized by her independence of thought, she would become a pioneering naturalist, working at the cutting edge of the new science of entomology and – in an age when science was the elite hobby of gentlemen of means – perhaps the first woman to make a living out of science. She has been acclaimed as both the world's first ecologist and 'the greatest painter of plants and insects that ever lived', admired for both the beauty of her paintings and their accuracy. Contemporaries

Carolina sphinx moth sucking nectar from a peacock flower (*Caesalpinia pulcherrima*), from *Insects of Suriname*, 1726.

the tropical climate they were ready to harvest in six months – yet no-one could be bothered to grow them. She was astonished at the indifference of the colonists to the marvels all around them. They cared for nothing but growing sugar, she complained, and mocked her researches. She expressed horror at their treatment of their slaves – but nonetheless it was slaves she had to rely on, both African and indigenous Amerindians, to travel to the plantations she visited and to venture into the rainforest. It was they who hacked her a path through the jungle and told her about the plants she discovered there. In marked contrast to the colonial settlers, her guides displayed a comprehensive knowledge of, and deep respect for, plants. Merian eagerly recorded the uses they put them to – the castor oil plant provided oil for lamps and was used to salve wounds; the sap from a palm treated worms; the root of Jatropha treated snakebite. She noted the care required to prepare cassava – grating the root and pressing out its poisonous juice, before drying it and baking it into a 'rusk'. More disturbing to her was the use of the peacock flower (*Caesalpinia pulcherrima*), a member of the pea family which occurs widely in tropical and sub-tropical America. It is prized today as a greenhouse exotic for its fine ferny foliage and showy flowers, but was used by pregnant women to induce miscarriage. A troubled Merian wrote:

> The Indian slave women are very badly treated by their white enslavers and do not wish to bear children who must live under equally horrible conditions. The black slave women, imported mainly from Guinea and Angola, also try to avoid pregnancy with their white enslavers and actually seldom beget children. They often use the root of this plant to commit suicide in the hope of returning to their native land through reincarnation, so that they may live in freedom with their relatives and loved ones in Africa while their bodies die here in slavery, as they have told me themselves.

For one of Suriname's enslaved people at least, the understanding of medicinal plants would offer a less drastic road to emancipation. The powerful emetic *Quassia amara*, used in traditional medicine to treat fevers and sickness and to ward off parasites, was named by Linnaeus after its 'first discoverer' Graman Kwasi (*c.*1692–1787), who

Castor oil plant, from *Insects of Suriname*
by Maria Sibylla Merian, 1726.

for 60 years became the colony's leading medicine man, treating African, European and indigenous races alike. Kwasi is a controversial figure, who arrived from Ghana as an enslaved child, but lived to be granted his freedom, to be honoured by the Prince of Orange and to become a planter himself, profiting from his own enslaved workers. For 30 years he kept the secret of *Quassia,* making a comfortable living from his remedies, before selling the secret to a Swedish botanist, who took it back to Europe in 1756. The enslaved Africans revered Kwasi as a diviner or sorcerer, able to protect them with magical amulets; while for the Dutch he was a 'faithful' friend, an invaluable ally in fighting the maroons, rebellious communities of runaway slaves. Among their descendants today, he is still regarded as a traitor.

Kwasi probably did not reach Suriname until after 1701, when a bout of malaria forced Merian to cut short her visit and return to Amsterdam. She and her daughter spent the next four years preparing *The Insects of Suriname.* As the plants were all new to her, and many new to science, she asked Caspar Commelin, keeper of Amsterdam's botanic garden, to help her with botanical descriptions. Very few illustrated accounts of the New World existed before 1705: with its dazzling butterflies, lizards and snakes, terrifying spiders and outsize caterpillars draped over lush tropical foliage, her book caused a sensation. Not only did it announce the incredible diversity of the rainforest but, 150 years before Darwin, presented a view of nature 'red in tooth and claw', where species were engaged in a ruthless battle for survival.

The book did not make Merian much money; she lived by selling specimens from Suriname. She had hoped to follow it up with a second volume on reptiles, but it proved too expensive to produce. When she died in 1717, she was buried in a pauper's grave. Although she was highly respected by 18th-century naturalists, during the following century she fell from grace: posthumous editions of her work were frequently adulterated, while her unladylike depictions of a cruel nature (particularly a nasty tarantula sucking the lifeblood from a hummingbird) were dismissed as both gross and fallacious. Recent scholarship has, however, restored her reputation, both for accuracy, and for introducing, a hundred years before Humboldt, a radical new way of looking at plants as key species supporting complex ecosystems.

Merian's depiction of the ecosystem in a guava tree
featuring a tarantula feeding on a hummingbird caused
consternation among European male commentators.

Fever tree

Scientific name
Cinchona

Botanist
Robert Spruce

Location
Ecuador

Date
1860

The cinchona tree derives its name from the Condesa de Chinchón, beauteous Spanish wife of the Viceroy of Peru. In 1638, the story goes, the countess was languishing on the point of death from malaria, until miraculously cured by a native Quechua remedy made by stirring ground cinchona bark into sweetened water. On returning to Spain in the 1640s, she introduced the bark to her grateful countrymen as a treatment for fever. (Malaria, which, ironically, was unknown in the Andes before the Spanish Conquest, was rife in Europe and Asia until well into the late 19th century; and Carlo Levi was still writing of impoverished southern Italian towns decimated by malaria as late as the 1940s.) Alas, the tale is a flight of fancy: the countess in fact died in Peru. However, the curative powers of cinchona bark had certainly been observed by Spanish missionaries in Lima as early as 1633, and when Father Bartolomé Tafur took some back to malaria-infested Rome in 1645, the fame of 'Jesuit's bark' soon spread.

Not everyone was convinced of its efficacy: Oliver Cromwell deemed it a devilish Popish potion, and preferred to die of malaria. Charles II, however, was successfully treated with a cinchona-based remedy devised by English apothecary Robert Talbor, and recommended it to his cousin Louis XIV: it soon became vastly popular, perhaps because it was liberally laced with opium. At this time the disease was thought to reside in 'miasmas', or noxious vapours in the air ('malaria' derives from *mal aria* – Italian for bad air); the link between malaria and mosquitoes was not fully understood until the 1890s. The active ingredient in the bark was identified in 1820, an alkaloid named 'quinine' by the French chemists who found it. It is still not entirely understood how it works, but essentially by causing the malarial parasite to poison itself. Once quinine could be extracted and dispensed in accurate doses, it could be used not only as a cure but a prophylactic.

Cinchona officinalis, from J. E. Howard, *Illustrations of the Nueva Quinologia of Pavon*, 1869.

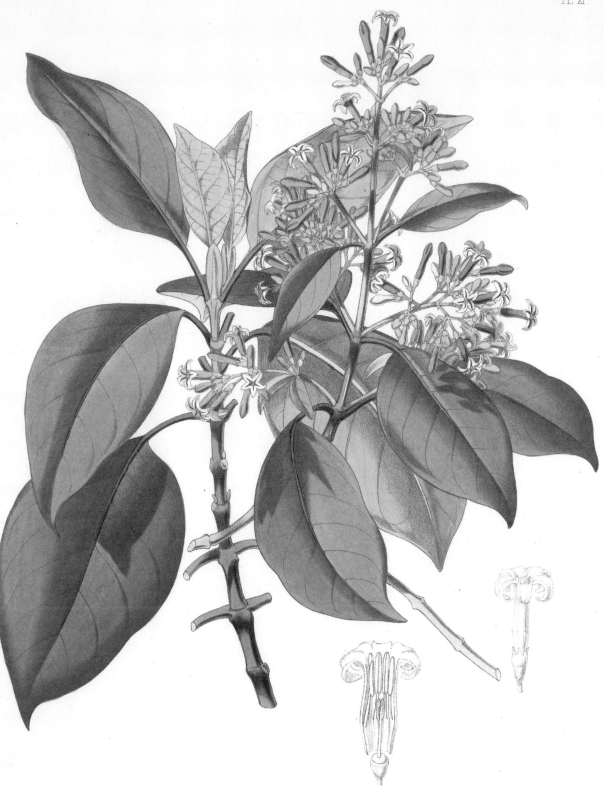

Cinchona bark is the source of quinine, which derives its name
from *quina-quina*, a local name for the tree. From J. E. Howard,
Illustrations of the Nueva Quinologia of Pavon, 1862.

There are 25 known species of *cinchona* (the most recent, *Cinchona anderssonii*, discovered in Bolivia only in 2013), growing in humid montane forest on the eastern flanks of the Andes all the way from Colombia down to Chile. The leaves are glossy and evergreen, the sweetly scented flowers held in loose clusters, most often pink in colour. The trees rarely exceed 12m (39ft) in height. But there is huge variation both between species and even within species in the amount of quinine they contain. As the empire-building nations of Europe extended their rule ever deeper into the tropics, there was an ever-growing need for quinine – just as political instability in South America, along with unsustainable methods of harvest, rendered supplies ever more expensive and uncertain. To secure their own supplies of cinchona – and especially those trees richest in quinine – became an urgent imperial project.

A French expedition to Peru had attempted to bring back live plants in 1745, but they were washed overboard in a storm. British botanists (not least Joseph Banks) were eager to try to establish cinchona trees in India where, by the turn of the century, a million people were dying of malaria every year. But well aware of the value of their monopoly, Colombia, Ecuador, Peru and Bolivia all prohibited the export of cinchona plants and seeds. A Dutch botanist managed to smuggle 500 live plants out of Peru in 1851, but only 75 made it safely to the Dutch East Indies.

By 1858 the India Office, which had succeeded the East India Company in the administration of British India, finally heeded the appeals of the botanists and appointed one of its junior clerks, Clements R. Markham, to gather cinchona – on the grounds he could speak Spanish and had been to Peru. Having scant botanical knowledge, he was advised, before leaving, to consult William Hooker at Kew. Hooker recommended that he employ Richard Spruce, an impoverished but experienced botanist who, despite almost endless ill health and ill fortune, had been successfully sending specimens from South America since 1849. Spruce was a prolific collector, highly regarded at Kew for the detail and accuracy of his notes, who studied the uses of plants as he travelled and had been urging the collection of cinchona for some years. He investigated a whole range of plants employed in the Andes and Amazonian regions – from fibres and dyes, resins and timbers to the stimulant properties of guarana. He was the first to report on the psychoactive Amazonian brew *ayahuasca*, and to provide detailed botanical information on the latex-yielding tree *Hevea brasiliensis*, which would shortly follow cinchona to the British colonies.

In 1860 Markham arrived in Peru, and managed to secure 450 cinchona plants before he was detected and had to flee. His plants were shipped to the Nilgiri Hills in South India, where every one perished. Meanwhile, Spruce was patiently making his way over the Andes towards Chimborazo in Ecuador. It was in the forests beneath the great volcano where the most prized 'red bark' form of cinchona was to be found.

It was a journey full of terrors – largely by open canoe through rapids, whirlpools and falls, over high passes, through dense forests infested with poisonous snakes and caterpillars. Every kind of setback impeded him, from deluges of rain and swollen rivers, to revolutionary warfare (all but one of his collecting team was conscripted by local militias), to unseasonably cool weather that inhibited the seed from ripening. He had struck a deal with a local landowner that for $400 he could take as many seeds and plants as he wanted, as long as he did not touch the bark. 'I began to fear we should get no ripe seeds,' he lamented to his journal, especially when 'one morning, when I made my round among the trees, I found that two of them had been stripped of every panicle, undoubtedly by some one who calculated on selling me the seeds. This was very provoking, for the seeds were far from ripe.' Offering protection money for the remaining trees, however, proved effective: 'I do not think a single capsule was molested afterwards.' More trouble came from the soldiery: 'for six weeks we were kept in continual alarm by the passing of troops, and it needed all our vigilance to prevent our horses and goods being stolen; indeed, one of my horses was carried off, though I afterwards recovered it.' He lived largely on plantains from a deserted farm, until they were all stolen too. And most of the time, he could barely walk: he suffered from a debilitating illness which caused agonizing bouts of paralysis.

Nonetheless, Markham's mission proved successful. Robert Cross, a gardener from Kew who had germinated dried seed Spruce had sent in 1859, eventually joined him in Ecuador, and they set up a cuttings nursery deep in the jungle. As usual, things did not go smoothly. The smell of rotting mules, commandeered by the military then left to die in the jungle, kept them awake at nights. Then, 'In the month of October we had several earthquakes, in one day no fewer than four,' wrote Spruce to his friend, John Teasdale. 'So you see that what with commotions below and above ground earthquakes, revolutions, fires, etc., people live here in

continual alarm.' But by December 1860 they were ready to leave with a haul of young plants and over 100,000 seeds. They made a raft of logs strapped together with bignonia vines to float down-river to the coast. On it were stashed 647 plants, in Wardian cases, lined with calico as glass was deemed too fragile to withstand the journey. They were right: three times the raft smashed into overhanging trees and was badly damaged, yet miraculously every case survived. By the time they were loaded on a ship for Cross to convey them to Kew, 'the plants…bore scarcely any traces of the rough treatment they had undergone…and the only thing against them was that they were growing too rapidly, owing to the increased temperature to which they had lately been subjected.'

According to Alfred Russel Wallace, who edited Robert Spruce's notebook after his death, Spruce's labours 'were crowned with success. The young plants reached India in good condition, and the seeds germinated and served as the

A map of the *cinchona*-rich area of Villcabamba, Ecuador,
illustrated with buildings, rivers, people, animals and
flowering plants and trees.

starting-point of extensive plantations on the Neilgherry [sic] Hills in South India, in Ceylon, in Darjeeling, and elsewhere.' However, Wallace also noted that these plantations were not thriving, and suggested the trees would do better in Malaya or Borneo, where the patterns of rainfall more closely resembled their natural habitat.

In the end it was Dutch Java (modern Indonesia) that would corner the market. Another British adventurer, Charles Ledger, arrived in Peru in the 1830s, and resolved to make his fortune by exporting alpacas to Australia. When that venture failed, he tried his luck with cinchona. Ledger had a secret weapon – a native Bolivian friend and assistant, Manuel Incra Mamani, who was able to identify the trees richest in quinine, and secured him 20kg (45lb) of the very finest seed. In 1865, flushed with triumph, Ledger approached Kew. His timing could not have been worse: as far as the India Office was concerned, the job was done. It was no longer interested in growing on cinchona at Kew, which was now left with a stack of plants to get rid of, and certainly did not want more. In the end, Ledger was able to sell only a pound of seed, for just £20, to the Dutch (plus a small amount to a private planter in India). This variety (named *Cinchona ledgeriana*) prospered in Java's climate (though it didn't in India) and proved, as promised, to have an exceptionally high quinine content. The Dutch would monopolize the global trade in quinine for the next hundred years, while the South American trade foundered.

Colombia experienced a brief revival during the Second World War, when the Japanese took control of Java, and the US sought alternative sources of quinine.

Cinchona calisaya (as *C. pahudiana*), from J. E. Howard,
Illustrations of the Nueva Quinologia of Pavon, 1862.

But by 1944, US chemists had developed a synthetic quinine (actually patented by Bayer in Germany) that proved highly effective against malaria, with fewer side effects. Natural quinine dwindled from wonder-drug to a pleasant flavouring for tonic water. (The myth of gin and tonic as the anti-malarial tincture of the Raj is, alas, just that – a myth.) However, over the years, the malarial parasite has become increasingly resistant to synthetic preparations, so it may be that cinchona has not quite had its day.

Both Ledger and Spruce died in poverty. Spruce spent a further three years in the Andes and the Amazon, studying not only the plants but also the people he encountered, their customs, traditions and languages. Eventually his broken health drove him back to Britain: he could no longer eke out a precarious existence selling his specimens to collectors. Writing to a grumbling client in 1862, he explained:

> I had never calculated on losing the use of my limbs, and yet nothing was more likely to happen, if the sort of life I led be considered…I have met many men who…have made more money in two or three years than I in thirteen, and that without being exposed to thunderstorms and pelting rain, sitting in a canoe up to the knees in water, eating of bad and scanty food once a day, getting no sleep at night from the attacks of venomous insects, to say nothing of the certainty of having every now and then to look death in the face, as I have done.

On returning to his native Yorkshire in 1864, Spruce spent the rest of his life working on his monumental *The Hepaticae of the Amazon and the Andes of Peru and Ecuador*. Published in 1885, and still a key text, it describes over 700 species, 500 collected by himself, of which more than 400 were new to science.

He is not as well-known as he deserves, perhaps because he was a very unassuming man, and the mosses and liverworts that were his particular passion are not the showiest of plants. There is a simple slate plaque, put up in 1970, over the door of the cottage where he ended his days. It commemorates a 'Distinguished botanist, fearless explorer [and] humble man'.

Brazil nut

Scientific name
Bertholletia excelsa

Botanist
**Alexander von Humboldt,
Aimé Bonpland**

Location
Colombia

Date
1800

ON 30 MARCH 1800, a young Prussian nobleman clambered into a canoe bound for the lower reaches of the Orinoco river, in search of a waterway that contemporary science dictated could not exist. Yet there were tales of a secret river deep in the Amazon rainforest that joined that immense river system to the mighty Orinoco, and Alexander von Humboldt (1769–1859) was determined to find it. Over rapids and through crocodile-infested waters he paddled, making copious notes all the way, accompanied by his unflappable companion, French botanist Aimé Bonpland (1773–1858). Week after week they pressed deeper into the jungle, until their supplies were exhausted. They subsisted on handfuls of dry cacao powder and huge nuts that they found on the riverbanks, cracking them open to get at the nutritious seeds within. Eventually they found and mapped the Casiquiare river, which connected the Orinoco to the Rio Negro. When they reached the end of their journey, after 2,250km (1,400 miles) of dodging jaguars, piranhas and boa constrictors, being eaten alive by biting ants and blood-thirsty mosquitoes, and evading – just – the venomous plant and animal life of the Amazon, the travellers were dismayed to learn that they were not, in fact, the first to find the Casiquiare. At least the outsize nut they had discovered was not known in Europe: *Bertholletia excelsa*, the Brazil nut tree.

After this adventure, Humboldt's original plan had been to go north to Mexico. But early in 1801, he learned that an expedition to the South Pacific, which he had hoped to join three years earlier, had finally set off from France. With any luck it would call at Peru towards the end of the year, where he could intercept it and sail on to Australia – which gave him just enough time to send a year and a half's worth of specimens back to Europe, and trek 4,023km (2,500 miles) overland

Bertholletia excelsa by A. von Humboldt,
from *Plantes Equinoxiales*, 1808.

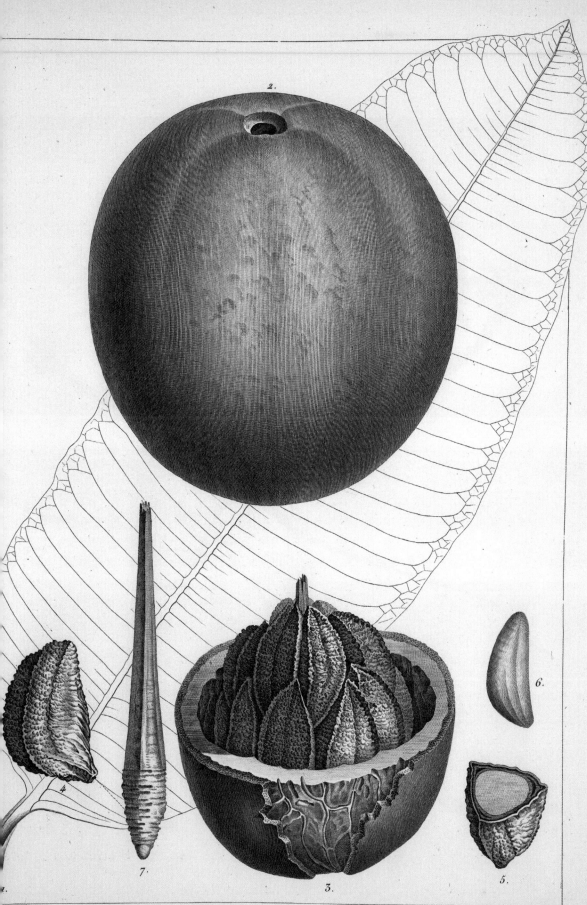

Tableau Physique des Andes et Pays Voisins, from Alexander von
Humboldt, *Essai sur la Géographie des Plantes*, 1805.

across South America, from the northern coast of what is now Colombia through the high Andes to Lima in Peru. On the way he would attempt to climb Chimborazo, a volcano in modern Ecuador then thought to be the highest mountain in the world.

The French ships never did call at Lima, and Humboldt never got to the South Pacific. But he did climb Chimborazo, and it was here, having climbed higher than any man in recorded history, that this visionary scientist came to an understanding about the global distribution of plants that would guide plant explorers from that day forward. More than that, it would change our understanding of science.

The climb was arduous. Their hands and feet torn, and suffering badly from altitude sickness, the explorers made it to a record 6,327m (19,413ft), stopped a frustrating 305m (1,000ft) short of the summit by an impassable deep ravine. Abandoned by their porters, they had lugged heavy scientific instruments up through the snow and along knife-edge ridges, taking measurements all the way – altitude, air temperature, barometric pressure, even the blueness of the sky – and observing the plant and animal life as they ascended. Now, with that strange clarity that comes where the air is thin, Humboldt looked down at the world spread out beneath him and began to see it differently. Science, in all its disciplines, had absorbed him since his teens; by 30, he had published significant works in the fields of botany, physiology and mineralogy. But in looking at the extraordinary manifestations of nature in isolation, he saw he had been missing the point. What really mattered was how things were connected.

The ascent of the mountain, he reflected, had been like a journey from the equator towards the North Pole. They had begun their journey amid humid tropical forest, luxuriant with orchids and palms. Next they had passed through areas of temperate forest similar to that of Europe, giving way to scrub and then an alpine flora not unlike that of the Swiss Alps. As

they neared the snowline, Humboldt saw lichens that reminded him of Lapland and the Arctic Circle. Then after 5,490m (18,000ft), there was nothing at all. Surely there was more to these resemblances than random chance?

For centuries, the study of plants had been concerned with classification, looking at plants in super-close-up detail and pinpointing the minute differences between them. Horticulturally minded plant collectors such as Bartram (see page 222) had widened the frame a little – noting the conditions in which plants were discovered made them easier to cultivate. But it took Humboldt to understand how much more could be learned from taking the panoramic view – seeing plants as part of regional or indeed global patterns, in which altitude, soil, climatic factors and indeed human interventions all played their part. (He was an early observer of just how damaging these interventions could be, detailing the disastrous effects of deforestation in Venezuela.) These patterns would become apparent not just among plants but in all aspects of nature. (Humboldt, for example, invented isotherms – the lines on weather maps which show where the temperature is the same in places across the world.) And all these aspects were interconnected: in a vision that anticipated 20th-century Gaia theory, Humboldt would urge us to think of the world as a living organism, a 'web of life' in which nothing exists in isolation.

To be fair, Humboldt was not the first to observe that plants which shared similar climatic conditions displayed similar characteristics. He had spent long hours discussing the notion of climate zones with his friend Carl Ludwig Willdenow (the botanist who confusingly renamed the dahlia, see page 214), who had already noted that plants of polar regions grow on mountaintops at lower latitudes, speculated that plant diversity increases from pole to equator and suggested that vegetation zones appeared to be arranged according to latitude rather than longitude. What Humboldt did was to build on these ideas, backing them up with comprehensive data and finding an effective way of communicating what he had learned.

This was achieved very largely through a representation of Chimborazo, which he began sketching out almost as soon as he got down from the mountain, and which would be published in 1807 as the centrepiece of his *Essay on The Geography of Plants*. A large fold-out drawing depicted a cross-section of the volcano, showing how plant species were distributed according to elevation. On either side were columns providing related information, ranging from air temperature, humidity, light intensity

and geology to the cultivation of the soil – again all related to elevation. Reference to other mountains showed how these patterns of relationship between plant life, altitude and climate were repeated around the globe. Humboldt's *Naturgemälde*, or 'painting of nature', while immensely dense in detail, could be understood in outline at a glance: in his quest to make his unified vision of nature comprehensible to a non-scientific audience, he had more or less invented infographics.

After reaching Lima, Humboldt and Bonpland continued to Mexico, Cuba and briefly to the US, enjoying a warm welcome from President Thomas Jefferson before returning to Europe in 1804. Their five years in the Americas had yielded 12,000 plant specimens and created new ways of thinking about plants that still inform us today – concepts such as plant communities, ecological diversity and the interrelationship of environment, plant and animal life that we now know as ecosystems.

Humboldt spent the next two decades in Paris, then the scientific capital of the world, exhausting the fortune he had inherited (and which had funded his trip) in publishing the results of his explorations. He brought out 16 volumes on botany (including descriptions of some 8,000 plant species, of which half were new), two on zoology, four books of astronomical and geophysical observations, three on the exploration of the Americas, four on the political economy of New Spain, along with a never-finished travelogue. He wrote over 50,000 letters (and received many more) and was perceived as the lynchpin of European science, his fame second only to that of Napoleon. In 1827 he returned to Berlin, and for the next 30 years laboured on his masterwork, *Cosmos*, a book which sought nothing less than to bring together all that he knew of science and culture in a single holistic view of the universe. He was still working on it when he died at the age of 90. It was a fitting end for a man who insisted that scientific knowledge was always a work in progress, never complete.

Bonpland eventually returned to South America, where he had a chequered career, imprisoned for nearly a decade in Paraguay before becoming a citrus farmer in Argentina. Both men are better remembered now in that continent than in Europe – though both, remarkably, have features named after them on the moon.

But what of the delicious nut that sustained Humboldt and Bonpland in their hour of need?

B. excelsa, the Brazil nut tree, is a splendid example of the complex interrelationships in nature that Humboldt began to grasp on Chimborazo.

The explorers came across the nut in Amazonian Colombia, but it occurs also in the Guianas, Venezuela, eastern parts of Peru and Bolivia, and of course Brazil. The fruit takes a long time to mature – 14 months for the familiar angular seeds (which we call the nuts) to develop inside a hard, round woody shell much like a coconut. The trees are immensely tall (50–60m/164–196ft), rising above the rainforest canopy as 'emergent' trees, and the seed capsule is heavy, weighing up to 2kg (almost 5lb). Yet so thick is the shell (often a centimetre or more) that it does not burst open when the ripe capsule falls to the ground: it takes a determined rodent with teeth sharp as chisels to break open the casing and get to the seeds.

The agouti, a shy, rabbit-sized rodent related to the guinea-pig, plays a critical part in the complex ecosystem on which the Brazil nut depends. There can be as many as 25 seeds packed into the fruit like the segments of an orange, too many for the agouti to eat all at once. So having eaten its fill, it buries some of the seeds for later. Some of these caches will be forgotten, and if light levels permit, the seeds will eventually germinate to produce new trees.

Many attempts have been made to cultivate Brazil nuts commercially – without success. For the agouti is not the only creature vital to the plant's life cycle. The creamy-yellow flowers of *B. excelsa* are pollinated by bees – not any bees, but only female euglossine or orchid bees that are big and strong enough to force their way into the tightly coiled and hooded flowers. These females will mate only with males that seduce them with a specific irresistible perfume, a cocktail of scented wax gathered from various rainforest orchid species, principally *Coryanthes vasquezii*. If these orchids cannot be found nearby, the bees do not mate, the flowers are not pollinated and no nuts are produced.

With such a complicated and highly specialized ecosystem, it has proved impossible to cultivate the trees outside the rainforest: nuts can only be harvested from the wild, from pristine mature forest. As logging and other human activities threaten not only the trees themselves but the crucial orchids, the harvest is at risk – and with it the livelihoods of many thousands of families in the Amazon. Another threat to the harvest is over-collection: when too many fruits are taken, there are not enough young trees replacing the old to keep the population stable.

This was a problem that Humboldt observed with the gathering of cinchona bark for quinine during his South American journey (see page 250). And even

this indicates what a different outlook Humboldt brought to the study of nature. Since the days of Aristotle, it had been axiomatic that nature was created for the benefit of mankind. But in coming to believe that all nature was one vast web of interconnecting strands, Humboldt was approaching a world-view in which, for the first time, humans were no longer central. They could no longer force their will on the planet without considering the consequences.

AGUTI

The agouti, a sharp-toothed Amazonian rodent, is
essential to the dispersal of the Brazil nut.

Bougainvillea

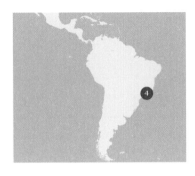

Scientific name
Bougainvillea spectabilis

Botanist
**Philibert Commerçon,
Jeanne Baret**

Location
Rio de Janeiro, Brazil

Date
1767

FOR MANY OF US, bougainvillea is the archetypal holiday plant: while native to large tracts of South America (from Brazil, west to Peru and south to southern Argentina), its vibrant colours (mainly shades of magenta, purple, pink, scarlet and orange) and sturdy resistance to heat, salt and drought, have made it a popular ornamental choice in warm climates worldwide. In Amazonia, however, bougainvillea has long been regarded as medicinal herb, traditionally used to treat respiratory conditions. Current research suggests it possesses valuable anti-bacterial, anti-inflammatory and contraceptive properties, and may even be helpful in treating stomach ulcers and diabetes.

This brilliantly coloured vine is named after soldier, scholar and mathematician Louis-Antoine de Bougainville, who in 1766 was appointed to lead a French mission to hand over the Falkland Islands to Spain. As he had founded the French colony on the Falklands himself (and at his own expense), this was a bitter duty. His consolation was to be commissioned by Louis XV to continue the journey onward round the globe, prospecting for anything that might be of benefit to France and her colonies. It was the first voyage of discovery to be accompanied by a professional scientific team – an astronomer, a cartographer and the distinguished botanist, Philibert Commerçon.

While Bougainville set out on the *Boudeuse*, Commerçon arrived with so much baggage that he was allocated to the mission's store-ship, the *Étoile*. Curiously, he arrived without the servant to which he was entitled, but at the last moment engaged a young man loitering on the quayside, one Jean Baret.

Jean proved an invaluable assistant, already an expert botanist who, according to Bougainville's account of the voyage, uncomplainingly carried Commerçon's huge weight of collecting paraphernalia though forest and jungle, up frozen mountains

*Foliage and Flowers of a Brazilian Climbing Shrub
and Humming Birds* by Marianne North, 1873.

PL. XXX

brought back the exotic vine that Commerçon named after his commander. (The plant was officially named in 1789 by another French botanist, Antoine Laurent de Jussieu, using Commerçon's herbarium specimens and expedition notes.) Jean, however, was not popular with the *Étoile*'s crew, who noted his stand-offish ways and curiously secretive toilet habits.

After 52 weary days battling to get through the Magellan Strait, in April 1767 the exhausted crews landed on Tahiti. Commerçon and Bougainville were enraptured: they named the island New Cythera, and their gushing accounts of its gentle and amorous inhabitants living a peaceful life 'far from the vices and disagreements of the rest of mortals' would prove central to the notion of the 'noble savage' uncorrupted by civilization – so powerful a strand in 19th-century French thinking. For Baret, however, Tahiti was catastrophic – for it was here, according to Bougainville, that 'Jean' was unmasked as Jeanne, Commerçon's long-standing housekeeper, mistress and botanical collaborator. As women were barred from all French naval vessels, if she wished to accompany her master, she had no choice but to bind her breasts and masquerade as a man. Commerçon ungallantly claimed to have no part in the deception: this seems unlikely, as Baret was the main beneficiary of his will. Worse was to follow: according to the journal of the ship's surgeon, on reaching Papua New Guinea, Baret was waylaid on shore and gang-raped by the crew.

Having sailed to within 160km (100 miles) of Australia before being deflected by the Great Barrier Reef (thus leaving the coast clear for Cook and the *Endeavour*), the expedition arrived in November 1768 at the French colony of Mauritius (then Isle de France) in the Indian Ocean. When the ships departed, Commerçon and

the now pregnant Baret did not rejoin them, having allegedly received orders to remain and explore the natural history of Mauritius, its neighbouring islands and Madagascar. (These orders may have been genuine, rather than merely an attempt to avoid scandal: the Governor, Pierre Poivre, was a noted naturalist, and the ship's astronomer was redeployed at this point to India, to observe the forthcoming transit of Venus.)

For the botanizing pair, this new scenario was no hardship. Commerçon collected mineral samples from hitherto unexplored volcanoes, noted the many forms of endemic wildlife on the islands and declared Madagascar to be a 'promised land' for naturalists, its 'models of nature' thrillingly different from any encountered elsewhere. His health, however, continued to decline and, still nursed by the loyal Jeanne, he died early in 1773, aged just 45.

Bougainville arrived at St Malo on 16 March 1769, the first Frenchman to circumnavigate the globe. He was greeted as a national hero. This did not save him from imprisonment during the French Revolution. (He was, after all, scientific adviser to Louis XVI.) But he was released at the end of the Terror and, grateful to have survived, retired to Brie with the intention of living quietly and growing roses. However, in 1799 he met Napoleon, who admired him greatly and propelled him back into public life as a senator, making him a count for good measure.

A year after Commerçon's death, Jeanne, left alone and penniless, married a French solider, Jean Dubernat, and in 1775, the pair returned to France with all Commerçon's papers and 6,000 specimens. In so doing, Jeanne became the first woman to circumnavigate the globe. She was able to claim her inheritance, and in 1785 was forgiven her 'indiscretion' and awarded a government pension of 200 livres for her work with Commerçon. She died in 1807, aged 67.

In addition to Baret's haul from Mauritius, Commerçon had shipped back 34 cases of plants, seeds, fish and drawings to Paris before he died. Today, 1,735 specimens, including five herbarium specimens of bougainvillea, are listed under his name at the French National Museum of Natural History. At least some of them should more properly bear the name of Jeanne Baret.

Bougainvillea spectabilis, from J. Paxton, *Magazine of Botany and Register of Flowering Plants*, 1845.

Monkey puzzle

Scientific name
Araucaria araucana

Botanist
Archibald Menzies

Location
Chile

Date
1795

IN MARCH 1795, the HMS *Discovery*, towards the end of its four-year circumnavigation of the globe, made landfall at Valparaiso in Chile. The captain, along with the ship's surgeon, naturalist Archibald Menzies, was promptly invited to dine by the splendidly named Governor-General of Chile, one Don Ambrosio O'Higgins de Vallenar. (His illegitimate son, Bernardo O'Higgins, would later lead the Spanish colony to independence.) Among the sumptuous dishes was a dessert including some unfamiliar nuts. Intrigued, Menzies slipped them into his pocket and sowed them on returning to the ship. This account has been disputed by some, on the grounds that these pine nuts, rather like chestnuts, are delicious when roasted, but somewhat indigestible when raw. But whether it was these nuts Menzies sowed, or fresh ones he collected on the long ride back to the ship, by the time he returned to England six months later, he had five (possibly six) healthy saplings of the majestic monkey puzzle tree (*Araucaria araucana*, originally *A. imbricata*).

That the saplings should make it home was little short of a miracle. Relations between Menzies and ship's captain George Vancouver were strained. Vancouver resented the space that Menzies' 'garden hutches' took up on deck, ignored his complaints that the plants were being gnawed by rats and burned by tarry drips from the rigging, and repeatedly refused him permission to go ashore to botanize. When Vancouver reassigned the servant employed to care for the plants to nautical duties, with the result that most of Menzies' finds were destroyed in a storm, there was a furious row and Menzies was placed under arrest. A month before his homecoming, a plaintive letter to Joseph Banks lamented, 'I can now only show the dead stumps of many [plants] that were alive and in a flourishing state when we crossed the equator for the last time.' Nonetheless, two young trees were

Puzzle-Monkey Trees and Guanacos, Chili. This painting by Marianne North in 1885 shows the trees in their mature bare-trunked form.

planted in Banks's own garden, and three at Kew, where one survived till 1892.

A. araucana is a tall, coniferous evergreen, native to southern Chile and Argentina, growing chiefly in temperate rainforest on the lower slopes of the Andes. The first European to discover it, around 1780, was the Spanish explorer Francisco Dendariarena, engaged by the Spanish government to seek out timber trees for shipbuilding, for which it proved very suitable. But the craze for the monkey puzzle as an ornamental tree began in the 1820s, when James McCrae, a collector for the Horticultural Society in London, returned from Chile with a small consignment of living plants (most had been spoiled by seawater) and seeds variously packed in paper, sand and sugar. Twelve saplings were distributed to eager subscribers in 1826, and within a few years the first nurseries were offering the 'Chili pine' for sale at excruciating expense. No doubt the cost added to the cachet: Sir William Molesworth paid 20 guineas for the specimen he planted in the 1830s at Pencarrow. It was one of Moleworth's guests, barrister Charles Austin, who famously observed that to climb so prickly a tree 'would puzzle a monkey'. In 1843, the first avenue was planted out at Bicton in Devon, and caused a sensation. By this time, seeing the market opportunity, nurseryman James Veitch had sent the first ever commercial plant collector, William Lobb, to South America in search of further seed, where he was temporarily puzzled, like the imagined monkey, by the prodigious height and unclimbable nature of the trees. He solved the problem by shooting down the cones, and was able to send over 3,000 seeds back to Exeter.

Soon the monkey puzzle became the 19th-century equivalent of the Porsche or Prada handbag. Nowhere was it used with more aplomb than at Elvaston Castle in Derbyshire. Here the 4th Earl Harrington, cast out from polite society for marrying his actress mistress, made for his bride 'the biggest wedding present in the world', a garden made on a theme of chivalric love. No-one else was allowed to enter the garden, which used small monkey puzzles as dot plants in flower borders (a practice which would be widely copied), while a star pattern of beds centred on an 8m (26ft) tree 'of a curious pendent shape'. In addition there were at least three avenues containing araucarias – over a thousand plants in all. It must have cost a fortune. But by 1856, four-year-old plants that had fetched 2–5 guineas 20 years previously were selling for just two shillings, and even modest suburban homes could aspire to a monkey puzzle. They were planted in their thousands, with scant

Male cone of *Araucaria araucana* (as *A. imbricata*)
by Mary Anne Stebbing, Kew Collection, 1946.

regard for the fact that, in their natural habitat, they can grow to 50m (164ft) and live for a thousand years. They were not well adapted for city living, as amateur naturalist and antiquarian Sir Herbert Maxwell noted in 1915:

> There is no tree which has suffered so much from injudicious planting among inappropriate surroundings…and I know of no more dismal object in the world of plants than an araucaria stuck down in front of a suburban villa, stifled with smoky deposit, retaining a despairing grip on life, whereof the only visible sign is the green tips of its poor blackened branches.

Today, over a third of the world's conifers, including the monkey puzzle, are threatened with extinction in the wild. Prized as a timber tree for its colossal straight trunks, durability and resistance to fungal decay, populations of *A. araucana* dating back 200 million years have been decimated in little over a century by over-logging. This was outlawed (in theory) in 1976, when the tree was declared a 'Natural Treasure' in Chile. However, growing as it does in a habitat that is vulnerable to fire – not least from volcanic activity – it remains at risk. In the last decade, thousands of hectares of araucaria forest have been destroyed by fire: today only 200,000 hectares (500,000 acres) remain.

The International Conifer Conservation Programme, led by Martin Gardner, was established at the Royal Botanic Garden Edinburgh in 1991 and is now one of the most comprehensive *ex-situ* conservation networks for threatened woody plants anywhere in the world. It has succeeded in establishing over 200 'safe sites' in Britain and Ireland, including an extensive recreation of Chilean habitat at Benmore in Scotland. Together, these sites offer shelter to over half of the world's critically endangered conifers. Meanwhile, conservation efforts in Chile, in collaboration with partners such as Rainforest Concern and Chilean NGO Fundación FORECOS, have resulted in the creation of the Nasampulli Reserve. This 1,650-hectare (4,000-acre) private reserve of primary Araucaria forest is home not only to ancient trees, but also pumas, wild cats, the world's smallest deer and a mouse-like marsupial known as the *monito del monte*, or 'little monkey of the mountains' – another 'living fossil' species as ancient as the trees it lives among.

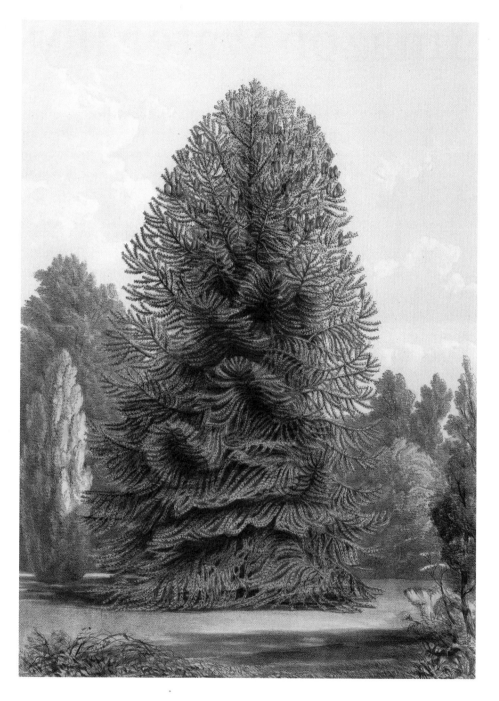

Araucaria araucana, from E. J. Ravenscroft,
The Pinetum Britannicum, 1863–84.

Amazon water lily

Scientific name
Victoria amazonica

Botanist
Robert Schomburgk

Location
Guyana

Date
1837

EXPLORER ROBERT SCHOMBURGK was explicitly *not* engaged as a plant hunter: these were the clear instructions of London's Royal Geographical Society, who sent him in 1835 to survey the entirely unknown interior of Britain's newly acquired colony in South America, now to be known as British Guiana. In a letter of rebuke from the Society, displeased that his exploration of the Essequibo river had been curtailed by an insurmountable waterfall, he was reminded that mapping these uncharted lands must take clear precedence over botany. But as the Society had granted him insufficient funds for this task, and required him to complete it at his own expense, the only way to keep afloat (literally – the interior was a labyrinth of rivers) was to gather orchids for sale to Loddiges nursery. Enough of them survived in protective Wardian cases to gather funds for a second expedition. But on the whole, Schomburgk had to concede, his plant collecting had been lamentable. His first cache of plants, along with most of his geographical notes and equipment, had been lost when one of his two canoes was overturned in rapids. On his second journey, his canoe had been stolen. And like Aimé Bonpland before him, he struggled to dry plants for herbarium specimens: if they weren't eaten by insects they went mouldy in the ceaseless rain. So as he struggled up a third river system on New Year's Day in 1837, tormented as ever by mosquitoes, low on supplies and with an ailing crew, his hopes for the year ahead could scarcely have been lower. Having forced their way upstream through innumerable obstacles, the river widened to a calm basin, and all at once, the dejected traveller couldn't believe his eyes…

Guiana, according to the Elizabethan explorer Sir Walter Raleigh, was, or had been, the site of El Dorado, the mythical city of gold for which Europeans had searched in vain. Now Schomburgk had struck gold – botanical gold. Floating on

Lithograph of opening flower of *Victoria amazonica* by Walter Hood Fitch, from W. J. Hooker, *Victoria Regia*, 1851.

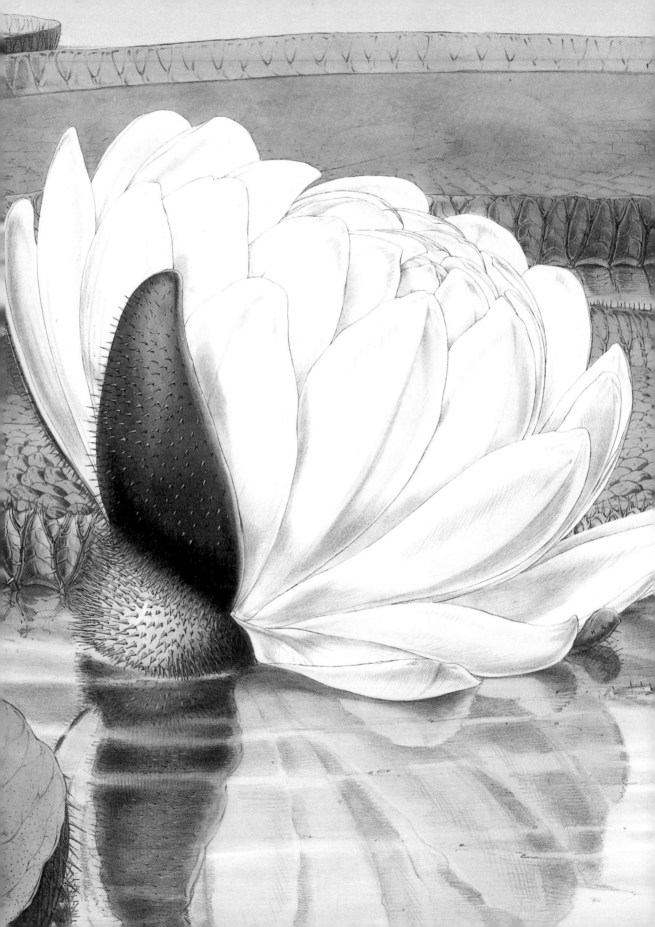

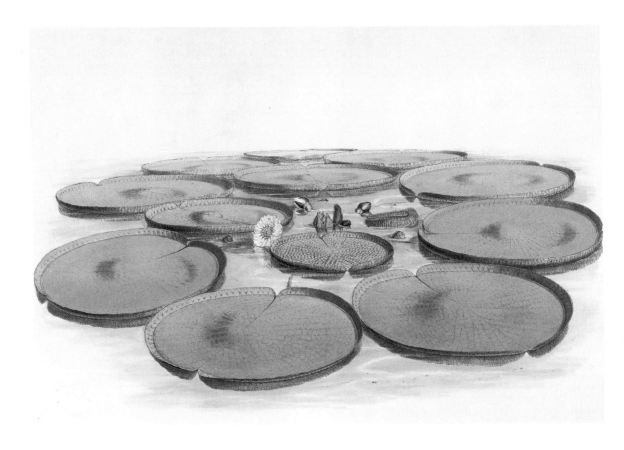

the muddy water were gigantic 'salver shaped' leaves, 1.5–1.8m (5–6ft) across, 'with a broad rim of a light green above, and a vivid crimson below'. Then, 'quite in character with the wonderful leaf was the luxuriant flower consisting of many hundred petals passing in alternate tints from pure white to rose to pink.' Schomburgk's path was blocked once more – but this time by headily fragrant water lilies of inconceivable size and splendor: truly, in that oft-repeated Victorian phrase, a 'vegetable wonder'.

In fact, it would be another few months (June 1837) before Victoria's reign began. But Schomburgk at once conceived the idea of dedicating this most splendid of flowers to the young princess, and as soon as he returned from this third expedition he worked up a large oil painting from the notes and sketches he made at the scene, which he humbly suggested might be presented to Her Highness by the Society. By the time they reached England, Victoria was queen,

Victoria amazonica by Walter Hood Fitch,
from W. J. Hooker, *Victoria Regia*, 1851.

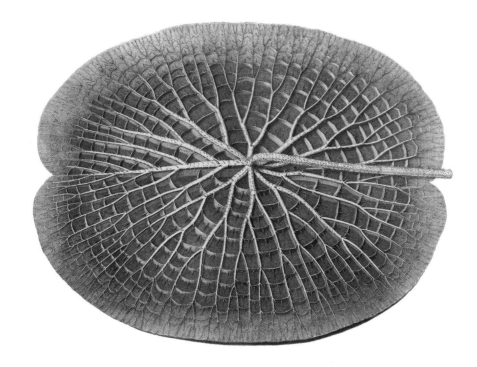

The blooms of *V. amazonica* may be large (up to 30cm/12in across) but each is surprisingly short-lived. In the wild, they are pollinated by nocturnal beetles. The flowers open at sunset, white in colour to attract the insects, and emitting a powerful sweet scent which has been likened to both pineapples and butterscotch. And to tempt them further, the flowers are 'thermogenic', meaning they produce heat. Into this warm, sweet-smelling bower fly the beetles, where they feed contentedly into the night while the flower closes around them. Here they stay cosily throughout the next day, transferring pollen from their bodies onto the stigma, while the flower changes gradually from white to deep pink. As darkness returns, the flower, no longer scented, opens once more, releasing pollen from the stamens arranged in a circle round the exit route. As the beetles, now sticky with plant juices, make their escape, the pollen attaches to them, to be carried to the next white flower. Within hours the rose-pink flower, having performed its task, sinks down towards the river floor. Schomburgk ended his days growing flowers in Santo Domingo – his hour of glory equally transient.

Victoria amazonica by Wiliam Sharp, from J. F. Allen,
Victoria Regia or the Great Waterlily of America, 1854.

Heliconia

IT WAS A WARM, quiet night in November 1822, and Maria Graham was sitting out on the verandah of her friend's house in Chile, where she had gone to nurse a young relative who had become dangerously ill. All at once there was a flash of lightning, and then…

the house received a violent shock, with a noise like the explosion of a mine. I sat still…until, the vibration still increasing, the chimneys fell, and I saw the walls of the house open…We jumped down to the ground, and were scarcely there when the motion of the earth changed from a quick vibration to a rolling like that of a ship at sea…

Scientific name
Heliconia

Botanist
Maria Graham

Location
Rio de Janeiro, Brazil

Date
1825

Quickly she rushed to drag out the sick young man, and watched as the newly built house collapsed. But Graham had the presence of mind to make detailed observations, including the 'large rents' that appeared along the seashore and rock forced up out of the water in Valparaiso Bay. Such violent uplift, she went on to speculate, might have been involved in the formation of the Andes – a notion that would inform Charles Lyell's groundbreaking theories on the formation of landmasses. (Later her account would be questioned: as a woman, it was alleged, she would have been far too frightened to make accurate observations during the quake.)

It had not been a good year for Maria Graham. A well-travelled sea captain's wife in her 30s, she had arrived in Valparaiso in April 1822, bearing the corpse of her husband, who had died rounding the Horn. Once he was decently buried, she was expected to rush back to England, but instead scandalized local society by taking a small cottage wreathed in roses, and going botanizing in the hills accompanied

Heliconia, from the Flora of Rio de Janeiro Collection, by Lady Maria Callcott, Kew, 1825.

only by a peon. She sent seeds to her brother Robert Graham at the Royal Botanic Garden in Edinburgh and collected bulbs that she later passed on to the celebrated Vineyard nursery in Hammersmith, in London. She used her fluent Spanish to learn from local women the uses of the plants she gathered, and also to involve herself in the politics of the newly independent nation. Her friendship with Lord Cochrane, engaged by Chile to command its navy, caused much malicious gossip. And maybe it was this, or just the simple desire for a house with four walls after weeks in a tent rattled by aftershocks, that persuaded her it was time to return to Britain.

She set off by way of Rio de Janeiro where, rather to her surprise, she was offered a job as governess to the Brazil's royal princess – the future Queen Maria II of Portugal.

Graham made a hasty dash to England to get her publishing affairs in order. She had earned her living as a writer since her travels in India, following her marriage to Thomas Graham in 1809, had been turned into two highly successful books. These described not only the 'manners and habits of [India's] natives and resident colonists' but also the richness of the country's plants. She was especially struck by the Botanic Garden at Calcutta, where she met William Roxburgh (see page 97) and admired the exquisite paintings he had commissioned to illustrate his mammoth *Flora Indica*. It may well have been Roxburgh who encouraged her lifelong interest in the practical and economic uses of plants, which she considered as really more important than their classification.

Graham returned to Rio in September 1824, but her appointment was short-lived: she was dismissed by the emperor just six weeks later. But before she had left Britain, she had been introduced to William Jackson Hooker, Professor of Botany at Glasgow, who became a regular correspondent. She wrote to him of the 'Jiquitibà' tree (possibly *Cariniana legalis*), used for ship masts because it is so tall and straight, of the silk cotton *Bombax pentandrum* growing in her hedge and 'half a dozen kinds of Cactus as grotesque as possible'. And for the remainder of her time in Brazil, she sent him plants, including 'twenty two Varieties of Fern all growing between my cottage in the Larenjeiras & the top of the Corcovado on Granite rock 1700ft high'.

Like most middle-class young women, Graham had been taught to draw, and while she had no great confidence in her artistic abilities, they would serve, she

felt, at least to render the correct colours of flowers and leaves, for like many fellow collectors in hot and humid South America, she had trouble preparing dried specimens. 'I do not habitually draw flowers,' she wrote, 'but I could do that – & also any peculiar form of seed &c. – Only let me know how I can be useful & I will try to be so.' Between 1824 and 1825 she made around a hundred drawings of Brazilian flora, noting when and where each plant had been found, and very often depicting it against its landscape habitat, as with the *Heliconia* shown on page 285.

Heliconia is named after Mount Helicon, the seat of the Muses, the nine goddesses of the arts and sciences in Greek mythology. Formerly considered part of the banana family, *Heliconias* now occupy the sole genus of in the family of Heliconiaceae, which occurs widely throughout the tropical forests of the Americas. (Some species are also found in the islands of the Western Pacific.) The long, drooping, brightly coloured 'flowers' are not really flowers at all, but are made up of waxy bracts (a leaf structure at the base of a flower), with small true flowers hidden inside. The bracts are usually vividly coloured – red, orange, yellow, purple, pink, green or any combination of the above. They are chiefly pollinated by hummingbirds, although some species are also pollinated by bats.

At the end of 1825 Graham returned to England to a literary life, writing on art and history and producing several books for children which somehow always sneaked in an element of botany. (Her last book was an account of plants mentioned in the Bible.) In 1827 she married Notting Hill landscape painter, Augustus Wall Callcott, who ten years later received a knighthood. The energetic young woman so voracious for knowledge she had been dubbed the 'metaphysician in muslin' was now a respectable invalid, Lady Callcott. She died, after years of crippling illness, in 1842, remembered as the author of *Little Arthur's History of England,* a children's history that remained popular for a century, while her contribution to science was forgotten.

Senna alata, from the Flora of Rio de Janeiro
Collection, by Lady Maria Callcott, Kew, 1825.

much diminished the upper
being often 4 inches in length
proportion.

Nat. ord. Leguminosae
_____ monogynia

The lower leaves always reverse

Orchidelirium

Scientific name
Cattleya labiata

Botanist
William Swainson

Location
Brazil

Date
1818

IN 1818, BRITISH plant hunter William Swainson had a consignment of rare plants ready to despatch from the forests of Brazil. Spotting some robust, leathery leaves, he wrapped them round his treasures and sent them off to Britain. On opening the box, the recipient, William Cattley, was intrigued by this unorthodox packaging and coaxed it into growth, to be rewarded by enormous, frilly, lavender blooms. The plant was named in his honour, *Cattleya labiata*. And as news of this remarkable plant spread, so began a passion that would soon hold Britain, indeed all of Europe, in its thrall – a mania for orchids so intense it became known as 'orchidelirium'.

Nineteenth-century Europeans were by no means the first to treasure orchids. The orchid was one of the 'Four Gentlemen' of Chinese art and horticulture, a symbol of spiritual refinement honoured by Confucius as the 'king of fragrant plants', and later prized by the shoguns of Japan. In Java, orchids were the mantle of a goddess, left on earth. In 16th-century Mexico, the vanilla orchid flavoured the Aztecs' chocolate drinks, while the Turks ground orchid roots into an aphrodisiac ice-cream.

Europe, of course, had plenty of orchids of its own: there are well over 28,000 species, spread across every continent except Antarctica. And tropical orchids had been seen before – one from the Caribbean island of Curaçao blooming in Holland in 1698, while another from the Bahamas was flowered by plantaholic London merchant Peter Collinson (see page 224) in 1725. Between 1760 and 1813, Kew acquired 46 tropical species. But none approached *C. labiata* in splendour. The trouble was, Swainson had disappeared without trace (it turned out he had sailed to New Zealand), and no-one knew where more of these spectacular orchids might be found. Botanist George Gardner hunted high and low and twice believed he had found the

Cattleya labiata, from R. Warner,
The Orchid Album, 1882.

constant votaries' but also provide 'an entertainment...which might attract the man of pleasure by its splendour, the virtuoso by its rarity and the man of science by its novelty and extraordinary character'. One such man of science was Charles Darwin (1809–82), also an orchid-fancier, who in 1859 published *On the Origin of Species*. This world-changing book set out his controversial theory of natural selection, to the profound dismay of the pious Bateman. Nonetheless, in 1862 Bateman sent him a batch of unusual orchids from Madagascar, including the beautiful star-shaped *Angraecum sesquipedale*, distinguished by its exceptionally long nectary, a spur almost a foot (30cm) in length. Only an insect with an unusually long proboscis would be able to pollinate it, observed Darwin, and speculated that somewhere in Madagascar must be some kind of moth (the orchid released its scent by night) with a proboscis able to extend some 10 or 11 inches (25–28cm).

Darwin had been thinking about the relationship between plants and insects since at least 1839, noting how flowers and insects became adapted to each other until they fitted together like a lock and key. Each profited from this co-adaptation: the insect enjoyed an exclusive source of nectar, while the plant, by 'choosing' a very specific pollinator, ensured its pollen would not be wasted on other species. *A. sesquipedale* (also known as the star or comet orchid) offered the perfect demonstration of this, as Darwin described in his snappily titled *On The Various Contrivances By Which British and Foreign Orchids are Fertilised By Insects And on the Good Effect of Intercrossing* (1862). This feature was particularly evident in orchids, which did not disperse their pollen, but relied on pollination by (often very specific) insects, birds or bats, frequently luring them by crafty mimicry. (Certain bee orchids, for example, emit the scent of female bees, tricking males into trying to mate with them, only to leave disappointed and coated in pollen; so-called 'pseudocopulation' occurs in two thirds of orchids.)

There was no sign, however, of the long-tongued moth Darwin had predicted, prompting much ridicule among his critics. And indeed, it was never found in his lifetime, but in 1903 an enormous hawkmoth was discovered in Madagascar. Its proboscis, which it carried coiled up like a hose-reel, was 30cm (12in) long: it was named *Xanthopan morgani praedicta* – *praedicta* translating as 'the predicted one'. This was perhaps premature, as no-one had actually witnessed the moth visiting the orchid; it would not be until 1992 – 130 years after Darwin's hypothesis – that

51.

2 3

Angraecum Sesquipedale Lindl.

their interaction was finally observed. Video evidence was captured by American biologist Phil de Vries in 2004 and makes gripping viewing on YouTube.

'In my examination of Orchids, hardly any fact has so much struck me as the endless diversity of structure... for gaining the very same end, namely, the fertilisation of one flower by the pollen of another,' wrote Darwin. Orchids offered compelling evidence of evolution in action – vivid examples of natural selection delivering a whole range of mechanisms that would ensure the perpetuation of the species.

This was anathema to Bateman, who, like most of his peers, believed in the Biblical account of creation, and insisted this wondrous variety was instead proof of God's beneficent plan. 'Ferns and flowerless plants came early in the divine programme...while the genesis of Orchids was postponed until the time drew near when Man, who was to be soothed by the gentle influence of their beauty, was about to appear on the scene.' It was certainly the 'endless variety of the tribe' that appealed to Bateman's aristocratic readers, such as the 6th Duke of Devonshire, who had his head gardener Joseph Paxton busily building orchid houses at Chatsworth. In 1836 they sent senior gardener John Gibson to India and Burma (see page 94), whence he returned with over a hundred orchids. By 1838 Paxton had 83 varieties in flower at Chatsworth, but when two Chatsworth gardeners were drowned on a mission to America, they lost heart for any further expeditions.

Orchid hunting was dangerous. French explorer Aimé Bonpland, who travelled with Alexander von Humboldt (see page 258) at the turn of the 18th century, was imprisoned in Paraguay for over a decade. Others came to a sticky end: William Arnold was drowned in the Orinoco River; David Bowman died of dysentery in Bogotá; both German collector Gustav Wallis and the tireless George Ure Skinner died of yellow fever, Ure just a day before he was due to return to England. Albert Millican, who found fame in 1891 with his *Travels and Adventures of an Orchid Hunter*, survived five perilous trips to the Andes, only to be stabbed to death on the sixth. Others were variously shot, burned or eaten.

Many of these unfortunates were employed by commercial nurseries. First in the field were the Veitch nurseries, who began by sending William Lobb to the Americas, then despatched his brother Thomas to the Far East in 1843, specifically in search of orchids. But by the end of the century it seemed every tropical hotspot was swarming with collectors and competition was cut-throat: collectors were

Angraecum sesquipedale, original illustration by Aubert du Petit Thouars, from *Curtis's Botanical Magazine*, 1859.

known to threaten each other with guns and ruin each other's collections by peeing on them. Collecting practices could be lamentable: thousands of trees were cut down to reach the orchids growing in their canopies; collectors would denude whole tracts of forest of plants, and what they couldn't carry away they would destroy. In this way they maintained the rarity of their plants and boosted the exorbitant prices they commanded at auction (by 1910 orchid-fanciers would pay 1,000 guineas for a new variety) but all too often what they left behind was environmental holocaust. In 1878, *The Gardener's Chronicle* announced the imminent arrival of a shipment of two million orchids from Colombia, while Frederick Sander, most famous and ruthless of orchid entrepreneurs, claimed to have imported from New Guinea over a million specimens of a single species. Sander employed some 40 hunters at various times, including the alarming Benedict Roezl from Prague, who instead of one hand had a metal hook; and the luckless Wilhelm Micholitz, who was so terrified of his boss he was prepared to dig a desirable orchid from the eye-sockets of a human skull.

Once orchids could be successfully cultivated under glass they began to lose their cachet. And the First World War put paid to orchidelirium. But there are still obsessional collectors willing to risk life, limb and jail to own, or just to photograph, the orchid of their dreams. Orchid hunting remains dangerous. In 1999, having ignored all advice not to traverse the Darién Gap between Panama and Colombia, British plantsman Tom Hart Dyke and American Paul Winder were captured by FARC guerrillas and held prisoner for nine months. Every day of their captivity they were frustratingly surrounded by fabulous orchids.

Orchids everywhere are now protected by CITES legislation which, by controlling international trade in plants, seeks to prevent the kind of pillage carried out at the height of orchidelirium. Today's legitimate orchid-hunters come from major scientific institutions like Kew, engaged in trying to identify and preserve endangered populations. Paradoxically, the ban on taking orchids from the wild may itself be a threat to their survival. Sharing is what ensures the survival of plants: restoration of wild populations is only possible if the plants are being cultivated elsewhere.

It's a curious fact that while nothing prevents loggers or palm oil farmers tearing down the rainforest, it would be illegal to rescue the orchids before they do.

Oncidium ornithorhynchum by Sarah Anne Drake,
from J. Bateman, *The Orchidaceae of Mexico
and Guatemala*, 1837–42.

Pl. 4.

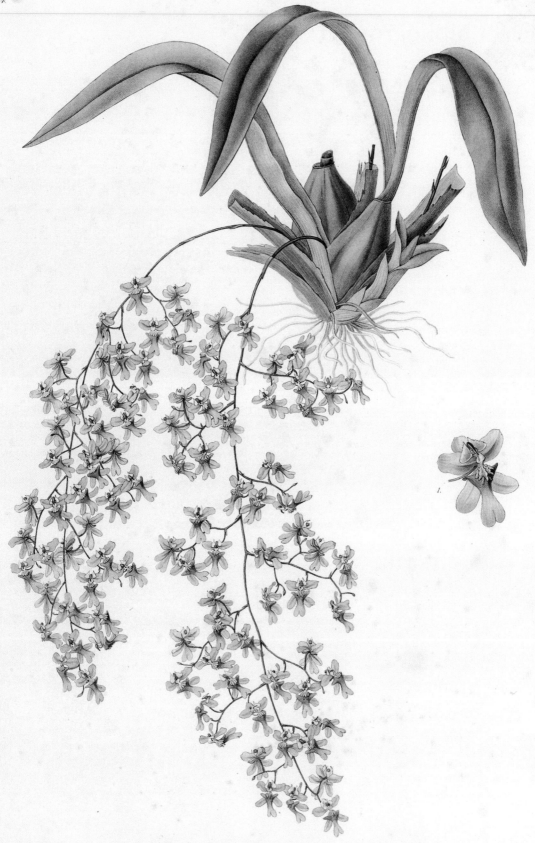

1.

M.S. Drake, del. M. Gauci lith 9 North Crescent Bedford S.⁰

Select bibliography

Allen, Mea, *Plants That Changed our Gardens,* David & Charles, 1974

Banks, Sir Joseph, *The Endeavour Journal of Sir Joseph Banks, 1768–71,* Project Gutenberg of Australia, 2005

Bailey, Kate, *John Reeves. Pioneering Collector of Chinese Plants and Botanical Art,* ACC Art Books, 2019

Berridge, Vanessa, *The Princess's Garden, Royal Intrigue and the Untold Story of Kew,* Amberley, 2017

Campbell-Culver, Maggie, *The Origin of Plants,* Headline, 2001

Christopher, T., ed., *In the Land of the Blue Poppies, The Collected Gardening Writing of Frank Kingdon Ward,* Modern Library Gardening, 2002

Cox, Kenneth, ed., *Frank Kingdon Ward's Riddle of the Tsangpo Gorges,* Antique Collectors' Club, 2001

Crane, P., *Ginkgo: The Tree that Time Forgot,* Yale University Press, 2015

Desmond, Ray, *The History of the Royal Botanic Gardens, Kew,* Royal Botanic Gardens, Kew, 2007

Desmond, Ray, *Sir Joseph Dalton Hooker, Traveller and Plant Collector,* Antique Collectors' Club, 1999

Douglas, D. (1904). *Sketch of a Journey to the Northwestern Parts of the Continent of North America during the Years 1824-25-26-27. The Quarterly of the Oregon Historical Society,* 5(3), 230-271. Retrieved March 15, 2020, from www.jstor.org/stable/20609621

Edwards, Ambra, *The Story of Gardening,* National Trust, 2018

Elliott, Brent, *Flora. An Illustrated History of the Garden Flower,* Scriptum Editions, 2001

Fisher, John, *The Origins of Garden Plants,* Constable, 1982

Fortune, Robert, *Three Years Wandering in the Northern Provinces of China,* John Murray, 1847

Fry, Carolyn, *The Plant Hunters,* Andre Deutsch, 2009

Fry, Carolyn, *The World of Kew,* BBC Books, 2006

Gooding, Mabberley & Studholme, *Joseph Banks's Florilegium. Botanical Treasures from*

Cook's First Voyage, Thames & Hudson, 2019

Harrison, Christina, *The Botanical Adventures of Joseph Banks,* Royal Botanic Gardens, Kew, 2020

Harrison, Christina & Gardiner, Lauren, *Bizarre Botany,* Royal Botanic Gardens, Kew, 2016

Harrison, Christina & Kirkham, Tony, *Remarkable Trees,* Thames & Hudson, 2019

Hobhouse, Penelope, *Plants in Garden History,* Pavilion, 1992

Hobhouse, Penelope & Edwards, Ambra, *The Story of Gardening,* Pavilion, 2019

Holway, Tatiana, *The Flower of Empire,* Oxford University Press, 2013

Hooker, J. D., *Rhododendrons of the Sikkim-Himalaya,* 1849, Royal Botanic Gardens, Kew facsimile, 2017

Horwood, Catherine, *Gardening Women. Their Stories from 1600 to the Present,* Virago, 2010

Hoyles, Martin, *Gardeners Delight. Gardening Books from 1560–1960,* Pluto Press, 1995

Hoyles, Martin, *Bread and Roses. Gardening Books from 1560–1960,* Pluto Press, 1995

Johnson, Hugh, *Trees,* Mitchell Beazley, 2010 edition

Laird, Mark, *The Flowering of the Landscape Garden. English Pleasure Grounds 1720–1800,* University of Pennsylvania Press, 1999

Lancaster, Roy, *My Life in Plants,* Filbert Publishing, 2017

Lyte, Charles, *The Plant Hunters,* Orbis, 1983

Masson, Francis, *An Account of Three Journeys from the Cape Town into the Southern Parts of Africa; Undertaken for the Discovery of New Plants, towards the Improvement of the Royal Botanical Gardens at Kew,* Philosophical Transactions of the Royal Society of London , 1776, Vol. 66 (1776), pp. 268-317

Morgan, Joan & Richards, Alison, *A Paradise out of a Common Field,* Harper & Row, 1990

Mueggler, E., *The Paper Road: Archives and Experiences in the Botanical Exploration of West China and Tibet,* University of California Press, 2011

O'Brian, Patrick, *Joseph Banks, A Life,* Collins Harvill, 1987

Pavord, Anna, *The Naming of Names,* Bloomsbury, 2005

Pavord, Anna, *The Tulip,* Bloomsbury, 1999

Potter, Jennifer, *Seven Flowers,* Atlantic Books, 2013

Primrose, Sandy, *Modern Plant Hunters. Adventures in Pursuit of Extraordinary Plants,* Pimpernel, 2019

Rice, Tony, *Voyages of Discovery. Three Centuries of Natural History Exploration,* Scriptum, 2000

Rinaldi, Bianca Maria (ed.), *Ideas of Chinese Gardens, Western Accounts 1300–1860,* Penn, 2016

Robinson, William, *The English Flower Garden,* Bloomsbury, 1996

Rivière, Peter, ed., *The Guiana Travels of Robert Schomburgk 1835–1844: Volume I: Explorations on Behalf of the Royal Geographical Society 1835–1839,* Hakluyt Society, 2006

Roberts, James, *A Journal of His Majesty's Bark Endeavour Round the World, Lieut. James Cook, Commander, 27th May 1768, 27 May–14 May 1770, with annotations 1771,* Mitchell Library of New South Wales

Schama, Simon, *A History of Britain (3 vols),* BBC, 2001

Spruce, Richard, ed. Wallace, Alfred Russel, *Notes of a botanist on the Amazon & Andes: being records of travel during the years 1849–1864,* Macmillan & Co, 1908

Sox, David, *Quaker Plant Hunters,* Sessions Book Trust, 2004

Taylor, Judith M., *The Global Migrations of Ornamental Plants,* Missouri Botanical Garden Press, 2009

Telstsher, Kate, *A Palace of Palms. Tropical dreams and the making of Kew,* Picador, 2020

von Humboldt, Alexander and Bonpland, Time, *Essay on the Geography of Plants,* 1807, ed. Stephen T. Jackson, translated by Sylvie Romanovski, University of Chicago Press, 2009

Walker, Kim & Nesbitt, Mark, *Just the Tonic. A Natural History of Tonic Water,* Royal Botanic Gardens, Kew, 2019

Watt, Alistair, *Robert Fortune. A Plant Hunter in the Orient,* Royal Botanic Gardens, Kew, 2017

Wilson, E. H., *A Naturalist in Western China with Vasculum, Camera, and Gun. Being Some Account of Eleven Years' Travel, Exploration, and Observation in the More Remote Parts of the Flowery Kingdom* (London: Methuen & Co., 1913), 2 vols.

Wulf, Andrea, *The Brother Gardeners. Botany, Empire and the Birth of an Obsession*, William Heinemann, 2008

Wulf, Andrea, *The Invention of Nature, The Adventures of Alexander von Humboldt*, John Murray, 2015

SELECTED JOURNAL ARTICLES

Arnold, David, 'Plant Capitalism and Company Science: The Indian Career of Nathaniel Wallich', *Modern Asian Studies*, Vol. 42, No. 5, Sept 2008

Bailey, Beatrice M. Bodart, 'Kaempfer Restored', *Monumenta Nipponica*, Vol. 43, Sophia University, 1998

Bastin John, 'Sir Stamford Raffles and the Study of Natural History in Penang, Singapore And Indonesia', *Journal of the Malaysian Branch of the Royal Asiatic Society*, Vol. 63, No. 2, 1990

Clarke C., Moran J. A., Chin L., 'Mutualism between Tree Shrews and Pitcher Plants: Perspectives and Avenues for Future Research', *Plant Signal Behaviour*, 2010

Aaron P. Davis, 'Lost and Found: *Coffea stenophylla* and *C. affinis*, the Forgotten Coffee Crop Species of West Africa', *Frontiers in Plant Science*, 19 May 2020

Aaron P. Davis, Helen Chadburn, Justin Moat, Robert O'Sullivan, Serene Hargreaves and Eimear Nic Lughadha, 'High Extinction Risk for Wild Coffee Species and Implications for Coffee Sector Sustainability', *Science Advances* Vol. 5, No. 1, 16 Jan 2019

Dewan, Rachel, 'Bronze Age Flower Power: The Minoan Use and Social Significance of Saffron and Crocus Flowers', University of Toronto, 2015

Fan, Fa-Ti., 'Victorian Naturalists in China: Science and Informal Empire.' *The British Journal for the History of Science*, Vol. 36, No. 1, 2003

Fraser, Joan N., 'Sherriff and Ludlow', *Primroses*, The American Primrose Society, Vol. 66, 2008, pp.5–10

Greenwood M. et al., 'A Unique Resource Mutualism between the Giant Bornean Pitcher Plant, *Nepenthes rajah*, and Members of a Small Mammal Community.' *PLOS ONE*, June 2011

Harvey, Yvette, 'Collecting with Lao Chao [Zhao Chengzhang]: Decolonising the Collecting Trips of George Forrest', *NatSCA blog*, July 2020

Hagglund, Betty, 'The Botanical Writings of Maria Graham', *Journal of Literature and Science*, 2:1, 2011

Lancaster, Roy, 'Mikinori Ogisu and his Plant Introductions', *The Plantsman*, June 2004, pp.79–82.

Mawrey, Gillian, 'From Spices to Roses', *Historic Gardens Review 40*, Winter 1919/20

Milius, Susan, 'The Science of Big, Weird Flowers', *Science News*, Vol. 156, No. 11, 1999

Nelson, E. Charles, 'Augustine Henry and the Exploration of the Chinese Flora', *Arnoldia*, Vol. 43, No. 1 (Winter, 1982–1983), pp. 21–38

Rehder, Alfred, 'Ernest Henry Wilson', *Journal of the Arnold Arboretum*, Vol. 11, No. 4 (October, 1930), pp. 181–192

Rudolph, Richard C., 'Thunberg in Japan and His Flora Japonica in Japanese', *Monumenta Nipponica*, Vol. 29, No. 2, January 1974, pp. 163–179,

Saltmarsh, Anna, 'Francis Masson: Collecting Plants for King and Country', Royal Botanic Gardens, Kew, 2003

Thomas, Adrian P., 'The Establishment of Calcutta Botanic Garden: Plant Transfer, Science and the East India Company, 1786–1806', Journal of the Royal Asiatic Society, Vol. 16, No. 2 , July 2006

KEW ACKNOWLEDGEMENTS

Kew Publishing would like to thank the following colleagues for their feedback on the text: Martin Cheek, Colin Clubbe, Phillip Cribb, Aaron Davis, David Goyder, Ed Ikin, Tony Kirkham, Gwil Lewis, Carlos Magdalena, Mark Nesbitt, Martyn Rix, Tim Utteridge and Richard Wilford. Thank you also to Pei Chu and all the staff of Kew's Library, Art and Archives for tireless picture research and to Paul Little for digitising the images from Kew's Collections.

AUTHOR ACKNOWLEDGEMENTS

The sources I consulted in researching this book are too numerous to fit on these pages, including scientific papers and journals primarily accessed through JSTOR; I would like here to record my debt of gratitude to the many scholars not acknowledged here. In particular, I should like to acknowledge the invaluable contribution of a range of online sources, from botanical gardens, notably Kew, Edinburgh, Oxford, Missouri and the National Tropical Botanical Garden in Florida and Hawaii; from museums, especially the Natural History Museums in London and Paris, the British Museum, the Royal Museums in Greenwich and the Sieboldhuis in Leiden; and media organizations, including the BBC, Dw.com, *The Guardian*, *Daily Telegraph*, *New York Times* and *Hindu Times*. The British Library and Royal Horticultural Society have helped with a wide range of material, as have myriad blogs and websites ranging from conservation organisations to the United Nations, from The Garden Trusts' indispensable blog to the brilliant plantspeopleplanet. org.au, from Botanical Art and Artists to Cor Kwant's Ginkgo pages. Thank you to you all. I am especially grateful to the Biodiversity Heritage Library, Project Gutenberg and similar programmes for making classic historic texts available online – a lifeline in Covid-afflicted times, when all the libraries were shut.

I would like to offer special thanks to the great Roy Lancaster, both for his help in researching Mikinori Ogisu, and for his unfailing generosity and support. Special thanks also to Christina Harrison and to Professor Nigel Maxted for generously sharing their research. Finally, thanks to the many Kew experts who have been involved for their help and guidance, especially Martyn Rix.

Index

Page numbers in *italics* refer to illustration captions.

Picture credits

Excepting those individually listed below, all photographs and illustrations come from the collections of the Royal Botanic Gardens, Kew, and are reproduced with their kind permission.

p10 Padua Botanic Garden (public domain) via wikimedia.org

p26 © The Collection: Art and Archaeology in Lincolnshire (Usher Gallery, Lincoln)/Bridgeman Images

p36 *Hoya australis*, Editions Alecto/Trustees of the Natural History Museum, London

p39 *Wollemia nobilis*, Beverley Allen, © Royal Botanic Gardens & Domain Trust, Sydney

p41 *Wollemia nobilis* © Beverley Allen

p53, 223, 268 Peter H. Raven Library/Missouri Botanical Garden

p66 East 61st Street, New York (*Ginkgo biloba*), © Rory McEwen from the Shirley Sherwood Collection

p74 Island of Deshima, Dutch East India Company, Wellcome Collection

p75 ART Collection/ Alamy Stock Photo

p79 *Wisteria sinensis*, The Natural History Museum/ Alamy Stock Photo

p80 Stanley Spencer, *Wisteria at Cookham*, Artiz/Alamy Stock Photo

p115 *Lilium regale*, © Coral Guest from the Shirley Sherwood Collection

p141 *Epimedium flavum*, © Christabel King

p178 Heritage Image Partnership Ltd/Alamy Stock Photo

p201 *Delonix regia*, © Masumi Yamanaka

p243, 246, 249 Maria Sibylla Merian images, Trustees of the Natural History Museum, London

p252 Wellcome Collection, Creative Commons CCBY

p255 A map of the area of Villcabamba, Ecuador, Wellcome Collection

p265 Iconographic Archive/Alamy Stock Photo

Additional caption information:

p2 *Victoria amazonica* (as *Victoria regia*) by Walter Hood Fitch, from *Curtis's Botanical Magazine*, 1847.

p4 *Victoria amazonica*, original drawing and lithograph by Walter Hood Fitch, Kew Collection, 1851.

First published in Great Britain in 2021
by Greenfinch
An imprint of Quercus Editions Ltd
Carmelite House
50 Victoria Embankment
London EC4Y 0DZ

An Hachette UK company

Text copyright © 2021 Ambra Edwards
Illustration copyright © Board of Trustees of the Royal Botanic Gardens, Kew

A CIP catalogue record for this book is available from the British Library

HB ISBN 978-1-52941-011-2
eBook ISBN 978-1-52941-012-9

10 9 8 7 6 5 4 3 2 1

Design by Bobby Birchall, Bobby&Co, London
Cover design by Andrew Smith
Cover image © Royal Botanic Gardens, Kew: The Blue Egyptian Water Lily (*Nymphaea caerulea*) after a painting by Peter Henderson for *The Temple of Flora*, by Robert John Thornton, 1799–1804.

Printed and bound in Italy by L.E.G.O SpA

MIX
Paper from responsible sources
FSC® C023419
www.fsc.org

Papers used by Greenfinch are from well-managed forests and other responsible sources.